Changing Hands: Art Without Re

Contemporary Native

from the Southwest

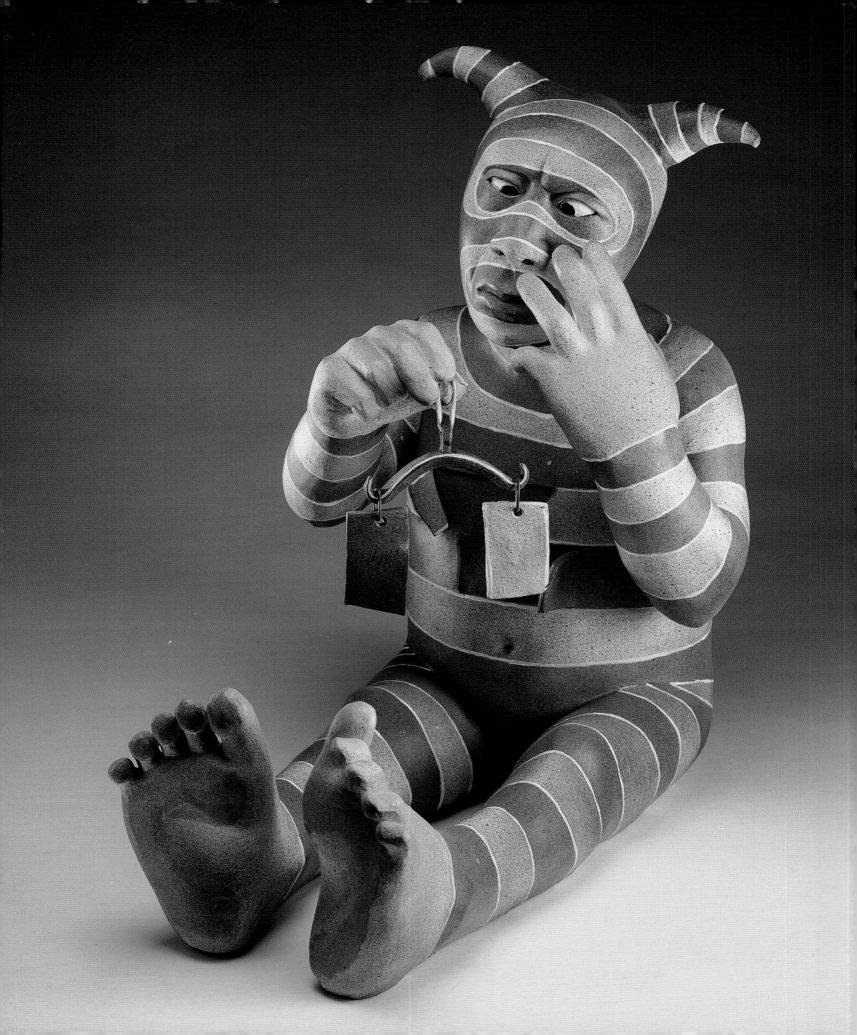

Changing Hands: Art Without Reservation, 1

Contemporary Native American Art from the Southwest

General Editors
David Revere McFadden and
Ellen Napiura Taubman

american craftmuseum

MERRELL

First published 2002 by
Merrell Publishers Limited
42 Southwark Street
London SE1 1UN

in association with

American Craft Museum
40 West 53rd Street
New York, New York 10019

Published on the occasion of the exhibition
Changing Hands: Art Without Reservation, 1
Contemporary Native American Art from the Southwest
organized by the American Craft Museum, New York

Exhibition itinerary:

American Craft Museum, New York
May 9 – September 15, 2002

Museum of Texas Tech University, Lubbock, Texas
October 13, 2002 – January 5, 2003

Philbrook Museum of Art, Tulsa, Oklahoma
January 19 – March 16, 2003

Distributed in the U.S. by Rizzoli International Publications, Inc.,
through St. Martin's Press, 175 Fifth Avenue, New York,
New York 10010

This publication and exhibition are made possible with support from
Philip Morris Companies, Inc., the Rockefeller Foundation, Hunter
Douglas Window Fashions, and anonymous donors.

Library of Congress Control Number: 2002104610

British Library Cataloging-in-Publication Data:
McFadden, David
Changing hands : art without reservation
1: Contemporary Native American art from the Southwest
David McFadden and Ellen N. Taubman
1.Indian art 2.Indian crafts
I.Title II.Taubman, Ellen N. III.American Craft Museum
704'.0397

ISBN 1 85894 188 1 (hardcover edition)
ISBN 1 85894 186 5 (softcover edition)

Produced by Merrell Publishers Limited
Designed by Karen Wilks
Edited by Nancy Preu
Printed and bound in Italy

Front jacket/cover: **Rebecca Lucario** *Plate*, 2000; see p. 216
Back jacket/cover (left to right): **Julia Upshaw** *Eyedazzler Rug*, 2000;
see p. 41 / **Roxanne Swentzell** *Vulnerable*, 2002; see p. 173 / **Jacquie
Stevens** *Double-spouted Jar*, 2001; see p. 95 / **David Gaussoin**
Controlled Chaos, 2002; see p. 213
Page 2: **Roxanne Swentzell** *A Question of Balance*, 1998; see p. 173

Note about measurements:
All measurements are cited first in inches, with centimeters
in parentheses.

Contents

Advisory Committee and Gallery Associates

Lenders to the Exhibition

Lenders to the Exhibition

Tony Abeyta and Patricia Michaels
Dr. and Mrs. E. Daniel Albrecht
American Indian Sciences and
 Engineering Society
René-Pierre and Alexis Azria
JoAnn and Bob Balzer
Harvey Begay
Allison and Mike Bird-Romero
Jane Bischoff's Out West
 Indian Arts
Blue Rain Gallery
Blue Sage Gallery
Margie and Clayton Ross Braatz
Rutt Bridges and Ilene Brody
Jane and Bill Buchsbaum
Chris Byrd
Larry Calof
Daniel Chattin
Sharon R. Chavez
Dan Checki
Cheff Collection
Robert Chomat
Judge Jean S. Cooper
Judy Cornfeld
Mr. and Mrs. Robert Cowie
Mr. and Mrs. Raymond E. Cox
Robert Denison
Valerie T. Diker and
 Charles M. Diker
Mr. and Mrs. John Ditsler
Barbara and Eric Dobkin
Marcia and Alan Docter
Marc A. Dorfman and
 James M. Keller
Lowell and Penny Dreyfus
Preston Duwyenie
Juanita Eagle

Faust Gallery
Natalie Fitz-Gerald
Four Winds Gallery
Lyn A. Fox, Fine Historic Pottery
David Gaussoin
Pamela Elizabeth George
Steve Getzwiller
Larry Golsh
Constance and Malcolm
 Goodman
Bob Haozous
Mr. and Mrs. Daniel Hidding
Yazzie Johnson and Gail Bird
Darrell Jumbo
King Galleries of Scottsdale
Melanie A. Kirk and Kimberlee
 A. Kirk, Isleta Silver Shop
Anita and Walter Lange
The Legacy Gallery
Jann and Vivian Levinsky-Carter
Bruce and Debby Lieberman
Sara and David Lieberman
James Little
Phyllis and Walter Loeb
Leslie Logan
Dennis and Janis Lyon
Jim and Jeanne Manning
Thomas and Nancy Martin
Emile H. Mathis II
Virginia V. Mattern
Linda Lou Metoxen
The Mooney Family
Thomas Musiak
Morris Muskett
Robert F. Nichols Gallery
Niman Fine Art
Lovena Ohl/Waddell Gallery
Myron Panteah

Peabody Essex Museum
Dylan Poblano
Jovanna Poblano
Veronica Poblano
Becky and Ralph Rader
Charlene L. Reano
Mabel L. Rice
Judith Richard and Martin
 Madorsky
Ken Romero
Dr. Elizabeth A. Sackler
Ramona Sakiestewa
Dr. Stephen Schreibman and
 Judy Schreibman
Ruth and Sid Schultz
Shiprock Trading Post
Rochelle and Charles Shotland
Mavis Shure and Lanny Hecker
Fred Silberman
Philip M. Smith
Marlys and Harry Stern
Martha Hopkins Struever
Mr. and Mrs. William Stuber
Ellis Tanner Trading Company
Ellen Napiura Taubman
Oliver Daniel Taubman
John and Lorely Temple
Susan H. Totty
Twin Rocks Trading Post
Philip and Kay Vander Stoep
Van Zelst Family Collection
Rosie and Peter Wakefield
Pat Warren
Margaret Wood
Raymond C. Yazzie
Margot and Richard D. Zallen
Private Collectors

Acknowledgments

The curators of *Changing Hands: Art Without Reservation* wish to thank the following individuals and institutions for their encouragement, advice, and assistance in preparing the exhibition and publication.

First and foremost, we wish to pay homage to the artists presented in *Changing Hands* for their exceptional talents, for who they are, and for what they represent in the cultural life of America. They have invited us into their lives and, through their art, have given us a special perspective on the ideas and issues that inform the work of Native American artists today. We are proud that so many friendships have developed as a result of this endeavor; our personal and professional lives have been enriched through knowing these extraordinary individuals.

Collectors in this field have been integral to the process of change in the contemporary arts of the Southwest that the publication documents. Collectors from all regions of the United States have recognized both established and emerging talent and lent their support. Their commitment to the artists and their work is admirable and impressive. This project would not have been possible without their generous help.

Distinguished members of the *Changing Hands* Advisory Committee made themselves and their knowledge available to us from the very outset of the project. They have continued to help us shape the exhibition, compile the catalogue, and plan the educational programs organized in conjunction with *Changing Hands*. Many of our advisers are also lenders to the exhibition, several have become donors of works to the Museum's permanent collection, and others are exhibition sponsors. We thank them for the insights and ideas they provided so freely, and for their unfailing spirit of collaboration and cooperation. We especially wish to thank collector and American Craft Museum Board of Governors member Natalie Fitz-Gerald for planting the seeds of an idea that has grown into this unique exhibition and publication.

Our Gallery Associates were always on hand to answer inquiries, provide essential data, and facilitate our communications with the artists. They have also been generous lenders and have laid the groundwork for the Museum's exploration of the cultural milieu of the Southwest through this project. We are indebted to them for their cooperation.

Our colleagues and associates at other museums and cultural institutions have been generous with their time and expertise. We particularly wish to acknowledge the assistance of the staff of the Wheelwright Museum of the American Indian,

Santa Fe, New Mexico; the Heard Museum, Phoenix, Arizona; the National Museum of the American Indian of the Smithsonian Institution, Washington, D.C.; and the Peabody Essex Museum, Salem, Massachusetts. In addition, the staff of the American Craft Museum, New York, has been supportive and worked tirelessly to see the project through to its completion. Special thanks to Division Assistant Elisa Flynn, volunteer Maxine Ferencz, and our Swedish intern Maria Schreiber. Museum staff members from the Registrar's Office and the Curatorial and Education Divisions deserve commendation for their contributions. Special thanks are offered to Director Holly Hotchner for her recognition of the value of this project for the American Craft Museum, and her willingness to dedicate significant time, effort, and funds to see it happen. Nancy Preu has transformed the manuscript into its final and elegant form.

The contributions of our photographers, who made themselves available within a demanding schedule, have played a vital role in the completion of this volume and in its final appearance. Our gratitude is extended to Dirk Bakker, David Behl, Jon Bolton, Bill Bonebrake, Jeff Caven, Addison Doty, Thomas DuBrock, Eva Heyd, Herb Lotz, Maggie Nimkin, Craig Smith, and WindSong Studio.

Merrell Publishers has given us the opportunity to share this publication with an international audience. We thank them for their commitment to the project, for a memorable design, for their invaluable expertise, and for their forbearance in the face of our long-distance relationship and the time constraints involved. Thank you, Julian Honer, for your kind patience and your belief in *Changing Hands: Art Without Reservation*.

On a personal level, we want to say thank you to Peter and Jane Marino, who sat us next to each other at a dinner party over two years ago. Our conversation that evening resulted in our collaboration on *Changing Hands: Art Without Reservation*.

Lastly, thank you to our family and friends, who have been tolerant of the lengthy absences, late hours, constant telephone calls and e-mails, and changes in daily schedules that commanded our attention for so many months.

David Revere McFadden
Ellen Napiura Taubman
January 2002

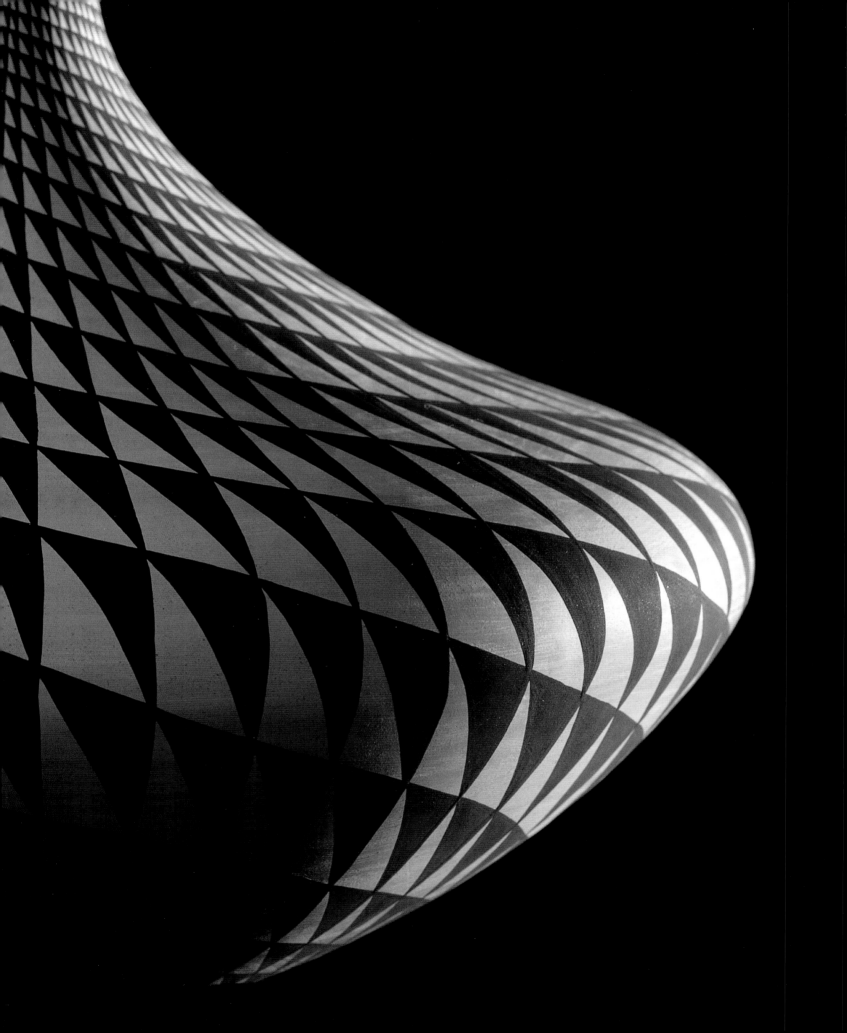

Dorothy Torivio
Seed Jar, 2001; see p. 98

Foreword

The American Craft Museum is proud and honored to present *Changing Hands: Art Without Reservation*, comprising the work of one hundred of America's most talented, creative, and innovative artists. In its breadth and depth, *Changing Hands: Art Without Reservation* is the most comprehensive exhibition of contemporary work by Native American artists from the Southwest to date. This exhibition and its accompanying publication serve as testaments to the renewal of creative energy in the arts of the Southwest, and also to the explosion of new talent and ideas in such traditional craft media as clay, fiber, metals, glass, and wood. This exhibition is the first of three dedicated to the presentation and interpretation of Native American work today in all of its manifestations, and it underscores the Museum's commitment to increasing the diversity of our permanent collection.

When the American Craft Museum opened its doors in 1956 to welcome artists and crafts practitioners to the first museum in this country dedicated solely to their work, a primary goal was to make the Museum a tangible way to acknowledge the contributions of established artists, and also to serve as an advocate for emerging artists. This philosophy was supported by an energetic exhibition program entitled Young Americans, and followed by numerous group and individual shows of emerging art. The Museum also sought to develop a unique permanent collection that would document the history of our field.

Owing to the nature of craft, which embraces a wide range of creative activities in an equally wide range of contexts, the Museum took a leading role in highlighting the gender and cultural diversity in this country. For example, the very nature of craft worldwide has meant that from our very beginnings the work of women has been represented on an equal basis with that of men. This is a distinction that few museums in this country can claim, and I believe it has been one of our greatest strengths.

The Museum has also been committed to cultural diversity in its programming. In 1994, Janet Kardon, then director of the Museum, and a team of scholars organized *Revivals! Diverse Traditions* as part of a centenary program of exhibitions and publications called The History of Twentieth Century Craft. In this exhibition, work by African American, Appalachian, Colonial Revival, Hispanic, and Native American artists was highlighted.

However, the collections have not been equally representative of the rich diversity of traditions that make up our country. Until work began on this exhibition, only three works by Native American artists— a burnished plate by San Ildefonso potter Maria Martinez, jewelry by Charles Loloma, and a more recent ceramic donated by the artist Richard Zane Smith—were part of the American Craft Museum. I am pleased to say that we have already added to the collection several major works by artists featured in this exhibition, and these will be highlighted in the exhibition and this publication.

The Museum has continued to amplify its mission and its commitment to present the rich tapestry of creative work that distinguishes our nation. A first effort in the Native American arena occurred in 1999 when the Museum hosted *Head + Heart + Hands = Native American Art in a Contemporary World*, organized by the Kentucky Art and Craft Gallery in Louisville, Kentucky. The exhibition presented the work of twenty-three artists from all parts of the country and was enthusiastically embraced by our visitors. This exhibition, along with important exhibitions of

contemporary art organized by the Wheelwright Museum of the American Indian, Santa Fe, New Mexico, the Heard Museum, Phoenix, Arizona, and the National Museum of the American Indian of the Smithsonian Institution, Washington, D.C., and New York, have all been inspirations for *Changing Hands: Art Without Reservation*. It is our hope that the present exhibition will move the field of Native American arts onto yet another plateau by underscoring the talent and dedication of the Southwestern artists whose works are being featured. We hope to further the Museum's overall goal of stimulating a new vision of the arts that eradicates the artificial boundaries that have isolated art, craft, design, and ethnographic objects in our times.

This exhibition could not have been accomplished without the dedication and hard work of so many individuals and organizations. Guidance and assistance to accomplish this ambitious project have come from many sources, led by our distinguished Advisory Committee and our Gallery Associates, along with numerous individuals, galleries, and artists who have lent generously of their collections, all of whom are listed on pages 6 and 7. We thank you so very much for your generosity and hope that many people will be able to take this opportunity to share your cherished objects with you.

Our sponsors have been equally vital to the accomplishment of the exhibition, publication, and our educational programs. I want to thank Philip Morris Companies for being the first to come forward with a generous offer of financial support, which launched the project. The Rockefeller Foundation made a magnificent donation to aid in the research and organization of the exhibition, and the realization of the extended educational programs that will enrich our presentation of *Changing Hands: Art Without Reservation*. Additional thanks go to Penny Steyer and Hunter Douglas Window Fashions for their support. Finally, I have a special person to thank for making an exceptionally generous donation to support the publication and the presentation of the exhibition. The fact that this person wishes to remain anonymous is indicative of the deep commitment that this enlightened and thoughtful friend of the American Craft Museum feels to the field, to the artists, and to the art.

We salute all the artists who have given so generously of their time and talents to bring this exhibition to fruition. I offer them my heartfelt gratitude and hope that they will all share my pride in this timely and important undertaking. To our catalogue authors and essayists, I reiterate my sincere thanks.

The responsibilities of the director of any museum are met only with an excellent and dedicated staff that ranges from our curators, educators, and registrar to the security staff, our store personnel, and our development staff.

We are indeed fortunate to have at our helm chief curator David Revere McFadden. His wonderful knowledge and passion for the field began while he was director of the Millicent Rogers Museum in Taos, at which time he established relationships with many Native artists. His broad knowledge, informed eye, and insuppressible commitment have made this project a reality. I wish to thank especially our guest co-curator for the project, Ellen Napiura Taubman. Ellen has brought an extensive knowledge of and experience in the field, and her presence can be sensed in every detail of *Changing Hands*. She has also brought with her the wealth of relationships with artists, collectors, scholars, and galleries that she has developed over her years in

the field, and this has been of inestimable value to all. Most importantly, she has brought her love of Native American art of both the past and the present; it is this warmth that pervades the exhibition and this publication.

The entire project began with inspiration from our esteemed board member Natalie Fitz-Gerald. It was through her unflagging energy that the project was set into motion. Their combined efforts have made *Changing Hands: Art Without Reservation* into a labor of love that can be shared with our many visitors.

A special thank-you is in order to Victoria Meyers and Thomas Hanrahan of Meyers & Hanrahan, our exhibition designers, for their generosity and talent. Merrell Publishers, and Julian Honer in particular, have been wonderful colleagues and partners in the design and publishing of this catalogue.

The new mission for the Museum posits a special place for our institution as one that presents the tangible evidence of the creative process. I congratulate all involved in *Changing Hands: Art Without Reservation* for your role in achieving this vital purpose for the American Craft Museum.

Holly Hotchner
Director

Introduction

"Change begets change. Nothing propagates so fast," wrote Charles Dickens in the middle of the nineteenth century. His words still resonate when one observes the powerful urgency of change that animates the creative spirit of Native American art today. A renaissance in Native American art is in process. As with any renaissance in the arts, it is the artists and their art that direct it to its ultimate destination. These changes lead any conscientious observer to a new viewing platform, from which a landscape of creativity can be clearly glimpsed, but one with decidedly permeable and shifting borders between craft, art, and design.

The exhibition and this publication, *Changing Hands: Art Without Reservation, 1: Contemporary Native American Art from the Southwest*, are the first in a series of three that will examine the current state of the arts in indigenous American societies. Subsequent exhibitions will survey work being made by Native American artists in the Plains and Plateau regions, and on the East and West coasts, including Hawaii.

The notions of change and exchange, of tradition and innovation, and of realities and stereotypes are core areas of inquiry in the exhibition *Changing Hands: Art Without Reservation*. The title for the exhibition sums up a process of observation, discussion, and interpretation that has engaged well over one hundred Native American artists from the Southwestern region of the United States, a wide variety of dealers, gallery owners, and traders, and an equally diverse group of collecting individuals and institutions that have acquired contemporary and non-traditional works for their private or public collections.

Our goal throughout the project was to provide a means of viewing the work being created by innovative and influential Indian artists of our time and, in so doing, to open doorways to a change in our perception and understanding of the art forms and the artists. From the outset, we recognized that Indian art today cannot be easily pigeonholed within the ethnographic and anthropological matrix. Rather, it has become an increasingly powerful tributary feeding the mainstream of American art.

In this publication, the art is presented thematically, rather than by medium or tribal affiliation. Works have been selected to compare and contrast with each other as independent works of art, not to illustrate cultural histories. The artists in *Changing Hands: Art Without Reservation* operate within a rich and powerful cultural and historical tradition, but each in his or her own way both acknowledges those traditions and transcends them. We hope and believe that this exhibition and publication will help redefine objects created in traditional craft media and utilizing many traditional techniques as art rather than as artifacts. The subtitle *Art Without Reservation* says it all: first and foremost, these objects are unreservedly defined as art, and it is art that does not fall within the stereotypes of "Indian craft from the Reservation."

Art made by Native American artists has typically been examined, dissected, and interpreted by a dominant society within a cultural context based primarily on tribal affiliations, historical classifications, and socio-political hierarchies. *Changing Hands: Art Without Reservation* began with different goals and a different methodology. Because of the vast number of contemporary Native artists working today, a geographical focus seemed an appropriate basis to use as a starting point for investigating the evolution of Native American art. This approach gave us access to a network of creative individuals who were knowledgeable about one another's work and

the cultural climate of the Southwest, and it also permitted us to include certain artists whose cultural affiliation may not be rooted in the region. A small number of artists in the current exhibition claim cultural heritage outside the Southwest. They feel, however, that their artistic identity is linked to the region, and, after discussion with them on this point, their work has been included.

A primary concern in the selection process was to focus on artists who are pushing the boundaries, establishing new parameters and goals for their art, and laying the groundwork for a revised critical history of their field. Such innovations and experiments included, but were not limited to, distinctive choice and treatment of traditional or entirely new materials; the creation of new and non-historical forms and ornaments; changes in scale that ranged from the monumental to the miniature; works that provocatively merged the old and the new with particular grace, skill, or beauty; works that expounded powerful social commentary pertinent to our times and our own self-consciousness; and even works that touched upon the taboo by including images of a highly personal and idiosyncratic nature that fall outside the standard realm of group culture.

We offer the works in this exhibition and publication as a document of change in our times. The diversity of materials, the broad range of formats from architectural sculpture to intimate jewelry, and the variety of messages—from the joy of making something beautiful to incisive political commentary—make these works special and memorable. Only recently has this type of work been shown within the context of art, leaving a dearth of critical literature on the subject. We have depended on the excellent work of pioneers in the documentation and presentation of contemporary Indian art, on the collectors and

dealers who are the most familiar with the artists and their work, and on the artists themselves. All are thanked in our acknowledgments, but it bears repeating that this is a field of art historical and critical inquiry still in its infancy. We would not have been able to complete this project without the groundbreaking work of our many colleagues.

There were various obstacles to getting this show organized in a timely manner. The geographic reality of both curators being located in New York while the majority of the artists and collectors resided in the Southwest complicated matters. In addition to the usual routes of access to the materials, such as trips to Santa Fe's Indian Market and the Heard Museum's Fair, and visits to numerous private and museum collections, we also relied on a new and influential technology—the Internet—to connect us with artists, galleries, and collectors. In cyberspace, a network of relationships was established that has knitted us together as an extended team. For us, the idea of "changing hands" also came to mean the information that flowed reciprocally among all those involved in the project as we shared discoveries and recognized trends.

Although our goal was to feature an artist's most recent work in *Changing Hands: Art Without Reservation*, often things did not work out as we had hoped. Some artists wished to make new work specifically for the exhibition and have succeeded in doing so. Other new work was beset by the usual problems, such as ceramics that cracked in firing. Other works were sold to collectors before they could be secured for the exhibition, leaving the artists and the curators empty-handed.

Changing Hands: Art Without Reservation remains a work in progress. As this introduction is being written,

new work is being made and new talents are emerging, neither of which can be included. However, if *Changing Hands: Art Without Reservation* accomplishes one goal, it will be in the repositioning of the arts and the artists of the Southwest as fundamental to the understanding of American art and culture in a new millennium. We salute the artists who have brought about the changes that are now making themselves felt nationally and internationally.

David Revere McFadden
Ellen Napiura Taubman
Curators
Changing Hands: Art Without Reservation

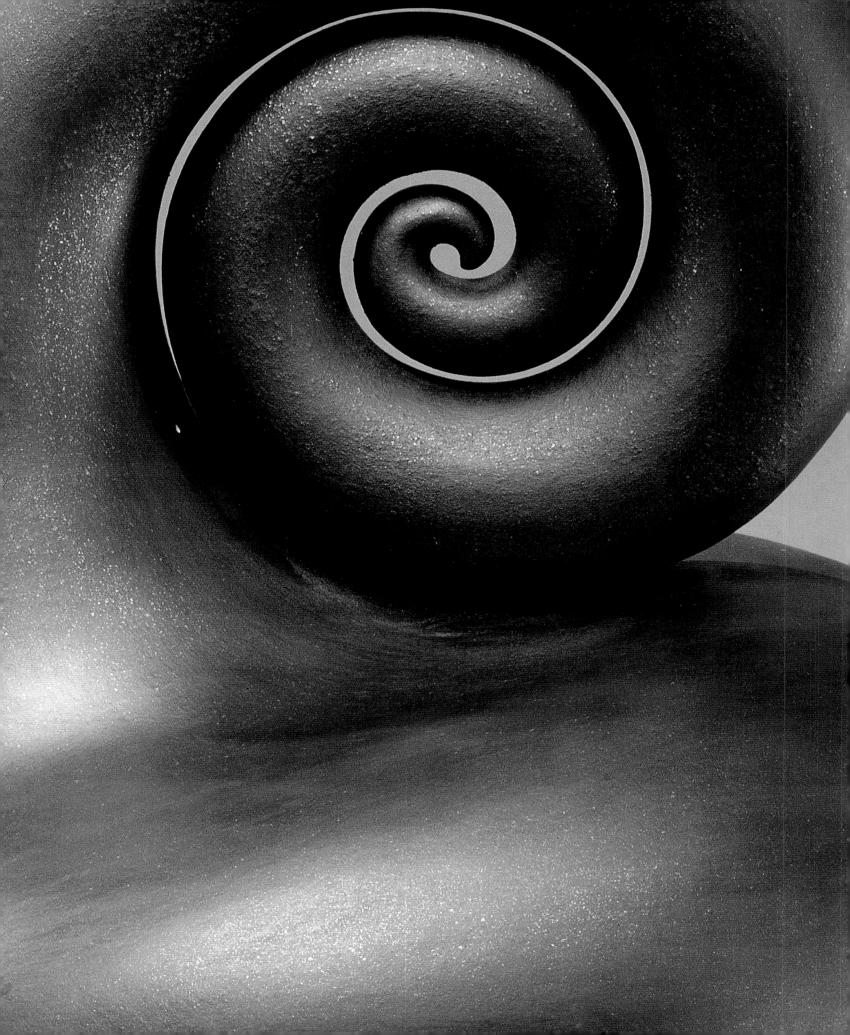

Christine McHorse
Gourd Vessel, 1999; see p. 118

Changing Hands: A Metaphor for Our Times

David Revere McFadden

In a letter written by potter Richard Zane Smith, the artist summed up the tenor of the times as reflected in the work of Native American artists throughout the United States:

> Over time even our native cultures seem to accumulate a residue, an encrustation, a stiffening around a once-living and breathing pattern of daily life. If change is the essence of a living culture, where are our songs to buy a new car? Where is the blessing ceremony that welcomes a new computer into our homes? The artist, like the prophet (or heretic), comes testing the very fabric of tradition and picks at the frayed edges of the status quo. Sometimes gently as the female rains and sometimes in the rage of a tornado. But come they must, for the artist is given that special gift and can't be silent, for a living culture is like clay. The Native American artist has a tough job to convey both beauty and truth. But like never before, the world is watching with eager eyes.
> (Letter to author, June 2001)

Smith's perceptions of the power and persuasiveness of the changes redefining Native American art of this moment are in sympathy with broader developments in the arts in general. A change in the context in which Native work is viewed and reviewed involves larger issues in the trajectory taken by the visual arts of today. We are living through an exciting (and for some confusing) period in which boundaries between art forms and media have become more permeable, more interconnected, and more mutually stimulating than we have seen throughout the past century. There is a growing awareness of how the aesthetic, critical, and financial boundaries used to structure the visual arts are deteriorating.

Artists themselves are moving freely between modes of expression, materials, and techniques. Creative protagonists are proposing new art forms, and a broader spectrum of creative interaction among individuals in different fields is notable and newsworthy. The work exists, but we are only now developing a language of criticism and interpretation capable of responding. In this rich and provocative chorale of ideas and objects, new voices are being heard: Native American art and artists have now joined the mainstream, and museums, galleries, collectors, curators, and critics are paying attention.

Harbingers of these changes could be heard in the 1980s when work by innovative and non-traditional Native artists was noted by surprised and pleased critics and curators. The major presentations of Native art at such venues as the Santa Fe Indian Market and the Heard Museum Biennial began to encourage a rethinking of how Native artists were using their own cultural resources, histories, and legacies as an element in shaping this change. Journalist and critic Richard Nilsen, writing in the *Arizona Republic*, insightfully proclaimed:

> It is time to dump the confining label of "Indian art." [The artists shown in the Heard Biennial] are artists who draw on their heritage in the same way Picasso drew on his Spanish heritage. . . . Most of the work in the Biennial is work that may have roots in Indian culture, but speaks to us about problems that are universal. (*Arizona Republic*, 20 October 1989, section D 1-2)

As is apparent in the work shown in *Changing Hands*, it is often the rich legacy of traditional art that gives these artists important animation and

inspiration. It has certainly given them resilience over the past two decades, as their work has challenged the attitudes of their own families as well as the stereotypes of Indians and Indian art so entrenched in American culture.

Of great significance to the public and the critical perception of Native arts today is the fact that the spirit of innovation and experimentation that informs works of the sort presented in this volume and in this exhibition demands a change in the ground rules of how Indian art should be viewed in our own country (and internationally). The artists themselves, and the works they produce, are catalytic agents for change.

The anthropologist and educator Ruth B. Phillips describes the turning point that we are now witnessing in the critical history of American Indian arts. Noting that Indian art first appeared as part of the interest in "primitive art" in the 1930s and was recognized as a discipline in universities only in the 1960s, she goes on to say: "During the past two decades . . . the discourse surrounding Native art has been moving in new directions, driven by the radical reformations of art history and anthropology as disciplines and by the growing Native critique of the Western art and culture system." (Phillips, 1999, p. 97)

It is difficult, if not impossible, to view contemporary Native work in clay, fiber, metal, glass, wood, and mixed media, such as that featured in *Changing Hands: Art Without Reservation*, as fitting neatly into the pigeonhole categories of "indigenous and traditional" cultures that seemed so appropriate for anthropology and for natural history museums. When Native work was collected or displayed in the context of an art museum or gallery, it was in the "primitive and ethnic" departments. Richard Hill,

former deputy director for public programs at the National Museum of the American Indian of the Smithsonian Institution, Washington, D.C., noted:

> Since the first American museums were developed, many anthropologists have defined Indians as ethnographic beings who produce cultural artifacts rather than fine art. Art in native societies has long been regarded as a technological process rather than as a personal quest for understanding. Since 1945, museums have presented Indian objects either as cultural specimens or primitive art. ("The Museum Indian: Still Frozen in Time and Mind," *Museum News*, May/June 2000, p. 40)

The spirit of change among Native artists is persistent and determined; within the larger cultural community it is welcome and overdue. *Changing Hands: Art Without Reservation* grows from belief in the value of change. It is refreshing to note that work by many of the over one hundred artists included in *Changing Hands* is being collected and exhibited in art museums, acquired by contemporary art connoisseurs, and, to a greater and greater degree, being traded in metropolitan art galleries and sold at auction. Such exhibitions as *Head + Heart + Hands = Native American Craft Traditions in a Contemporary World* (Kentucky Art and Craft Gallery, Louisville, Kentucky, 1999), *Clay People: Pueblo Indian Figurative Traditions* (The Wheelwright Museum of the American Indian, Santa Fe, New Mexico, 1999), and *Who Stole the Tee Pee?* (Phoenix, Arizona: Atlatl, Inc., 2000), to mention only a few of the most recent, have helped frame these changes by focusing on contemporary work by Native artists with a global, as well as regional and traditional, view.

The combined efforts of talented artists, perceptive curators, and intelligent critics have brought about what could be referred to as a sea change in the perception and presentation of Native American art. In many respects, the Native arts community, and especially that active in the culturally dense pressure cooker of the Southwest, is creating a renaissance in the arts. The works featured in *Changing Hands: Art Without Reservation* buttress this belief and encourage a diligent and rigorous reappraisal of the works within the regional, national, and international art-historical matrix. These works explore issues and ideas that are indeed universal. They tell stories, they reveal the artists' relationship with time, they give insights into the value systems that define artistic and cultural objects, and they invite the viewer to receive and respond to their messages. Lastly, and of primary importance, they engage our sense of pleasure in seeing beauty.

Changing Hands: Art Without Reservation examines five issues, or themes, that stand out in these works in various media. Some of the artists included in *Changing Hands: Art Without Reservation* have already established their reputations and their following; most, however, are of a younger generation and are being highlighted in a major museum exhibition for the first time. Themes and issues provide the backbone structure for both the exhibition and publication. The artists, who emanate from different regions and cultures, are presented without tribal affiliations, without ponderous contextual background as to their specific cultural practices or traditions and, importantly, with their own first-person narratives as to the inspiration, production, and interpretation of their work.

Many of the themes explored in *Changing Hands: Art Without Reservation* overlap and intersect. They are not intended to codify each of the works within a rigid structure. Rather, they are intended to be points of entry for viewing and interpreting the work of the artists, the beginning of a conversation with the creators about their work and their relevance to a wide and diverse audience.

Historical Provocation

Contemporary artists from the Southwest, like their peers and colleagues in any region, confront issues of history on a daily basis. All artists are, to one degree or another, products of their own past. The past means different things to different people; for some the past is behind them, while for others, it is the constant reminder of the coming future, and subject to analysis, criticism, and review. For Native artists in particular, issues of history are intertwined with those of continuity and validity, but also of authenticity and stereotyping. The politics of history cannot be divorced entirely from the creative process. Each artist establishes her or his own reference library of motifs, techniques, narratives, and forms from which new ideas may be drawn. The artists included in this section of the book and exhibition embrace or confront history in their own way, yet each takes from the historical library something that can be modified, amplified, exaggerated, or celebrated in the contemporary moment we all share.

The work of ceramic artist Nathan Begaye uses history as an intellectual and visual provocation, but one that reveals a deeply poetic strain. Begaye's *Reconstructed Vessel* of 1998 (p. 33) grows out of the artist's own childhood memories of finding ancient pottery shards near his home. The reassembled pot, made up of matching and mismatched fragments to create a semi-whole vessel, becomes a metaphor for the artist's own life, those "little empty spaces that are waiting to be filled."

Glass artist Tony Jojola, a Native pioneer in the use of glass as an artistic medium, likewise returns to the well of history for new ideas of shape, form, and color. His generous blown-glass ollas, or water jars (p. 43), are ultimately inspired by traditional ceramic and basketry forms and often include decorations common to indigenous artifacts. Carried out in the medium of glass, however, these forms become transparent "ghosts" of the past, reincarnated in a non-traditional material. Jojola's exploration of the past also includes the use of metalworking stamps inherited from earlier generations to ornament his vases. For Jojola, history is powerful but not suffocating, alive but not dominating.

The diamond-encrusted jewelry of Don Supplee uses history as a link between times and places. Supplee's *Pueblo Pendant* and *Bracelet* (p. 49) are part of a series of works that incorporate ancient ruins such as those at Mesa Verde or Canyon de Chelly into their designs. Supplee, whose father was a park ranger at Canyon de Chelly, remembers midnight walks to the ruins and viewing those hauntingly beautiful structures against the dark sky. Supplee's work recalls the fantasy pueblos and villages created by sculptor Charles Simonds, work that deals with clay as a metaphor for birth and decay. Supplee's architectural re-creations record in miniature the growth and decay of human culture, but they are made of gold, thereby rendering the evanescent permanent.

A historical presence that continues to permeate the cultural landscape explored by Native artists is evoked through stories, legends, or myths that offer the artist a rich visual vocabulary of form and motif. Many artists, Ric Charlie (p. 40) and Larry Golsh (p. 34) among them, return to ancient mythic designs from the Southwest for inspiration. Jewelry artists in particular have found an enormous library of ideas in the imagery their ancient forebears have drawn or painted on rocks in the area. Some of the symbols are unique to the region, such as dragonflies (see p. 44, right) and other local animals, while others, such as the spiral, are universal archetypes.

For other artists, history is embraced from a broader perspective. Julia Upshaw's bold zig-zag weavings (p. 41) are composed like modern paintings. The exceptional woven sashes of the young Morris Muskett (p. 30) grow directly from ceremonial clothing traditions. His work, however, has moved onto another plane; his weavings can only be adequately described as foldable paintings, their pure and disciplined geometries transformed when folded and overlapped. Ceramic virtuoso Tammy Garcia merges Pueblo culture and the Southwestern pottery tradition with her interest in classical Greek ceramics in her monumental work *Horses of Chaco Canyon* (p. 51), suggesting that clay artists of all periods and cultures share a common language.

Irony, satire, and humor are combined in the work of Diego Romero, one of the "bad boys" of Southwestern ceramics today. Romero's works are, depending on one's background and point of view, shocking, unorthodox, offensive, or hysterically funny. At the same time, and in a manner not unlike that of Jody Folwell, the pots ask us to attend to a story or savor a metaphor. His *Luncheon in the Canyon* (p. 178, left) teases Western art-historical landmarks by replacing the pale-skinned nude in Manet's *Déjeuner sur l'herbe* (itself already tweaking classical tradition) with a bronze-skinned Indian maiden between two figures that sprang directly out of Anasazi legend. Heroism and its definition in contemporary popular culture are also avenues for commentary in Romero's work. His *Iwo Jima* pot from the Never Forget series (p. 123, left) presents another kind of historical moment—the raising of the

flag at Iwo Jima in World War II—and reminds us of the tragic story of Ira Hayes, whose public image as a hero never matched with the image he held of himself.

Form Beyond Function

The decorative arts of all cultures have similar origins in their functionality or cultural purposes. Baskets are used to gather, hold, and cook food-stuffs, ceramics and glass contain and preserve liquids, and fiber provides warmth and protection for the body. Practical function alone is not the entire story of such objects, however. They also serve religious, cultural, and ceremonial purposes, provide a means to express emotional, spiritual, and artistic ideas, and serve as important indicators of status and affiliation in any cultural group. Southwestern arts are no exception. A large number of Native artists working today juxtapose the practical with the artistic in their works, and in so doing push formal qualities to the point that these objects no longer have the practical purposes that they once had. These artists begin their creative process through pushing even simple, ordinary or traditional objects onto a new level. In so doing, these objects have their own special role to play in the expanded territory that embraces craft, art, and design.

Ramona Sakiestewa has brought Southwestern tapestry weaving onto the international stage. Her deep interest in historical weavings led her to experiment with virtuoso techniques, but also with designs that bridge the past with the present. She was the weaver selected to execute designs created by architect Frank Lloyd Wright, a project with which she felt great sympathy owing to her love of architecture. She also wove designs for painter Kenneth Noland, revealing another side of her talent for bold composition. Her *Migration 14* and *Migration 15* (p. 94, left and right) are exuberant and graphic abstractions that evoke movement and music. Metaphors for her own migrations, travels, and experiences, her works are about the joy of seeing.

Young experimenters in the pursuit of form through new ideas include jewelry artist Dylan Poblano. Grandson and son of jewelers, Poblano sees his own niche as that of an international artist with a goal of transforming tradition itself. Poblano's *21st-Century Neckpiece* (p. 74) is a chaotic and perplexing assemblage of parts that can function on several levels. Worn assembled as a necklace, the work is as intriguing as a puzzle, featuring spiky appendages and moving parts. Many of those parts can be removed to serve as pins, earrings, or other wearables. When not worn, the work is intended as a freestanding sculpture. Among the many artists in *Changing Hands* to challenge the stereotype of "Indian jewelry," Poblano is among the most vocal and exuberant.

Other artists who push form beyond practical function include several artist/designers who have created designs for table flatware, such as Norbert Peshlakai (p. 78), Edison Cummings (p. 85), and Cheyenne Harris (p. 84). Linda Lou Metoxen's *"Deer Hunter" Coffee Service* of 2001 (p. 89) is entirely raised from sheet silver, documenting the emergence of a new design interest among Southwestern artists.

Sculpture is growing in significance throughout the Southwest among artists working in clay and carved wood, which are traditional, as well as in bronze and mixed media. The ceramists Christine McHorse (p. 83) and Les Namingha (p. 47) have used clay either in its natural state, as in the case of McHorse, or painted with acrylic paints, a method adopted by Namingha. The shift in emphasis from pottery forms

to purely sculptural concerns can be traced in the graceful, burnished surfaces and powerful creations of innovator Nancy Youngblood (p. 73), as well as in the delicate mixed media (clay and silver) vessels made by Preston Duwyenie (p. 93).

The pursuit of form beyond function is exemplified in the work of prolific and internationally acclaimed artist Dan Namingha. Namingha's *Cloud Image* from 1996 (p. 82) comprises interlocking upright panels that suggest both a figure and architecture. Painted on the panels in brilliant acrylics is a series of abstract designs—spirals, grids, crosses—derived from ancient and traditional sources. The intersecting panels and surface motifs are intended to be fragments of religious katsinas (dolls representing ancestral spirits) and emblematic of the fragmentation of Native culture. Namingha's work addresses timelessness as well as change, and proposes that one of the roles of the artist is to serve as a scribe for cultural memories.

Nature and Narrative

Nature and storytelling have been rich sources of ideas for the visual arts since the beginning of time. Flora, fauna, and landscape have inspired artists in all media and continue to do so today. Likewise, storytelling in the form of visual narratives is an important bridge between individuals, families, and cultures. These two sources have found an especially fertile ground in the arts of the Southwest. A proud heritage of song and dance is shared in the region, along with lively oral traditions. These traditions have been nurtured by contemporary artists who see the values embedded in them, and their potential as present-day metaphors. And of all regions in the United States, the Southwest holds pride of place as a land of landscape. It is not at all

surprising that Native artists in all media have discovered their own routes within the glorious landscape of the region.

Imagery derived from traditional narratives about nature appears in the large-scale bronzes of Tammy Garcia (pp. 114–15), which narrate the story of corn and the role of clouds, lightning, and water in its life cycle, as well as the ceremonies that celebrate this aspect of Native culture.

It is a special poetry of place that Ken Romero captures in his delicately inlaid bracelet of 1999, called *Winter's First Snow at Taos* (p. 134, bottom). Through this brooch, Romero evokes his own experience of seeing Taos Pueblo, a centuries-old living structure made of glowing red-brown adobe, just after a fresh snowfall. The mixture of pale browns in the inlay suggests the color of the adobe, as viewed through the translucent layer of snow.

Describing the shapes, textures, and colors of the Southwestern landscape in a purely visual form offers a challenge to artists working in diverse materials. For fiber artist Joann Johnson, it is the massive outcroppings of rock, which interact with sky and sun to create vibrating color juxtapositions, that inspire such works as her set of three massive coiled trays (p. 120). A different approach to landscape, one that has become a hallmark of his personal style, has been taken by jewelry artist Jesse Monongye. His night vistas depicting the Southwestern horizons and the star- and planet-filled skies are stunning in the colors he is able to achieve with inlay (p. 112). Monongye's work describes aspects of nature that are based, in part, on close observation of reality and, to a greater extent, on the vivid landscape of the artist's own imagination and memories.

Variations on themes found in nature can range from the intense details of trout painted by ceramic artist and avid fisherwoman Jennifer Tafoya Moquino (p. 125), in which the contours, surfaces, and scale patterns of each fish are painstakingly reproduced in the difficult medium of colored slip. This celebration of nature finds a lively juxtaposition in the work of inventive jewelry artist Darrell Jumbo. For Jumbo, the world of nature is an apt metaphor for human strength and frailties. Through his amorous dogs, dancing cats, and defensive crabs and frogs (pp. 130–31), Jumbo pricks our conscience in a way that is gently mocking, yet filled with the humor of humanity.

Nature and narrative are closely linked. Narrative imagery can also be used as a vehicle for recounting important events, bringing them up to date to examine their relevance in a contemporary world. Ceramic artist Jody Folwell, a central figure in a multi-generational family of artists, was a student of history and political science. This background becomes apparent in many of Folwell's works. She may treat highly charged political issues frankly and directly, as in her *Buffalo Soldiers Vase* of 1998 (p. 145), in which a hidden chapter of American political life is exposed, but her pots also speak to us of beauty in their forms and delicate colors. Her vessels are firm but gentle reminders of our all-too-frail human natures.

Landscapes of the Southwest today look in two directions at once. Florence Riggs's *Dinosaur Rug* (p. 144) takes the viewer back into a carnival world of prehistoric color, peopled by pink, red, and blue dinosaurs cavorting at the local watering hole. By way of stark contrast, the landscape of Manhattan entered the consciousness of Southwestern artists after the terrorist attacks on the World Trade Towers on September 11, 2001. Martha Smith responded

by weaving a poignant reminder of the place and the people in her *United We Stand Skyline Rug* (p. 113), woven as a contribution to a relief charity.

The Human Condition

While the human figure frequently appeared in stylized or abstract ways in ancient and traditional Native American art, it has recently surfaced as a major theme for artists working in clay, fiber, wood, and metal, often with unexpected results. For these artists, the figure is not the subject of a distanced, art-historical "gaze." Rather it is used to illuminate issues, express sentiments, or ponder the systems of values that help give direction to our lives.

For several years Roxanne Swentzell has specialized in depicting human beings caught in a moment in time. Swentzell's talent lies in merging an ironic or satirical sense of humor with pathos, placing her figures somewhere between caricature and reality. Her *Reality Check* (p. 172) of 2001 continues a series of single figures begun several years ago to explore the intersection of public and private personae. In this work, a well-fed lady is seated on the beach wearing a "slimming," vertically striped bathing suit. She is comparing herself to another; her eyes catch the fleeting glance of the viewer, and her sunglasses become a mirror reflecting a svelte young nymph. It is the furtive glance and the reflections of what she is not that gives this work such engaging power.

The skilled carvings of Michael Dean Jenkins, who creates latter-day popular-culture katsinas (p. 183) wearing both traditional garb and the most stylish of modern clothes, describe the artist's own life in multiple worlds. An inheritor of a rich tradition, the artist is also a twenty-first-century individual;

Jenkins is a katsina carver and also a rock musician, a biographical detail referred to in many of his works.

Jenkins's personal narrative stands in contrast to that offered by ceramic artist Richard Zane Smith. His *Beans and Squash Lament . . . "What Have They Done to Our Sister?"* (p. 180), uses the anthropomorphized image of an ear of corn to comment on one important aspect of the human condition today—the imperilment of our relationship to nature through biological engineering. Like the recasting of a Greek tragedy, Smith presents a choral lament for "sister corn," a staple of the Native American diet, as she lies in a laboratory, connected with tubes and wires to render her infertile and to preserve the profits derived from genetically altered foodstuffs.

Two other approaches to the human figure deserve commentary. Clay artist and fashion designer Virgil Ortiz has created a memorable family of performers, exhibitionists, freaks, and fashion victims that have gained international recognition (pp. 186–87). Ortiz's work touches on the ways in which intimacy and exhibitionism are intertwined, and on the manner in which the "theater of our daily lives" makes everyone into an actor. Ortiz's pieces are filled with humor and satire, but also seem realistic in the way that we see ourselves in them.

Patricia Michaels's commentaries on the human condition often take the form of clothing. Her *Dress* of 2000 (p. 166) shows a front panel appliquéd with a black velvet spiral that recalls ancient petroglyphic art of the Southwest region. The other side reveals the other side of being an Indian; presented in the same black velvet appliqué is the artist's CIB (Certificate of Indian Birth) number, her mark of "authenticity" in American society.

Material Evidence

Each of the artists highlighted in *Changing Hands: Art Without Reservation* has found her or his particular medium, whether it be clay or fiber, metal or wood. A majority of the artists have learned to work their chosen material in a traditional manner, either through family members who also practiced the art, through apprenticeships with other artists, or through learning the techniques of each unique material at an educational institution such as the Institute for American Indian Arts in Santa Fe, New Mexico.

While honoring the traditional skills and precious, semi-precious, and other materials that are part of their cultural legacy, the artists selected for *Changing Hands: Art Without Reservation* have also been innovators and experimenters who have challenged stereotyping and "pushed the envelope" in their chosen field. These artists have sometimes introduced or developed entirely new techniques that embrace a wider range of tools than ever found in a traditional workshop, they have brought into their work a new diversity of domestic and exotic materials, and they have pushed technical excellence to new destinations. These artists are devoted to the pursuit of beauty and the visual pleasures derived from the experience of beauty, whether in a buckle, bracelet, or necklace, a sculptural vessel intended only for display, or a work of art for the wall. These artists are the virtuosi who are helping to create the new renaissance of art in the Southwest.

Among the jewelers who have been persistently innovative, Yazzie Johnson and Gail Bird are in the center of the spotlight. Their creations are pure essays in color, form, and texture (pp. 38–39). Unlike many jewelry artists working in the tried-and-true combination of turquoise and silver, Johnson and Bird search the world for materials that meet their

demanding eyes, such as strange square pearls, chalcedony and chrysoprase, hematite and covelite. A unique signature of the partners' work is the inclusion of intricate back plates for their mounted stones; these are often engraved, gilded, overlaid, and etched to create a piece of jewelry in reverse, known and appreciated by the wearer.

A relatively new material and technique in Native American arts is blown glass, introduced into the Southwest over a decade ago by such artists as Tony Jojola. The young glass artist and designer C. S. Tarpley has created ample vessel forms enriched with electrodeposited copper in a variety of patterns (p. 214). In his work, deeply sculpted passages define the ornamental bands, or patterns, each outlined in deposited copper. Tarpley uses many traditional motifs in his work but is also influenced by Islamic and Western European ornament. His skilled work and evocative designs are barometers of the internationalism of Native arts today.

An interest in the contextual settings of art within interior architecture, openness to mixed materials, and interdisciplinary connections between the fields of art, craft, and design have also bubbled to the surface in the Southwest. Among the leading figures at this time is the painter and sculptor Tony Abeyta (p. 54). In his mixed-media constructions, Abeyta uses unorthodox materials that can range from sand mixed with oil paints to metallic powders and found or appropriated objects. His *Untitled Collaborative Piece* of 2001 (p. 54) appears at first glance to be an entirely abstract essay in color and texture. Closer observation, however, reveals his use of commercially carved katsinas in the composition, split in half and attached to the surface. In his work, Abeyta establishes a dialogue between then and now, past and present. His work evokes his cultural traditions while transcending them.

Beauty in design, beauty in materials, and beauty in workmanship are important characteristics of the decorative arts. Working in the spirit of the great jewelry innovator Charles Loloma, Verma Nequatewa has consistently produced objects of stellar beauty and sculptural integrity. Her *Bracelets* (p. 212) are hallmarks of a new Native sensibility in design. As such they embody the joy of making art with the satisfaction of accomplished craftsmanship.

It is somehow fitting to conclude with Nequatewa's own words on the current scene in Native American art:

> It is an exciting time for Native American art. Native artists are no longer tied to traditional styles or forms, though they can use their own traditions as a foundation. Now they use all they see in the world as ways to develop those traditions. They can travel the world, see ideas from all cultures, use the artistic background of the entire world as well as their own culture. The new directions are exciting. That is change. That is art.

Changing Hands: Art Without Reservation allows us to be a part of this exciting moment in the artistic history of our country and to have a glimpse of the creativity of the artists whose visions will shape the future.

Julia Upshaw
Eyedazzler Rug, 2000; see p. 41

I Historical Provocation

History is a powerful inspiration for artists in all cultures. Through their creations, artists both record and comment on the past. For Native American artists, issues of history are intertwined with those of continuity and the need for change. History can provide the raw material for new ideas or offer insights into the past and into our interpretation of it. Each of the artists whose work is highlighted in this section of *Changing Hands* has explored the aesthetic and intellectual content of the past. Some of the artists have returned to the past to rediscover forms or patterns that reverberate with contemporary sensibilities. Others examine political, social, and cultural values as seen through the self-reflective lens of the past. History continues to permeate the cultural landscape of the Southwestern artist and also serves as an agent of change, renewal, and evolution.

Kee Yazzie, Jr.

Born 1969, Ganado, Arizona; lives Winslow, Arizona

Kee Yazzie has been making jewelry since 1995, working mostly in silver. While an interest in history has played a role in the artist's use of such motifs as ancient petroglyphs, he also acknowledges the influence of Norbert Peshlakai (pp. 78–79) and Mike Bird-Romero (p. 44) in his more contemporary designs.

Morris Muskett

Born 1975, Gallup, New Mexico; lives Church Rock, New Mexico

Morris Muskett is one of the few male Navajo weavers active today. Basically self-taught, Muskett began experimenting with yarns, dyes, and homemade looms that he built himself. The artist holds a degree in civil engineering from New Mexico State University, which he believes has nourished his interest in structure. For him, engineering and weaving both engage the right and left sides of the brain, particularly during the planning and the process of creating. He has studied historical Navajo weavings carefully and has been inspired by them. His work, however, lies in finding a contemporary mode of expression in his sashes and belts. Although he is young, Muskett's work has already been collected by major museums in the United States.

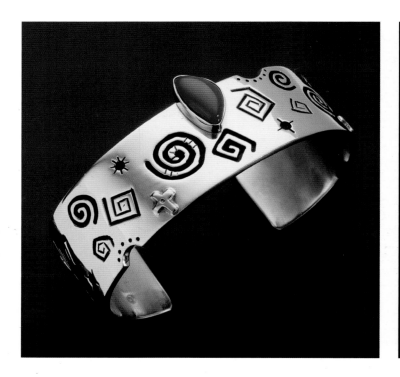

Bracelet, 2001
Sterling silver, 14k gold, coral
2¼ x 2¾ (5.7 x 5.7)
Private collection

Sash with Hopi Brocade, Black and Red Selvage Cords, 2001
Wool, cotton
46½ x 11 (118.1 x 27.9)
Collection of the artist

"My work is rooted in Navajo sash and rug weaving. I wanted to recapture the essence and context of sashes in ancient Navajo society. I researched at museums and then began experimenting with various natural fibers. When I wove this piece, I incorporated elements from a Navajo myth. I read the myth of how Coyote helped First Woman by carelessly throwing the blanket of stars into the night sky. This piece reflects traditional Navajo culture with my modern interpretation of that myth."

Susan Folwell

Born 1970, Santa Clara, New Mexico; lives Española, New Mexico

A member of the Folwell family of visual artists, Susan Folwell attended the Idyllwild School of Music and the Arts in Idyllwild, California, in the late 1980s. She continued her studies at the Center for Creative Studies in Detroit, Michigan, where she majored in photography. Her love of ceramics and the respect for this medium within the Folwell family continue to inform her work. She has won numerous awards and has been artist-in-residence at the Lawrence Art Center in Lawrence, Kansas. Her work is included in private and museum collections, including the American Craft Museum in New York. Her work is unorthodox in subject matter and technique, incorporating images from popular culture and using acrylic and metallic paints.

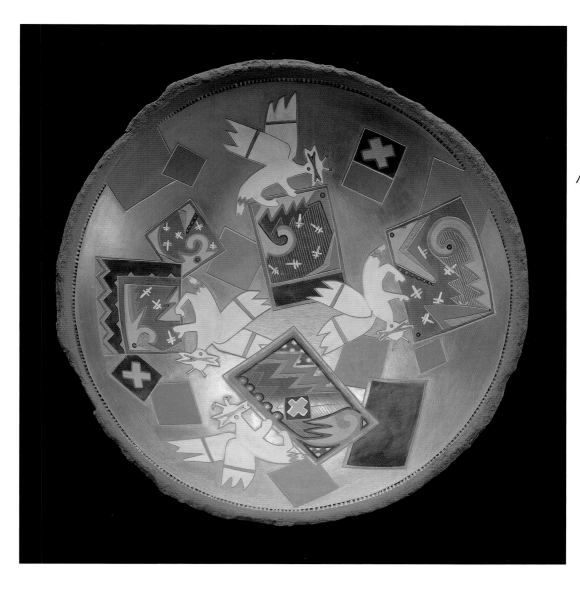

Mosquito Man Bowl, 2001
Polychromed earthenware, acrylic and metallic paints
5 x 19½ (12.7 x 49.5)
Collection American Craft Museum; purchased with funds from the Acquisitions Committee, 2001

"I am interested in blending non-traditional materials with ancient techniques of fabrication. The imagery on this bowl is drawn from history, but it is painted with acrylic paints. I think the meeting of the two worlds makes the piece vibrant and energetic."

Grace Medicine Flower

Born 1938, Santa Clara, New Mexico; lives Española, New Mexico
From a distinguished pottery family, Grace Medicine Flower has established her artistic niche as a maker of superbly designed and finished carved works. Her shapes and patterns can be entirely non-traditional. She has exhibited widely over the course of her career, and her works are collected widely in both private and public collections. Medicine Flower's works are marked by animated abstract patterns filled with movement.

"I think of myself as continuing the pottery tradition in which I grew up. At the same time, I like to experiment with new shapes and decorations. This unusual vessel, with its two spouts, grew out of my imagination. I don't know how, but it just came to me as I was working."

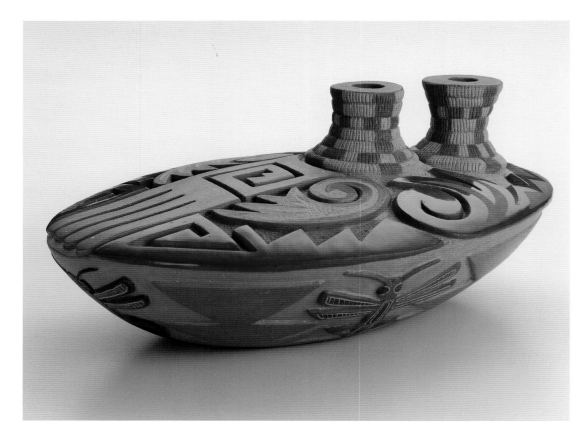

Canteen, 2001
Earthenware
2¾ x 5½ (7 x 14)
Collection Judge Jean S. Cooper

Nathan Begaye

Born 1959, Phoenix, Arizona; lives Santa Fe, New Mexico

Nathan Begaye is known as both an innovator and a provocateur in the field of ceramics. The artist began making pots when he was ten years old and exhibited publicly for the first time one year later. Begaye left home at age fourteen. Since then he has evolved a highly personal style that includes unusual forms, surprising decoration, and unorthodox construction techniques. Begaye studied at the Institute of American Indian Arts in Santa Fe, New Mexico, has exhibited widely throughout the United States, and is dedicated to being a teacher as well as an artist.

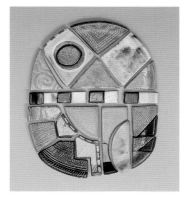

Mask, 1998
Polychromed earthenware
11¾ x 9 (27.9 x 22.9)
Courtesy Robert F. Nichols Gallery

Reconstructed Vessel, 1998
Polychromed earthenware
11 x 10¼ (27.9 x 26)
Collection Fred Silberman

"This vessel represents the many different facets of my world, the many different parts of me brought together. As a child I found pottery shards in the ruins and began to dream about ceramics popping out of the ground. It was magical. This reconstructed vessel recalls those fragments. But there are also missing pieces, little empty spaces that are waiting to be filled. It is a metaphor for myself."

33

Larry Golsh

Born 1942, Phoenix, Arizona; lives Scottsdale, Arizona

Larry Golsh studied sculpture and design at Arizona State University in Tempe, but also took classes in engineering and architecture. The artist worked with architect Paolo Soleri on Soleri's *Arcosanti* architectural exhibition, which toured the U.S. and Canada in the 1970s. In addition to making jewelry and sculpture, Golsh has also designed printed fabrics for Lloyd Kiva New. Golsh credits his meeting with luminary jeweler Charles Loloma as the inspiration for his own innovative designs. He was the first Native American to study at the Gemological Institute of America, and also studied with French-born master jeweler Pierre Touraine. In his work, Golsh draws on a vast repertory of motifs and ideas to defy the stereotypical boundaries of Native American jewelry design, using tufa and cuttlefish-bone casting to create highly textured surfaces.

Sandra Victorino

Born 1958, Acoma, New Mexico; lives Acoma, New Mexico

Sandra Victorino learned to create the painstakingly detailed fine-line designs so typical of Acoma pottery as part of her upbringing in a family of ceramists. Like most Acoma works, Victorino's intricate and complex patterns are painted with a brush made from yucca fiber. Local clay collected by the artist is built into generous vessels notable for their size and profile. The surfaces are then covered with fine-line patterns made from a black paint composed of yucca plants, wild spinach leaves, and rainwater. Victorino's designs evoke the heritage of Acoma pottery, but are also contemporary in spirit.

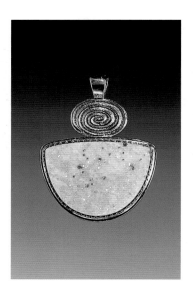

"I often use ancient or prehistoric symbols in my work as a way of referencing my own heritage. This pendant includes an archetypal spiral, a globally recognized motif found in numerous rock carvings from the Southwest."

"I like to work free-hand on my pots, creating these elaborate patterns using the traditional yucca fibers and my own pigments. Every work takes on its own character as the pattern develops, but the pattern is always held in balance by the form itself."

Vessel, 1999
Polychromed earthenware
14 x 13 (36.2 x 33)
Collection Judy Cornfeld

Drusy Quartz Pendant, 2001
18k gold, drusy quartz, crystal
2 x 1½ (5.1 x 3.8)
Private collection

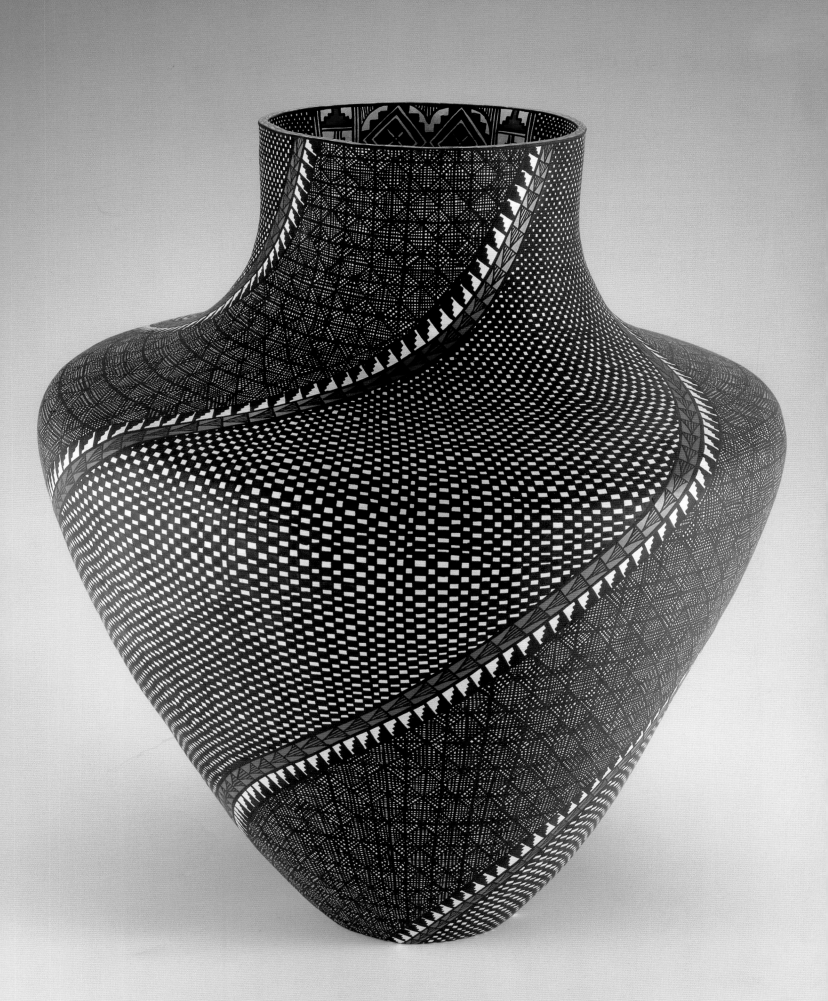

Marilou Schultz

Born 1954, Safford, Arizona; lives Mesa, Arizona

Marilou Schultz was born into a Navajo family of weavers, including her great-great-grandmother, all of whom inspired her work. From elementary school through college, Schultz produced and sold weavings of a traditional nature. The artist studied formally at Arizona State University, Tempe, Arizona, and received her bachelor's and master's degrees in education. She went on to receive teaching certification in mathematics. Her contact with museum curators and collectors encouraged her to experiment with innovative designs, and she has developed unique dyeing techniques to produce graduated colors, as well as distinctive combinations that evoke a rainbow range. Her fascination with techniques is stimulated by her interest in mathematics; recent works have been inspired by computer-chip patterns, as well as by surprising compositions that integrate traditional patterns in highly non-traditional ways.

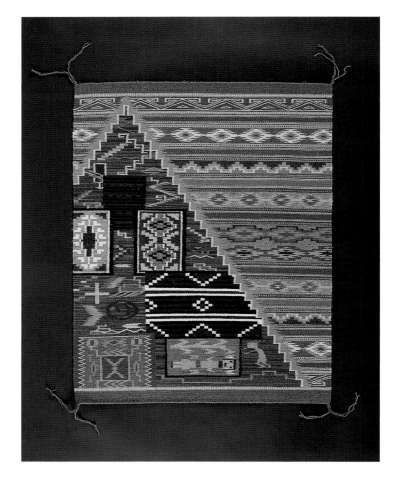

Diversity Weaving, 2001
Handspun wool, vegetal dyes
27½ x 36 (69.9 x 91.4)
Collection Philip and Kay Van der Stoep

Charlene L. Reano

Born 1966, Santo Domingo, New Mexico; lives Albuquerque, New Mexico
Throughout her childhood Charlene Reano was surrounded by jewelry, learning directly from her mother and father, both of whom were jewelers. Trained in both traditional and contemporary silversmithing, Reano has continually experimented with materials and methods, such as mixed metal techniques developed in Japan. She received her master's degree in art education from the University of New Mexico, and is today a professor at the Institute of American Indian Arts in Santa Fe, New Mexico. While her work may be inspired by traditional motifs, it is also global in scope.

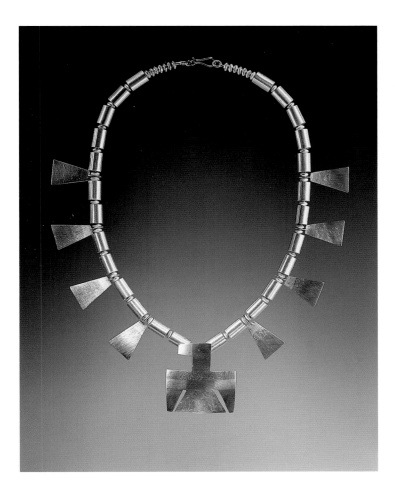

Santo Domingo Thunderbird Reiteration Necklace, 2001
Sterling silver, copper (*mokume gane*)
Length: 12½ (31.8)
Collection of the artist

"My grandmother used to make this particular kind of necklace, but during her time silver and other metals were rare, so she used old phonograph records and plastic from an automobile battery to create her work. While she would sell her 'recycled' necklaces for about a dollar each, today these rarities are worth thousands. This is where I got the idea to make a reiteration of that necklace, but in a modern style."

Yazzie Johnson
and Gail Bird

Born 1946, Winslow, Arizona, and 1949, Oakland, California; live northern New Mexico

Yazzie Johnson and Gail Bird have known each other since the early 1960s but did not begin to work collaboratively until 1979. The artists are renowned for their innovative jewelry designs, which highlight their love of unusual colored stones, abstract and asymmetrical compositions, and exotic materials such as natural and cultured pearls in an astonishing array of colors and forms. Work by the artists has been featured in exhibitions in New York, Washington, D.C., Albuquerque, and Phoenix, and has been collected by museums across the United States. Both artists have also served as exhibition curators, authors, and educators.

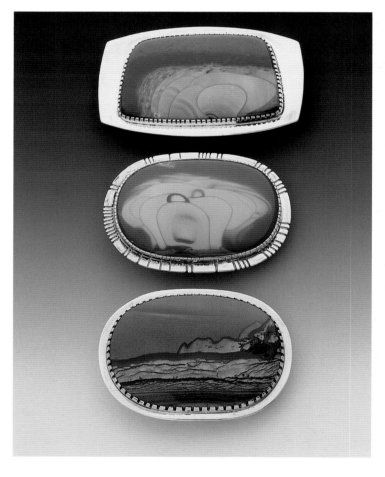

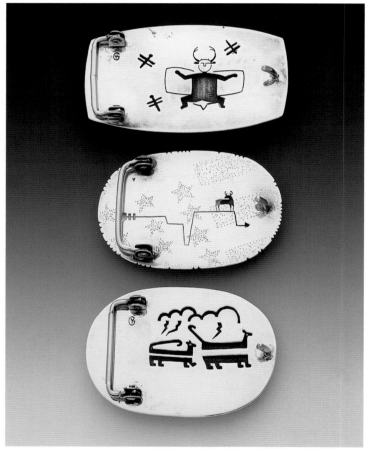

Three Buckles, mid-1990s
Morissonite, Bruneau jasper,
Landscape Rocky butte, sterling
silver, gold
Widths: 3⅛ (7.9); 2½ (7.1); 2⅜ (7)
Collection Charles Diker

"Yazzie began to overlay or under-lay designs in silver on the under-side of metal casings of buckles, pendants, and clasps. The images we chose were adapted from Pueblo pottery designs, Southwest petroglyphs, and realistic drawings of animals and birds."

Three Buckles (reverse)

Turquoise Necklace, late 1990s
Sleeping Beauty turquoise, 18k
gold, covelite
Length: 31⅜ (79.9)
Collection Valerie T. Diker

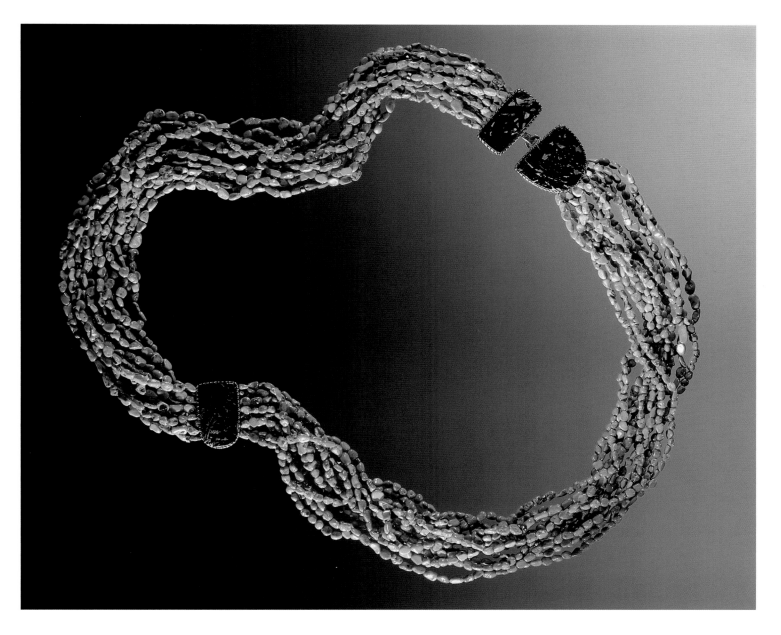

Ric Charlie

Born 1959, Tuba City, Arizona; lives Flagstaff, Arizona

Ric Charlie's reputation as a jeweler working primarily in gold has been built upon his virtuoso handling of the tufa-stone casting process, combined with his rich color palette of gemstones and his rainbow range of patination on the metal. In addition to this painterly approach, Charlie engraves his works with dental tools to enrich their textural and graphic qualities. Charlie received a sports scholarship to Arizona State University, Tempe, and the University of Arizona in Tucson, where he was able to take classes in jewelry and metalworking. In addition to his active career as a jewelry artist, Charlie is also a dedicated teacher, working with a new generation of jewelry artists.

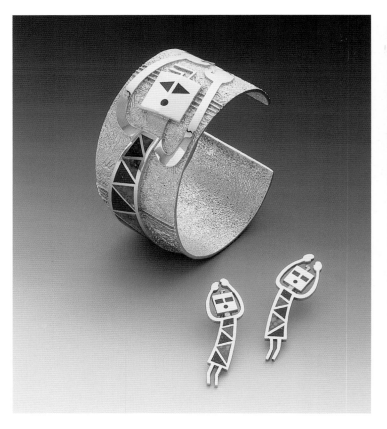

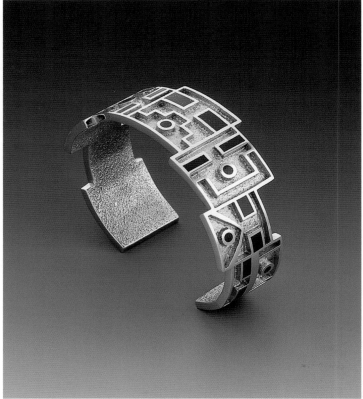

Yei Dance Bracelet and Earrings, 2001
14k gold, lapis lazuli, sugulite
Bracelet width: 2¼ (5.7)
Collection René-Pierre and Alexis Azria

"My knowledge and respect for traditional ways of Native people, including their ceremonies, dances, and celebrations, came from watching older people slowly adjusting to new technologies and world ideas. I have always had an inquisitive nature, and I try to broaden the horizons of artistic achievement in my field and in my culture."

Chanting Dance Bracelet, 2001
14k gold, Carico Lake turquoise, lapis lazuli, sugulite
Width: 2½ (6.4)
Collection Marge and Clayton Braatz

"The modern art world has had its ups and downs, certainly among jewelry designers and other artists working in traditional materials. I want my work to be branded as neither traditional nor progressive; it is work that has deep roots in the past, but is inextricably linked to the contemporary world."

Julia Upshaw

Born 1938, Gallup, New Mexico; lives Gallup, New Mexico

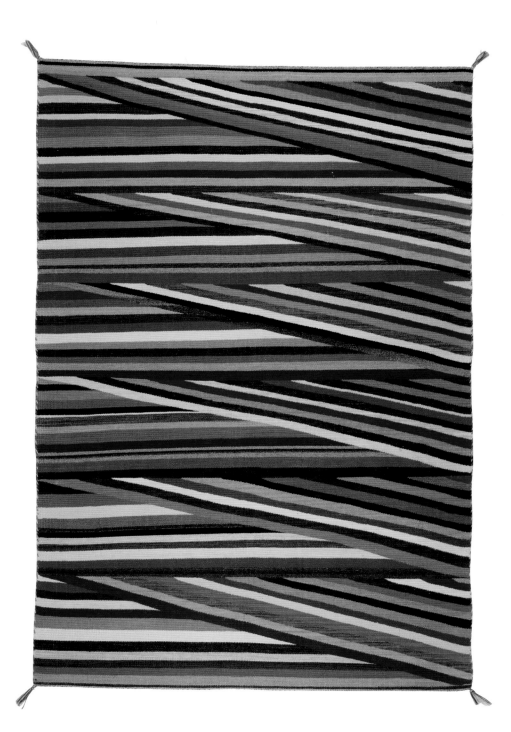

Eyedazzler Rug, 2000
Churro wool, vegetal dyes
60 x 40 (152.4 x 101.6)
Courtesy Steve Getzwiller

"Waves, water, and rainbows
were the inspiration for this work."

Lonnie Vigil ✗

Born 1949, Nambe, Santa Fe, New Mexico; lives Nambe, Santa Fe, New Mexico

Lonnie Vigil began his career as a student of business administration, having received his bachelor's degree in business administration from Eastern New Mexico University, and worked in that field until 1983, when he began to make ceramics. Since 1990, Vigil has worked exclusively with indigenous micaceous clays. Vigil's distinctively monumental and refined works have been acquired by collectors throughout the United States (as well as by the Dalai Lama) and by such institutions as the Museum of Fine Arts, Boston; Los Angeles County Museum of Art; and the Horniman Museum and Gardens, London, England. While remaining active as a ceramist, Vigil is also a community activist, teacher, and board member of many organizations, including several local museums. Vigil's work bridges past and present; made of indigenous clays and hand built in the traditional manner, his large and imposing vessels have a timeless and universal quality.

"Family is a very strong and important part of my creative process and, although the pieces are made by an individual, they are also group efforts of my family, friends, and community. My creative process is a way of expressing and interpreting my life. My aesthetic interests range from historic Native American traditions to the pottery of prehistory and Asia. The timeless quality and power of these works, which speak to us across generations and cultures, is what I strive to capture in my own works."

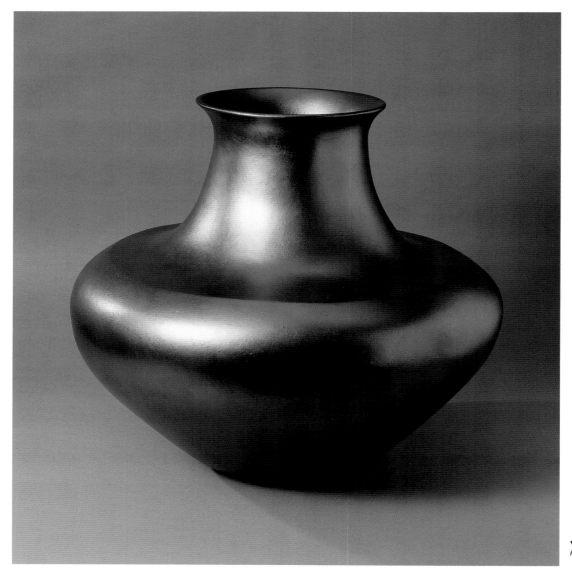

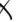

Large Black Olla with Flat Shoulder, 2001
Micaceous earthenware
18½ x 14 (47 x 35.6)
Private collection

Tony Jojola

Born Isleta, New Mexico; lives Taos, New Mexico

Tony Jojola became a seminal figure in the community of Native American artists by leading the way in the use of glass as an artistic medium. The artist's grandmother was a potter, and Tony learned to make pottery at a young age. He was also inspired by watching his silversmith grandfather working with turquoise and gold. Jojola studied at Haystack Mountain School of Crafts in Deer Isle, Maine. Further study at the Institute of American Indian Arts in Santa Fe, New Mexico, and at Pilchuck Glass School in Seattle, Washington, reaffirmed his dedication to the medium of glass. In addition to his active and prolific studio production, Jojola has opened a glass studio and school in Taos, New Mexico, where three hundred young students have learned glassmaking techniques under his guidance.

Three Vases, 1997–2001
Blown glass
Heights left to right: 12⅛ (30.8); 6⅝ (16.8); 9½ (24.1)
Collection American Craft Museum; purchased with funds from Nancy Olnick and Giorgio Spanu, 2001

"Even today my work is about taking the old Pueblo forms we are known for—baskets and pottery—and making them contemporary through the use of color, design, and light. I continue to rely on my culture for inspiration, but I want to be known as a contemporary artist, an innovator."

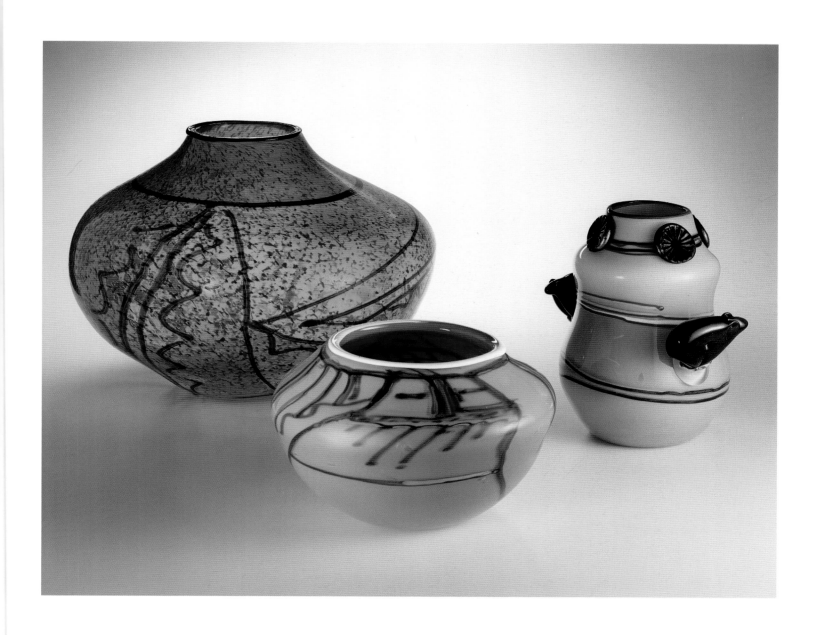

Charlene Sanchez Reano

Born 1960, San Felipe, New Mexico; lives San Felipe, New Mexico

Charlene Sanchez Reano studied art for a brief time at New Mexico Highlands University, Las Vegas, New Mexico, and also worked for a time for a jewelry company in Albuquerque, New Mexico. She attributes her style of work, however, to her husband's family, well known for their mosaics and their use of varied materials. Working as a designer and a cutter of stones and shell, she has developed, along with her husband Frank, a unique style of inlay. The techniques the two use were originally developed by Frank's mother, a jeweler who incorporated pieces of old battery cases and phonograph records in inlay designs in necklaces she made in the 1940s and 1950s.

Mike Bird-Romero

Born 1946, Santa Fe, New Mexico; lives Placitas, New Mexico

A self-taught silversmith, Mike Bird-Romero's work has become identified with the renaissance of new jewelry designs in the Southwest. The artist's works are created as small-scale sculpture and incorporate precious and non-precious stones in surprising combinations and contexts. Bird-Romero's interest in ancient petroglyphs has spawned an extended family of figural brooches. He and his wife Allison's research into historical Pueblo and Navajo crosses has resulted in nearly 150 different cross designs. Bird-Romero's skill as a lapidary is seen particularly in the intricately carved stones that he often uses in his brooches.

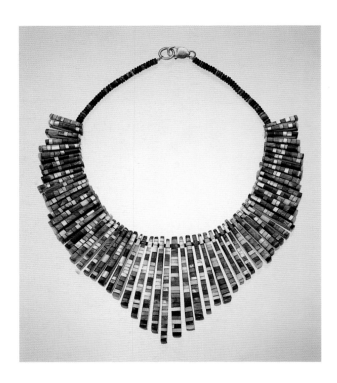

"I think about the colors and designs for pieces I want to make, and then I need to go out and find the materials to bring my ideas to life—going to Los Angeles for shells, Arizona for turquoise, and Santo Domingo for other materials. When people see our pieces they notice that they are different. It is a nice feeling to create something that people like."

Reversible Sandwich Inlay Necklace, 1999
Shell, mother-of-pearl, gold
Length: 19 (48.3)
Collection Marcia Docter

"The dragonfly motif is an old Navajo design. This particular one was inspired by a 1930s piece in silver that I saw. The coral I used on the piece is old fine coral. I felt that this coral, made by someone else at an earlier time, was so beautiful that it needed to be used in a special way. Navajo art reflects our people's interest in the relationship between human beings and the environment. Fossilized coral reminds us that even our lands were once covered by water. I wanted to honor this history in this design."

Necklace with Dragonfly Pendant, 2001
Coral, 14k gold, sterling silver
Length: 15¾ (40)
Courtesy Blue Rain Gallery

Steve Lucas ⟡

Born 1955, Rehoboth, New Mexico; lives Gallup, New Mexico

Steve Lucas began working in ceramics around 1989, having been born
into a pottery-making family. His aunt, Dextra Quotskuyva, one of the
most distinguished ceramists in the Southwest, encouraged his interest.
His early work featured designs inspired by the ancient pottery excavated
from the ruins of Sityatki village, As he progressed, his forms became
larger and his painting style more refined, and today he is known for
the grandeur of his vessels.

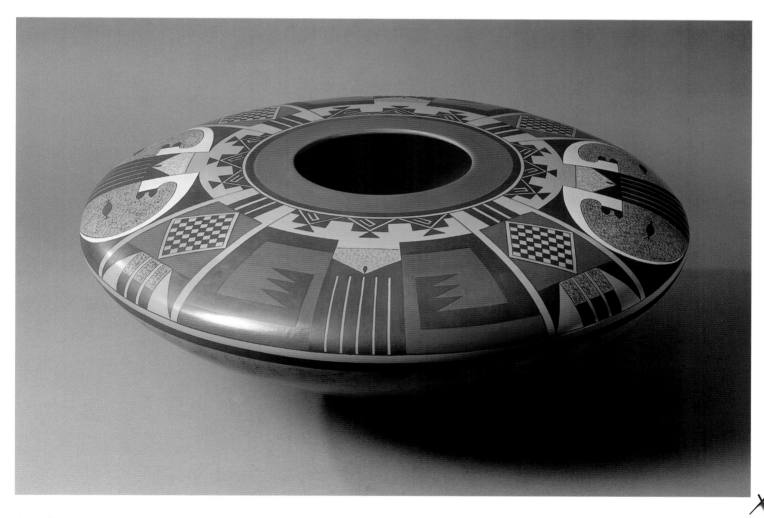

Large Seed Jar, 2000
Polychromed earthenware
8 x 21 (20.3 x 54.6)
Private collection

Rondina Huma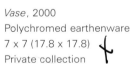

Born 1947, Keams Canyon, Arizona; lives Hopi, Arizona

Rondina Huma is a self-taught ceramist whose early work was decorated in the traditional manner. She soon began experimenting with new designs based on Hopi patterns, from which she developed her distinctive "mosaic" style. Her designs have become progressively finer and more complex.

Dextra Quotskuyva

Born 1928, Polacca, Arizona; lives Kykotsmovi, Arizona

Dextra Quotskuyva is a third-generation descendant of the renowned Hopi potter Nampeyo. She is among a group of the most distinguished Native American artists working today. She was declared an "Arizona Living Treasure" by the state in 1985. In 2001 her work was celebrated in a major retrospective at the Wheelwright Museum of the American Indian in Santa Fe, New Mexico. Over her long career, she has always remained on the cutting edge of innovation.

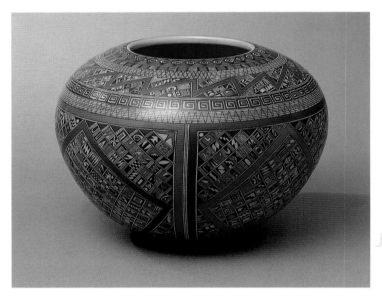

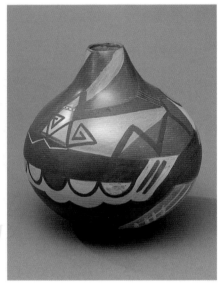

Vase, 2000
Polychromed earthenware
7 x 7 (17.8 x 17.8)
Private collection

"I decided that I did not want tradition to die out, but that I wanted to keep on with what our ancestors started. The ideas for my patterns are mostly traditional, but I like to mix them up."

In Memory of Rick Dillingham
Vase, 1995
Polychromed earthenware
7½ x 6 (19.1 x 15.2)
Collection Barbara and Eric Dobkin

Les Namingha ✗

Born 1967, Zuni, New Mexico; lives Orem, Utah

Les Namingha's childhood was spent making art, and he has never abandoned his love of graphic design and painting. Travels in England in the 1980s preceded his return to the United States, where he studied at Hopi with his aunt, Dextra Quotskuyva (opposite), one of the major Native American ceramists of our time. This period of intensive study took place in the company of his cousin Steve Lucas (p. 45), who had also decided on a career in ceramics. Namingha went on to study design at Brigham Young University in Provo, Utah. The artist has maintained his strong interest in painting, particularly that of the Abstract Expressionist school, and it continues to inform his work today. Namingha still paints on canvas and paper and uses acrylic paints on his pots as well.

Russell Sanchez ✗

Born 1963, San Ildefonso, New Mexico; lives San Ildefonso, New Mexico

Russell Sanchez began making pottery in his childhood, having been encouraged and inspired by the work of his aunt Rose Gonzales and by Dora Tse Pe. While he uses traditional materials and construction techniques, Sanchez also enriches his pots with added materials, such as shell *heishi*, and manipulates the forms to create unusual shapes and profiles.

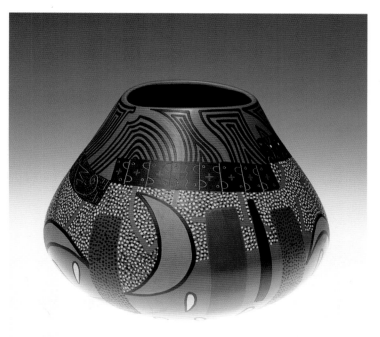

Seed Jar, 2001
Polychromed earthenware, shell *heishi*, copper overlay
7 x 4 (17.8 x 10.2)
Collection Bruce and Debby Lieberman

✗

Vase, 2001
Polychromed earthenware
7¼ x 6½ (18.4 x 16.5)
Private collection

"I sometimes treat the surface of the pot as if it were a canvas. I especially like using different techniques, such as underpainting, or different types of slips. The shapes of my vessels are built in the traditional way, but my designs are definitely abstract expressionist, asymmetrical."

D. Y Begay

Born 1953, Ganado, Arizona; lives Scottsdale, Arizona, and Tselani, Arizona

D. Y Begay, a third-generation weaver in her Navajo family, received her bachelor's degree in art education from Arizona State University in Tempe, Arizona, having studied at art schools and colleges in Arizona and Montana. Her studies included photography, silversmithing, and stained glass. Begay's intimate knowledge of weaving grew out of her early experiences raising and shearing sheep, and carding, spinning, dyeing, and weaving wool. Begay's patterns are inspired by traditional designs but modified through the eye of a weaver with a strong interest in drawing, graphics, and abstract composition.

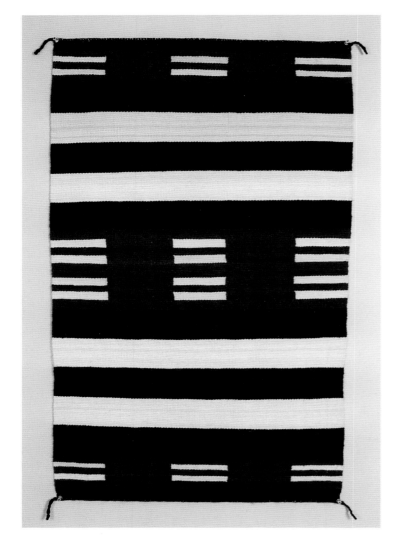

"Ute Style" Weaving, 2000
Wool, fleece, indigo
50 x 41 (127 x 104.1)
Collection Mabel L. Rice

"I like designs with simple patterns and bold colors. This piece is inspired by the old wearing blankets of the late nineteenth century."

Don Supplee

Born 1965, Ganado, Arizona; lives Phoenix, Arizona

Don Supplee is essentially self-taught as a jeweler, having learned some basic skills from his elder brother Charles. Prior to taking up sculpture and jewelry full time, Supplee worked as a medical specialist and as a chef. Jewelry became his primary occupation in 1989. Since that time, he has specialized in highly sculptural works, often informed by his interest in and love of ancient American architecture from sites such as Mesa Verde and Canyon de Chelly.

"My wife is in the building trade, and architecture is something in which I have always had an interest. My father was a park ranger in the Canyon de Chelly national monument, and I remember going on midnight excursions to the ruins. Viewed against the night sky, the ruins were magical places. I believe that these monuments reflect not only my Indian heritage but something that can be understood by all people. I want people to look into my work and see architecture, but also the heavens and the stars."

Pueblo Bracelet, 2001
18k gold, diamonds
2¾ x 2¼ (7 x 5.7)
Collection Mr. and
Mrs. Raymond E. Cox

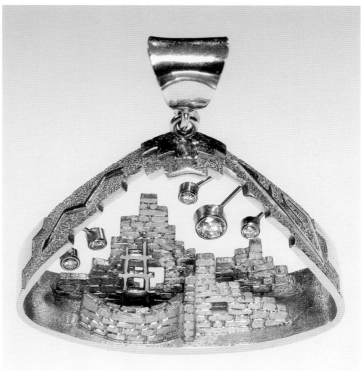

Pueblo Pendant, 1996
18k gold, diamonds
1¾ x 1¾ (4.4 x 4.4)
Collection Valerie T. Diker

Linda Lou Metoxen ⟩

Born 1964, Shiprock, New Mexico; lives Montello, Wisconsin

The daughter of a weaver, Linda Lou Metoxen was raised on the Navajo reservation. As a young person she was drawn to painting and sculpture, particularly the work of Orland C. Joel, a Navajo/Ute artist who inspired her to learn stone carving. In 1985 Linda pursued her studies in sculpture at the Institute of American Indian Arts in Santa Fe, New Mexico. In 1991 she was awarded a fine arts scholarship to the University of Wisconsin, where she learned techniques of metalworking. Metoxen graduated with a master of fine arts degree in 1996. She is among a small number of Southwestern metal artists to specialize in raised hollow ware.

Tammy Garcia ⟩

Born 1969, Los Angeles, California; lives Taos, New Mexico

From a Santa Clara Pueblo family, Tammy Garcia was a prodigy in the field of ceramics. At the age of twenty-one, she was awarded first prize at the Gallup Intertribal Ceremonials, the first of many awards given to the young artist. By the 1990s, her work had been published nationally and featured in numerous exhibitions. Garcia's working techniques—hand coiling, carving, burnishing—are traditional, but her imagery is entirely contemporary, inspired by the abstract patterns of Mimbres and Anasazi pottery. Garcia's ceramics range in size from the intimate to the monumental. Recently, the artist has expanded her repertoire of techniques to include bronze casting of limited editions.

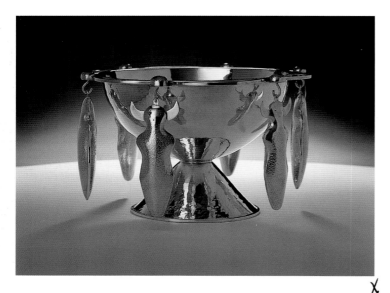

"The horse was one of the most prized possessions a Native American could own. I have chosen to depict these horses in a way more familiar to Europeans—as a stylized Greek horse. I'm always trying to go further to make each piece better than the last. I don't know if I'm blessed or tortured with the need to achieve perfection. I love what I do and each piece is special, but I can always see how there's room for improvement. That's what keeps it interesting. I have so many ideas. There's never enough time to use them all."

⟩

Horses of Chaco Canyon Vase, 1995
Earthenware
20 x 20 (50.8 x 50.8)
Collection Ruth and Sid Schultz

Footed Bowl, 2001
Sterling silver, turquoise
4½ x 7⅛ (11.4 x 18.1)
Collection Marc A. Dorfman and James M. Keller

⟩

"The human figures on the pendants are based on the traditional *Yei* images that my mom used in her weaving. I enjoy making modern interpretations of traditional themes."

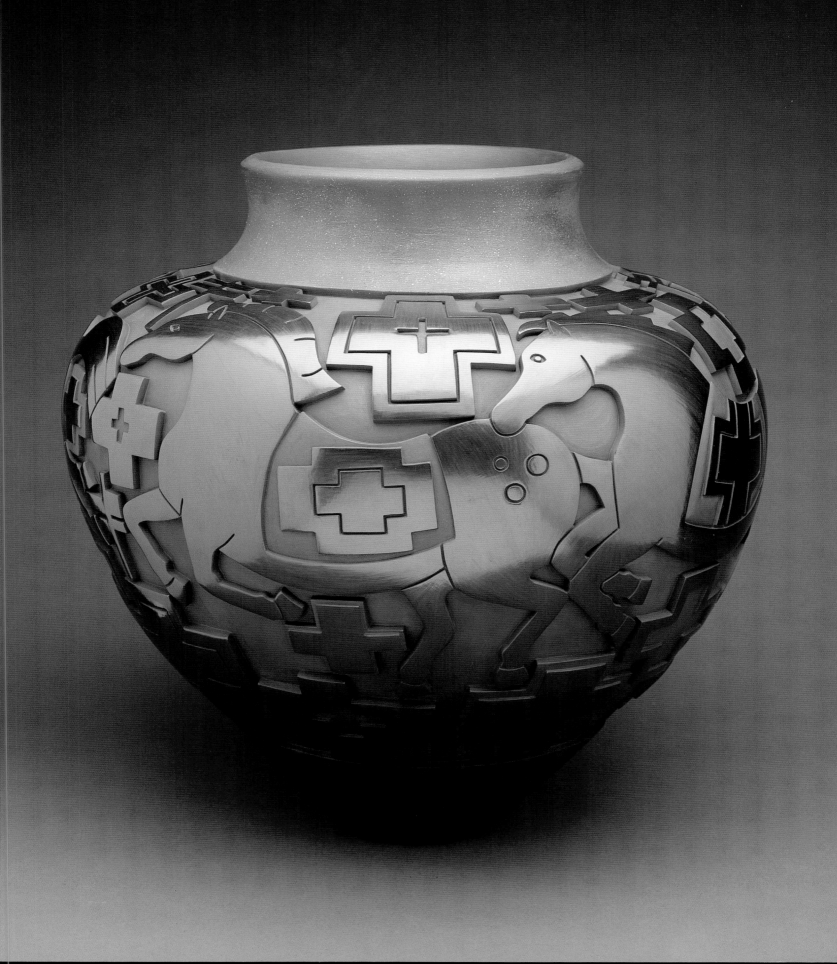

Andy Lee Kirk

Born 1947, Albuquerque, New Mexico; lived Albuquerque, New Mexico; died 2001

Born of Navajo and Isleta heritage, Andy Lee Kirk brought an artist's eye and a jeweler's virtuosity to his designs. With a degree in biology from the University of New Mexico, Kirk worked for years for the U.S. Fish and Wildlife Service and for the U.S. Forest Service. He began studying jewelry as an avocation while at university; in 1977 he became a full-time jeweler. Kirk is noted for his innovative lapidary work, but also for his inventive combinations of techniques, ranging from casting and stamping to overlay and engraving. In 1995 Kirk was named Artist of the Year by the Indian Arts and Crafts Association.

Kirk's daughter Melanie, a jeweler trained by her late father, commented: "My father did not believe in drawing, as he knew that nothing would be as full of life as the actual piece. His life was one-hundred-percent commitment to his art. He never believed in standing still, nor would he accept the stereotypes of Native American art. He embraced new technologies and techniques; he believed that art was always evolving, not standing still. It was this spirit of innovation that made his work come to life."

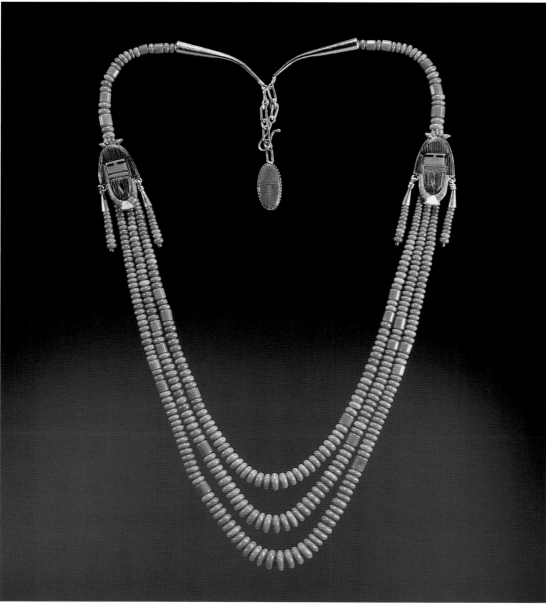

Triple-strand Coral Necklace with Two Katsinas, 2000
Coral, opal, turquoise, ironweed, 14k gold
Length: 17¾ (45.1)
Collection Melanie A. Kirk and Kimberlee A. Kirk

Triple-strand Turquoise Necklace,
1999
Lander, Chinese, Lone Mountain,
Nevada #5, Bisbee, and Burnham
turquoises, sugulite, coral,
14k gold, ironwood
Length: 16¼ (41.3)
Collection Kirk Family

Pendant with Two Masks, 2000
14k gold, lapis lazuli
3 x 1 (7.6 x 2.5)
Collection Juanita Eagle

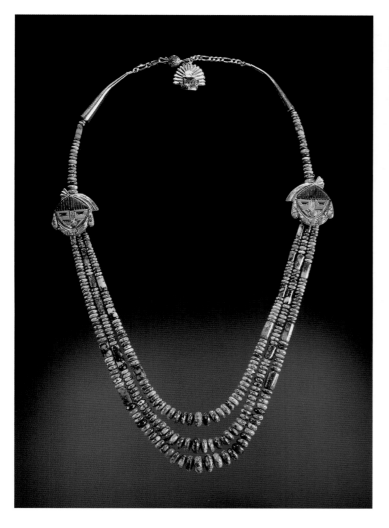

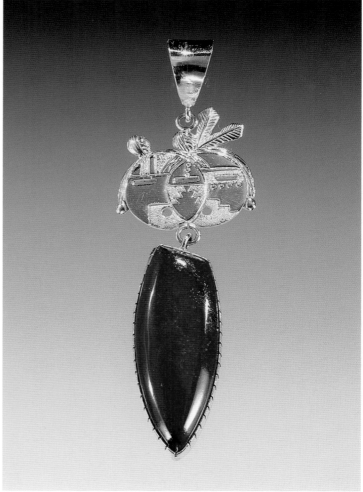

Tony Abeyta

Born 1965, Gallup, New Mexico; lives Taos, New Mexico

Tony Abeyta graduated from the Institute of American Indian Arts, Santa Fe, New Mexico, and subsequently studied at the Maryland Institute College of Art in Baltimore, and abroad in France and Italy. Abeyta was a Ford Foundation scholar at the Chicago Art Institute and is currently completing his master of arts degree in theory and criticism at New York University. Known primarily as a painter, Abeyta has bridged many disciplines in his work through his perennial experimentation with unusual materials in his paintings, ranging from encaustic wax, oil, and sand to various powdered metals. This bas-relief painting, which incorporates a carved ceramic panel in the center, was a collaboration between Tony Abeyta and the distinguished ceramist Tammy Garcia.

Untitled Collaborative Piece, 2001
(with Tammy Garcia)
Earthenware tile, sand, copper, and oil on wood panel
46 x 46 (116.8 x 116.8)
Collection Becky and Ralph Rader

"I experiment with images, techniques, and mediums, translating paint into an image both personal and spiritual. I am deeply involved in processes that echo natural forces of decay, erosion, and change. I consider myself first and foremost a painter, but the parameters of what painting is about have changed radically. In this work, I added colors and textures to Tammy's original carving. The collaboration allowed us to share each other's roles as ceramist and painter."

James Little

Born 1947, Flat Mountain, Arizona; lives Scottsdale, Arizona

James Little grew up as a traditional Navajo surrounded by art created by his mother, a weaver and beader, and his father, who, as a Medicine Man, made beaded ceremonial objects. Encouraged by his older brother, Woody, he took his first silversmithing classes in high school under the guidance of Stanley Mitchell, and later attended Navajo Community College, where he learned lapidary work and other techniques from Kenneth Begay. In the late 1970s, Little met up with Lovena Ohl, noted mentor to Charles Loloma, who encouraged him in his work and also encouraged him to learn English. Hearkening back to the stark landscape of his early years and evolving to the cityscapes he has now become accustomed to, his work is a unique melding of design and materials.

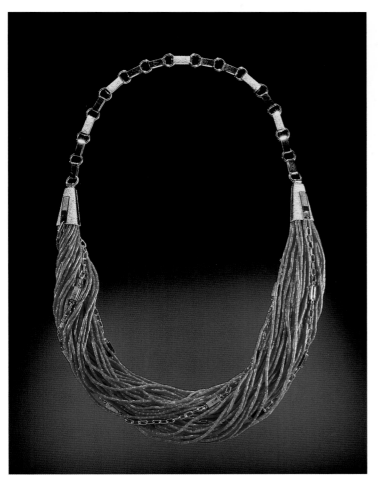

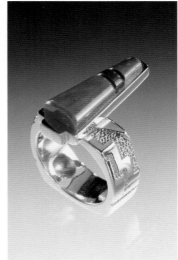

Ring, 2001
Gold, coral, sugulite, turquoise
1 x 1⅛ (2.5 x 2.9)
Collection Juanita Eagle

"The pieces I make reflect all that I see, colors, sounds, nature. There is always a Navajo story mixed into my designs."

Multi-strand Reversible Necklace, 2001
Coral, turquoise, 18k gold, sugulite
Length: 16 (40.6)
Collection of the artist

✗ **Elsie Holiday**
Set of Trays: Changing Woman,
2000; see p. 179

The New "Traders" and Their Influence on Southwestern Indian Art

Dexter Cirillo

Art dealers and traders are the unsung "culture brokers" of American Indian art, standing at the interface between artist and audience and translating one to the other. Often the dealer sees a new direction in art before the artist does, and begins the process of transforming vision into collaboration. The individuals discussed in this essay have had an impact on their respective fields of pottery, weaving, and basketry within the last quarter of a century. They are emblematic of the many art dealers and traders who have made a difference in the evolution of Southwestern Indian art through their passion and imagination, financial support and education. By necessity, many deserving individuals are excluded from this discussion, but that does not diminish their importance.[1]

The Art of Clay

In 1984, Gallery 10 of Arizona held the first show of contemporary Pueblo pottery in New York City, featuring Nancy Youngblood, Nathan Youngblood, Grace Medicine Flower, and Jody Folwell. Within two hours, the show was completely sold out, leaving Lee Cohen, Gallery 10's owner, and all of the potters ecstatic. That same day—April 12—the *New York Times* ran a feature story on the show. Almost twenty years later, it is worth noting some of the comments: "The quirky, often asymmetrical pottery of Jody Folwell sometimes brings disapproving clucks from tradition-minded folks on the Santa Clara Reservation. . . . Contemporary life—mostly television, radio, books and newspapers—provides much of her inspiration, Miss Folwell says."

Without question, Folwell's pieces were the most innovative pots in the show. That summer she would go on to win the coveted Best of Show at the

1984 Santa Fe Indian Market for an innovative pot she produced in collaboration with sculptor Bob Haozous—a feat that would not have been possible eight years earlier when she first met Lee Cohen at another Indian Market.

It was Folwell's innovative and whimsical style that attracted Cohen to her booth in 1976. Unlike the other Santa Clara potters, whose work was excellent but repetitive of traditional styles, Folwell's pots were singularly imaginative. The shapes were asymmetrical, with the mouth of the pot often pulled to one side. The slips produced variegated colors within the same pot. Sgraffito designs with personal and political themes roamed over highly polished surfaces. Cohen was entranced and ended up buying every pot she had brought to market. "That's how he started his gallery," Folwell recalls with amusement, "because he didn't know how he was going to get rid of all my pots otherwise."[2]

In 1977, Lee Cohen opened the first Gallery 10 in Scottsdale, one year after he had moved his family from Chicago to Arizona. Two years later, he opened a gallery in New York City, followed by a gallery in Santa Fe in 1985 and El Pedregal at the Boulders in Arizona in 1986. The premise of Gallery 10 was to present the highest-quality Southwestern Indian art available. "Jody Folwell was the first major, pivotal artist that inspired Dad," states his son, Phil Cohen. "He was impressed with her bold departure from the 'sea of black pots and beaded necklaces' that he was already growing weary of. Innovation and evolution thus became the foundation on which all of his decisions would be made in the future."[3]

Over the next eighteen years, until his death from cancer at age sixty-six in 1995, Lee Cohen became a seminal force in the evolution of contemporary

Southwestern Indian pottery. The formula was simple and twofold: first, he supported the potters he worked with by purchasing *all* of their works at a fair market price to allow them the financial freedom to create innovative and unique pieces. Secondly, he educated collectors to look for originality, not repetition, and to appreciate the intrinsic value of art.

In 1993, Cohen published *Art of Clay,* highlighting his favorite potters over the years, many of whom are in the current exhibition, *Changing Hands*: Al Qöyawayma, Grace Medicine Flower, Jody Folwell, Nathan Youngblood, Nancy Youngblood, Richard Zane Smith, Dorothy Torivio, and Tammy Garcia, among many others. In the introduction, he identified the trap that pottery had been caught in for so long:

> Scientists from the Smithsonian and the great universities came to the Southwest on archaeological expeditions and to record the Indians' daily life. When it came to pottery, they classified the physical appearance and the social significance of their finds with scant reference to artistic content. . . . The magnificent pottery created over centuries was regarded as scientifically interesting— which it also is—but the art of the pottery was essentially overlooked.[4]

Lee Cohen's mission was to effect a shift in thinking among his collectors from evaluating pottery exclusively for its historical significance to seeing pottery as an important art form. This is a concept that we take for granted today, but twenty years ago it was considered controversial.

* * *

If Lee Cohen's path took him from businessman to collector to gallery owner to advocate, Robert Nichols came to pottery through a more traditional and academic background. An anthropologist by training from the University of Washington (B.A.) and the University of Arizona (M.A./Ph.D. program), Nichols had hands-on experience with prehistoric pottery as part of the Wetherill Mesa Archeological Project at Mesa Verde between 1959 and 1965. He went on to spend years in the National Park Service as a curator/archaeologist.

In 1970, while working on an exhibit for Mesa Verde, Nichols realized that it would be easier for people to understand the process of making pottery if they were to see someone actually doing it. He proposed a short film on the famous San Ildefonso potter Maria Martinez, going on to write the script, raise the funds, and act as technical adviser for the film. The film, completed in 1972, won an award at Cannes and was widely shown on PBS, introducing Martinez and the art of Pueblo pottery making to an international audience.

In 1980, Nichols opened a gallery under his own name in Santa Fe, specializing in Southwestern Indian pottery, as well as folk art and antique Americana. By the mid-1990s, he had shifted his focus exclusively to pottery, featuring contemporary work. He credits Dick Howard, a fellow Park Service colleague at Mesa Verde and an inveterate collector of American Indian pottery, with imbuing him with the passion for collecting. Howard, the editor of *Hopi-Tewa Pottery: 500 Artist Biographies,* has been instrumental himself in supporting a pottery revival at Santo Domingo Pueblo, encouraging potters to use traditional materials and techniques. He has also been a champion of the lesser-known contemporary potters from Zia Pueblo.

Of his move from historical to contemporary pottery, Nichols states:

> It has become apparent to me that "change" has been one of the most important constants throughout the history of the pottery of the Southwest. In recent years, however, there has been increasing pressure by the marketplace to keep change within very narrow limits. The emphasis tends to be on high craftsmanship as an end unto itself rather than as a means to an end, resulting in the stifling of creativity and experimentation.

Rather than yielding to market demands, Nichols has created new markets for many of the cutting-edge potters he supports: Nathan Begaye (Hopi/Navajo), renowned for his abstract designs often executed in a rainbow of colors—green, purple, black, red, ochre, peach, all painstakingly derived from hand-ground minerals that he mixes to produce the right hue; Diego Romero (Cochiti Pueblo), who creates pottery as a canvas for his biographical stories and historical commentary; the Ortiz family of Cochiti Pueblo, whose innovative standing figures hearken back to the figurative tradition prevalent at Cochiti and Tesuque pueblos in the late nineteenth and early twentieth centuries.

Of all the potters he has encouraged, Nichols is, perhaps, most proud of his support of Les Namingha (Hopi-Tewa/Zuni). In 1998, Namingha stated his desire to paint his pots with bright acrylic colors rather than native dyes. Unlike many art dealers, who would have considered this heresy, Nichols encouraged Namingha, advising only that he create new designs rather than copy traditional motifs. At a subsequent group show, Namingha's acrylic pot was the first to sell to a collector—not of American Indian art, but of contemporary American art. Namingha subsequently won the Best of Division Using Non-traditional Materials at the 1999 Santa Fe Indian Market for another acrylic-painted pot, truly inaugurating a new direction in Southwestern Indian pottery.

* * *

Like Cohen and Nichols, Martha Hopkins Struever is an art dealer who has developed close personal ties to the artists she supports, most notably Hopi/Tewa potter Dextra Quotskuyva, one of the most creative potters working today. "She never repeats herself," states Streuver, who guest-curated *Painted Perfection: The Pottery of Dextra Quotskuyva*, an exhibition at the Wheelwright Museum of the American Indian in Santa Fe in 2001.

For more than twenty-five years, Struever has championed the work of Quotskuyva and her extended family, through exhibitions at her Chicago gallery in the 1970s and 1980s and in private shows in Santa Fe in the 1990s. She has also led over fifty personalized tours of the Southwest, initially with the Crow Canyon Archaeological Center and later on her own, educating several generations of collectors in the traditions and techniques of Native American art of the Southwest. Her own research into the life of Nampeyo, the matriarch of Hopi pottery, has made her a leading authority in the field of contemporary Hopi ceramic art.

If there is a trend to be noted among Cohen, Nichols, and Struever, it is their vision of creating a place in history for contemporary Southwestern Indian potters that goes well beyond a single sale. While they all applaud fine craftsmanship, they have focused on aesthetics, analyzing and reflecting

upon the effect a work of art has upon them, their collectors, and the evolution of pottery.

Navajo Weaving: New Directions

Navajo weavings tend to be defined by their style rather than their maker, and Navajo weavers have, until recently, remained fairly anonymous. Historically, the style of a weaving took its name from the region where it was woven, as did the trading post in that area: Two Grey Hills, Chinle, Crystal, Wide Ruins and so on. Isolated from the commercial and art centers in New Mexico and Arizona, Navajo weavers traditionally sold their pieces to traders on the Reservation.

Now considered romantic relics of the past, trading posts once dotted the vast landscape of the Navajo Reservation like scattered clumps of sagebrush. The arrival of the railroad in the Southwest in the 1880s spurred a new market for Native arts and crafts, expanding the role of the trader to art consultant.

Perhaps the most important trader/art advocate of the late nineteenth and early twentieth centuries was John B. Moore, who ran the trading post at Crystal, New Mexico. Moore demanded quality from his weavers, which he controlled by having the wool they used cleaned and processed in the East. He also dictated designs to weavers, drawing motifs from the popular Oriental rugs of the day. The Crystal style under J. B. Moore featured elaborate geometric designs within a border, and a palette of neutral colors taken from the various natural blends of the sheep's wool—a style that is more characteristic today of the Two Grey Hills tapestries. Marketing his weavings from his remote outpost in New Mexico, Moore was the first trader to publish a mail-order catalogue of Navajo rugs geared to an Eastern audience. By the end of his tenure at Crystal in 1911, Moore had put his mark on the emerging regional styles at Crystal, Two Grey Hills, Teec Nos Pos, and Ganado.

Juan Lorenzo Hubbell, whose trading post of the same name near Ganado was designated a National Historic Site by the U.S. Park Service in 1967, has also had a lasting influence on Navajo weaving. A well-educated man with an entrepreneurial spirit, Hubbell eventually launched an empire of fourteen trading posts on the Navajo Reservation. Like Moore, he offered designs for weavers to copy, providing them with original watercolors and oils of early Navajo blanket styles. The paintings, done by E. A. Burbank and other artists of the day, still hang in the rug room at the Hubbell Trading Post.

Hubbell promoted weavings that spoke to his personal taste, favoring banded designs punctuated with serrated diamonds and striking crosses against a brilliant red background known as Ganado red. The Ganado style of weaving, considered by many today to be the "traditional" Navajo style, was an instant hit among tourists, who avidly purchased the weavings at the Fred Harvey shops along the Santa Fe Railroad.

Both Hubbell and Moore influenced the direction of Navajo weaving. Moore especially raised the bar on trader/weaver relationships. At every stage, from preparing and dyeing the wool to collaborating on the design of the weaving, Moore was intimately involved with the weavers. Both traders provided materials and ideas to their weavers and created audiences for their product. And, in the process, they originated styles in Navajo weaving that are termed traditional almost three-quarters of a century later.

Steve Getzwiller is a modern-day "trader" whose impact on the evolution of Navajo weaving may eventually rival that of Hubbell and Moore. Born in 1949 into a family that has ranched in southern Arizona since the turn of the century, Getzwiller was reared on a ranch in Benson, Arizona. His interest in Native American art was inspired by his admiration for Dr. Charles DiPeso, a family friend and the director of the Amerind Foundation, a non-profit archaeological research facility and museum in Dragoon, Arizona, dedicated to the study of Native American cultures. Getzwiller studied anthropology at the University of Arizona between 1967 and 1971, leaving the program to immerse himself directly in Native American cultures.

In 1973, he was licensed as a trader at the Zuni Pueblo in New Mexico, supplying jewelers with Morenci and Bisbee turquoise. In his second year as a trader at Zuni, he sold his jewelry inventory, focusing entirely on Navajo weavings, which he had begun to buy and sell several years earlier. In a befitting nod to history, Getzwiller had his first introduction to weavers in the weaving room at Hubbell's Trading Post at Ganado.

Getzwiller began brokering rugs for various trading posts, selling them primarily to galleries in New Mexico and Arizona (his market has since expanded to outlets throughout the country). By the late 1970s, he was working directly with weavers from the Wide Ruins and Burntwater areas of the Navajo Reservation to expand their natural dye palettes of earth colors.

Getzwiller also provided the weavers with superior pre-spun New Zealand Romney wool to replace the inferior commercial wool used at that time. He commissioned the weavers at Wide Ruins and Burntwater to dye the wool, which he then placed

with prominent weavers in the Ganado, Chinle, and Two Grey Hills regions. In turn, those weavers were commissioned to weave Burntwater border/geometric designs. Ironically, this cross-fertilization between weaving regions on the Reservation was one contribution to the breakdown in regionalism in Navajo weaving—a fact that has caused other traders to criticize Getzwiller.

For almost thirty years, Getzwiller has traveled once a month to the Reservation from his ranch in southern Arizona to work with weavers from the Burntwater, Wide Ruins, Chinle, Two Grey Hills, Crystal, and Teec Nos Pos areas. Getzwiller's goal is to expand the color palette of Navajo weaving, improve the quality of the wool used, and inspire innovative designs.

Getzwiller is also one of several rancher/breeders intent upon building up flocks of pure Churro sheep, the breed introduced by the Spaniards in the seventeenth century and prized by early Navajo weavers for its long fleece and low lanolin content. The difference may be that Getzwiller is placing the wool in the hands of weavers to connect them to their historical past and to collaborate with them on design.

The result is the Navajo Churro Collection of weavings, launched in 1994. The weavings are all registered and numbered and accompanied by a certificate for the collector and for future historical reference. Julia Upshaw's weaving in *Changing Hands* (p. 41), for example, is registered as Churro 338.

Getzwiller commissions all of the Navajo weavings that he collects. Like J. B. Moore, he makes up kits with specific diagrams of weavings and color suggestions, which he gives to the weaver along with the wool for a weaving. At present, he works with

over fifty weavers, about whom he states: "They are all artists. They constantly experiment with color and design and are not above ripping out several weeks of work to improve their piece."

* * *

The trading-post system, which had given such autonomy to J. B. Moore, Juan Lorenzo Hubbell, and other early traders, because they provided the only centers of commerce on the Reservation, went into a slow decline after World War II. "Returning [Native American] veterans now had cash to spend on the modern appliances they had seen; they were also eager to trade in their wagons for pickup trucks, which increased their mobility and expanded their job opportunities."[5] Convenience stores started appearing, further limiting the trader's monopoly on business. In 1974, the Bureau of Indian Affairs enacted a set of regulations governing the sale of pawn jewelry that essentially spelled the death knell for traders.

The pawn system was a type of credit whereby a Navajo could leave his jewelry with the trader as security against his purchases. In a cash-poor society, this form of exchange allowed the Navajo to weather the lean months before the harvest or the shearing of sheep earned him enough money to clear his debt. It was understood that an individual could redeem his jewelry for ceremonial occasions but that it would be returned afterward to remain his bond until his bills were paid.[6] If the Navajo did not pay his bills within a specified period of time, the trader could sell the piece for a price that would include the interest that had accrued.

In 1972, in response to complaints that some traders were abusing the pawn system, the Federal Trade Commission launched an investigation of trading-post practices, drafting regulations that severely restricted the sale of pawn. By 1974, the pawn system had all but disappeared on the Reservation, further undermining the effectiveness of trading posts.

The crippling of the trading-post system had a profound impact on Navajo artists, especially the weavers. Without the support they had previously received, many stopped weaving. Others tried to figure out which regional style would be most popular with tourists. The result was a plethora of poorly woven, small rugs that weavers hoped to sell for some quick cash.

Chinle, for example, was a major weaving center with no trader in the area. The closest outlet for the weavers was Hubbell's Trading Post. In the Two Grey Hills region, the Toadlena Post, operated since 1909, closed in 1996, leaving the door open for Mark Winter, an established dealer for thirty years in antique Navajo and Hispanic weavings, to move in. Winter took over the old Toadlena Trading Post in the Two Grey Hills area of the Reservation in 1997, refurbishing and restoring it to an early twentieth-century style.

In his tenure at Toadlena, Winter has focused upon reviving the Two Grey Hills style of Navajo weaving. This style is derivative of the Oriental patterns J. B. Moore encouraged at Crystal at the turn of the century. The weavings are bordered, usually in black, and have a geometric pattern in the middle that comprises varying shades of natural wool in tans, beiges, whites, and grays. Only the black is dyed. Unlike the early Crystal weavings or the Ganado weavings, the Two Grey Hills style does not include reds or bright colors. The palette is soft, reflecting the earth tones of the landscape.

Winter states that he started collecting weavings from the Two Grey Hills area in the mid-1980s because the weaving was so fine. "It was the closest thing I had seen to the classic Navajo blankets in quality and tightness of weave," he states. Despite his years of selling weavings, however, he had never met any contemporary weavers.

In 1990, Winter began a genealogy of Two Grey Hills weavers, interviewing dozens of weavers and their families. His goal is to be able to attribute certain styles to specific individuals, particularly in the case of weavings from the 1940s and 1950s. "In 1997," he says, "there were maybe fifty to one hundred weavers working. The local traders just didn't support them anymore. I got the old grandmothers weaving again. Today, I buy weavings from over three hundred weavers. Some may just do one weaving a year, but they are weaving again." In the four years since he took over the trading post, Winter has bought over nineteen hundred rugs from the weavers.

Winter also founded a museum at the trading post to display his growing collection of historical and contemporary Two Grey Hills weavings, mounting a year-long exhibition entitled *The Generations Exhibit* in 2000 that featured the work of up to five generations of local weavers.

Both Getzwiller and Winter pay homage to the long tradition of Navajo weaving in their respective projects. Both play a pivotal role in setting a standard for quality in weaving that rivals the best of weavings from the classic period. Public awareness of their work is growing and will eventually determine its lasting success. For the moment, the weavers are exploring new dimensions in their art, and that has not occurred in many years.

Navajo Story Baskets

In 1992, Mary Holiday Black brought in one of her baskets to sell to the Twin Rocks Trading Post in Bluff, Utah. The basket was a depiction of the Fire Dance, a nearly extinct ceremony from the Navajo Mountain Chant. Steve Simpson recalls the importance of that event: "We were so excited that here was a Navajo weaver drawing on her own culture for material, instead of copying designs from other tribes. This was the beginning of the Story Baskets."

Steve and Barry Simpson had been collaborating with Navajo weavers on designs for several years at that point. Steve recalls going through basket books and photocopying designs that he thought would appeal to the weavers and to the public. At one point, he had approximately one hundred black-and-white photocopies of basket designs that he gave to weavers when they came into the trading post. "This was the 'cross-cultural' era," Steve Simpson states, "which began back in the 1970s when Virginia ('Chin') Smith at Oljeta Trading Post started encouraging Mary [Holiday Black] and Sally [her daughter] to do something different. *Arizona Highways* published their basket edition in 1974, and the weavers began to incorporate designs from other tribes into their own work."

In 1976, William W. ("Duke") Simpson, the patriarch of the Simpson family, opened Blue Mountain Trading Post in Blanding, Utah. Most of the basket weavers who came into Blue Mountain to sell their work were Ute. Duke asked them to weave pictorial baskets with designs he recalled seeing from his early years in Bluff. Some of the weavers resisted because the designs were associated with religious ceremonies. A few, however, did weave special pieces for the trading post. Both Mary Holiday Black

and her daughter Sally would periodically bring in baskets to the post, including large ceremonial baskets.

The Navajo wedding basket, also called a ceremonial basket, is still used by medicine men for healing ceremonies and for weddings. The prescribed design of the basket includes a white center surrounded by a semi-circle of multiple red bands, on either side of which are black step designs. While the symbolism of the ceremonial is multilayered, the pattern and colors were fixed by tradition for years, leaving little room for individual expression.[7]

Mary Holiday Black was one of the first weavers to incorporate other images into the ceremonial style, adding *Yei* (Navajo holy person) figures and horses to the traditional design. She also created double ceremonials, repeating one pattern within another. The acknowledged matriarch of contemporary Navajo baskets, Black was born in 1934 and grew up making wedding baskets for her father, who was a medicine man. Nine of her eleven children are basket weavers. In 1993, Mary received the Utah Governor's Award in the Arts. Two years later, the National Endowment for the Arts awarded her a National Heritage Fellowship for her role in sustaining and perpetuating Navajo basket making.

Basket making had all but disappeared among the Navajo in the twentieth century, except for a small group of weavers who continued making ceremonial baskets, handing down their traditions from one generation to the next. Three extended families from the Douglas Mesa area—the Blacks, the Rocks, and the Bitsinnies—comprise the current revival in Navajo basket weaving.[8] Douglas Mesa lies just north of Monument Valley and west of the tiny towns of Mexican Hat and Bluff, Utah. The proximity of the basket makers to the Simpson trading posts could not have been more fortuitous for both the weavers and the traders. So remote and isolated is Douglas Mesa from any major town that it was a gift to the artists to have a trading post in their back yard. As for the Simpsons, they suddenly had a plethora of baskets available to sell.

In 1989, the Simpsons opened Twin Rocks Trading Post in Bluff. In a continuing effort to inspire the weavers to come up with new designs for their baskets—and to stimulate the marketplace—Barry Simpson began sketching ideas for baskets based on his own research and sending the diagrams down to Twin Rocks, where the weavers tended to congregate because the post was closer to the Reservation.

Damian Jim, a young Navajo and computer expert, joined Blue Mountain Trading Post in 1995. A talented artist and graphic designer, Damian was hired to generate on a Macintosh computer basket designs based on Navajo stories. In a collaboration reminiscent of Juan Lorenzo Hubbell and J. B. Moore's influence on Navajo weavers, Damian and the Simpsons worked with the weavers to create an entirely new direction in Navajo basket making—the story basket.

Story baskets are the most technically challenging baskets the weavers make, reflecting the complexity of the characters and stories they depict: Changing Woman, Black God, Monster Slayer, Spider Woman, Butterfly Boy, Changing Bear Woman, and Coyote Placing the Stars. Story baskets also portray elements from healing ceremonies, or they may simply focus on animals: the horned toad, rabbit, coyote, deer, horse, lizard, and frog. In many ways, story baskets have returned the

Navajos to participating in an oral tradition that some think was in danger of disappearing. The younger weavers acknowledge that they did not know a lot of their own stories before they started exploring them with the Simpsons.

The renaissance in contemporary Navajo baskets taking place in southern Utah is not limited, however, to story baskets. Steve Simpson is particularly drawn to abstract designs and has developed a singular relationship with premier weaver Elsie Holiday, noted for her technical virtuosity in making single-rod baskets. They have collaborated for nine years and the result has been a series of brilliant baskets that have earned Elsie national recognition. The *Changing Woman* set of baskets in the current show, *Changing Hands* (p. 179), is based on paintings by the late Helen Hardin.[9]

A final word needs to be said about the marketplace. Hubbell felt it was the obligation of the trader to raise the standard of living of the people he traded with. There are few economic opportunities in Bluff or Douglas Mesa, Utah. Some people find the relationship between the Simpsons and the basket makers to be controversial and even invasive. Another perspective is to look at the history of trader/artist relationships. Hubbell used the technology of his day—the watercolor—to convey his preferences to Navajo weavers. The Simpsons use the technology of the twenty-first century—the computer—to do the same. J. B. Moore published a mail-order catalogue for his clients in the East. The Simpsons market baskets over the Internet.

Whether the current revival of basket making will endure remains to be seen, but for the moment, the Simpsons may be credited with stimulating an art form while providing an opportunity for Navajo basket makers to make a living.

* * *

The "new traders" discussed in this essay exemplify the many art dealers in the Southwest who serve as a vital link between Native American artists and the marketplace. The stronger the market, the more possibilities there are for artists to take creative risks and break new ground in their work. While it is seductive to romanticize the Native American artist, the fact is that many artists are isolated from commercial hubs and depend upon the individual relationships they establish with traders and art dealers in order to sell their work. It is inevitable that such relationships may lead to strong collaborations between artists and trader/dealers.

We accept the influence, for example, that Hubbell and Moore had on Navajo weaving, perhaps because the weavings have survived the test of time. It is much harder to predict the longevity of contemporary art. Rather, we can only document the sincerity and commitment of those individuals who are striving to make a difference.

Notes

1. Over the years, I have had the privilege of knowing and working with the art dealers and traders discussed in this essay, a fact that clearly predisposes me to selecting them, but also, I like to think, gives me some insights into their contributions that may not otherwise have been mentioned.

2. All quoted statements are from personal telephone interviews with the individuals cited and written statements that they have sent me in preparation for this essay. All interviews occurred between May 2001 and January 2002.

3. Phil Cohen worked at all the galleries and ran the Santa Fe gallery for many years.

4. Lee M. Cohen, *Art of Clay: Timeless Pottery of the Southwest* (Santa Fe: Clear Light Publishers, 1993), p. 15.

5. Dexter Cirillo, *Southwestern Indian Jewelry* (New York: Abbeville Press, 1992), p. 143.

6. *Ibid.*, p. 143.

7. There are various interpretations, but generally, the white center of the basket represents emergence or birth. The black step designs are the sacred mountains that surround the Navajo Nation. They are also symbolic of clouds, rain, and, by association, the storm, or pain, of life. The red bands alternately symbolize the sun's rays, which bring growth, as well as marriage and the intermingling of a couple's blood. The white outer section represents the gaining of enlightenment as one moves through life toward the spiritual world.

8. Historically, Navajos made utilitarian baskets for gathering, storage, and preparation of food; these were eventually replaced with manufactured goods introduced by traders. Traders also influenced the decline of ceremonial basket making by creating a larger market for blankets and rugs. Free of the restrictions associated with weaving ceremonial baskets, weavers found it faster and far more remunerative to weave rugs. They were also able to buy their ceremonial baskets from Ute and Paiute weavers, who did not have the same taboos imposed upon them.

9. Helen Hardin was a well-known artist from Santa Clara Pueblo. Born in 1943, she died at age forty-one. She became known for her abstract, geometric interpretations of pueblo life in her paintings.

Southwest Jewelry

Gail Bird

Regional and cultural arts often become burdened by the stereotypical view of what is traditional or what comes to be pronounced during a particular period as traditional. This is especially true of Southwest Indian jewelry, in which the classic style of silver, turquoise, and coral from the 1920s through the 1950s is often the dominant image.

What many forget or fail to see is that tradition grows and evolves over time. Jewelry's long history and presence in the Southwest has been marked by the ready acceptance of new materials and ideas that jewelers have fused with traditional values of historical and cultural significance to the peoples of the area. While this acceptance may not always be acknowledged, it is affirmed by the existence of prehistoric trade routes by which shells from the ocean and Gulf of Mexico were brought into the desert to be made into bracelets, pendants, earrings, and beads for necklaces. The incorporation of shell and coral, a non-Native material introduced by European trade after 1540, into the verbal history of the Navajo (the direction East is represented by white shell, and West, by coral or abalone) reemphasizes this acceptance.

If the 120 years in which metalworking has existed in the Southwest are roughly divided into ten-year cycles, it can be seen that within each of these periods there have been individuals whose skill and genius generated ripples of creativity, innovation, and influence. In the earliest times, between 1880 and 1900, unknown smiths learned to work metal for jewelry, developed tools and hand techniques to execute simple, yet technologically complex, ideas and designs, and were the pioneering innovators who laid the groundwork for others to build upon. The growing importance of jewelry making as a commercially viable product for non-Native consumers prompted traders to search for and make available to smiths finer tools and equipment, silver coins, and, later, sheet silver, raw materials, and pre-cut stones.

Ideas and skills expanded gradually throughout the Southwest, with definite styles slowly developing within tribal groups. Within each group and during each period, distinctive work by unknown makers stands out from the work of lesser-skilled smiths. In the 1940s and 1950s at Zuni, trader C. G. Wallace saw the importance of beginning to publicize the individual merits and names of artists. Two of the jewelers he featured were Leekya Deyuse and Leo Poblano. These men were excellent choices, excelling in imagination and craftsmanship, and bringing both realistic and stylized imagery of Zuni life and religion into wearable jewelry form. Wallace's recognition of artists by name grew in importance in the following decades, and the interest that his publicity generated began the cycle of what would become periodic movements of mass popularity and mass production of Indian jewelry.

In the 1960s and 1970s, Kenneth Begay and Charles Loloma concurrently broke away from stylistic Indian fashion—in Begay's case by simplifying and clarifying metalwork, and in Loloma's by incorporating new materials, which expanded the color range of his work, and by utilizing abstraction of shape, scale, and depth. Both set standards of creativity and excellence by respecting the past; both used that respect and knowledge to enlarge the scope of Indian jewelry.

Artists are often unaware of art other than their own. As a result, what they create in isolation and think to be original is often derivative or reminiscent of another's work. Most beginning jewelers start by

replicating a style or design in order to learn skills; far too many do not go beyond that first step.

We are in the midst of a period in which some of the greatest changes in Southwest jewelry are rapidly taking place. The current cycle is like no other in terms of technology, access to new materials, and instruction. Schools, workshops, manuals, and journals offer step-by-step instruction in fabrication and assembly. There are materials being offered that are of questionable quality and origin: facsimiles of accepted "Indian" goods, or altered or synthetic materials that jewelers need to question. The rising cost of diminishing natural materials and the accessibility of time-saving mechanical shortcuts and products can tempt anyone to substitute a lesser product for one of quality. The desire or pressure to create work that is different and distinctive can sometimes result in the random adoption of mainstream ideas, techniques, and materials.

It is difficult to reconcile the need and time to create new and original work when also confronted with the necessity for a livable income. One must juggle the demands of schedules and changing movements and fashion, yet not be unduly swayed by what is popular and therefore marketable. The best work, the work that will endure, will be the work that develops over time, combining skill, clear personal vision, and, as in the case of the work of the great early jewelers, a sense of the past and a respect for traditional styles and cultural values. That is the work that will achieve an individual name for itself and stylistic recognition, and will join the continually evolving tradition of Indian jewelry begun by the defining works of the 1880s and invigorated by the distinguished art and legacy of Leekya, Poblano, Begay, and Loloma.

Jacquie Stevens
Double-spouted Jar, 2001;
see p. 95

II Form Beyond Function

Most decorative arts and crafts share their origins in utilitarian objects specifically created to fulfill practical needs and to reflect cultural or social values, including status, power, and affinities. Such objects are powerful means of communicating emotional, spiritual, intellectual, and artistic ideas. The Native American artists presented in this section of *Changing Hands* have used traditional and practical objects as a launching point for exploring purely visual qualities. Through their works, art, craft, and design are brought together in a symbiotic relationship. These objects evoke their functional or cultural origins but juxtapose this historical matrix with equally important visual qualities that privilege form over function.

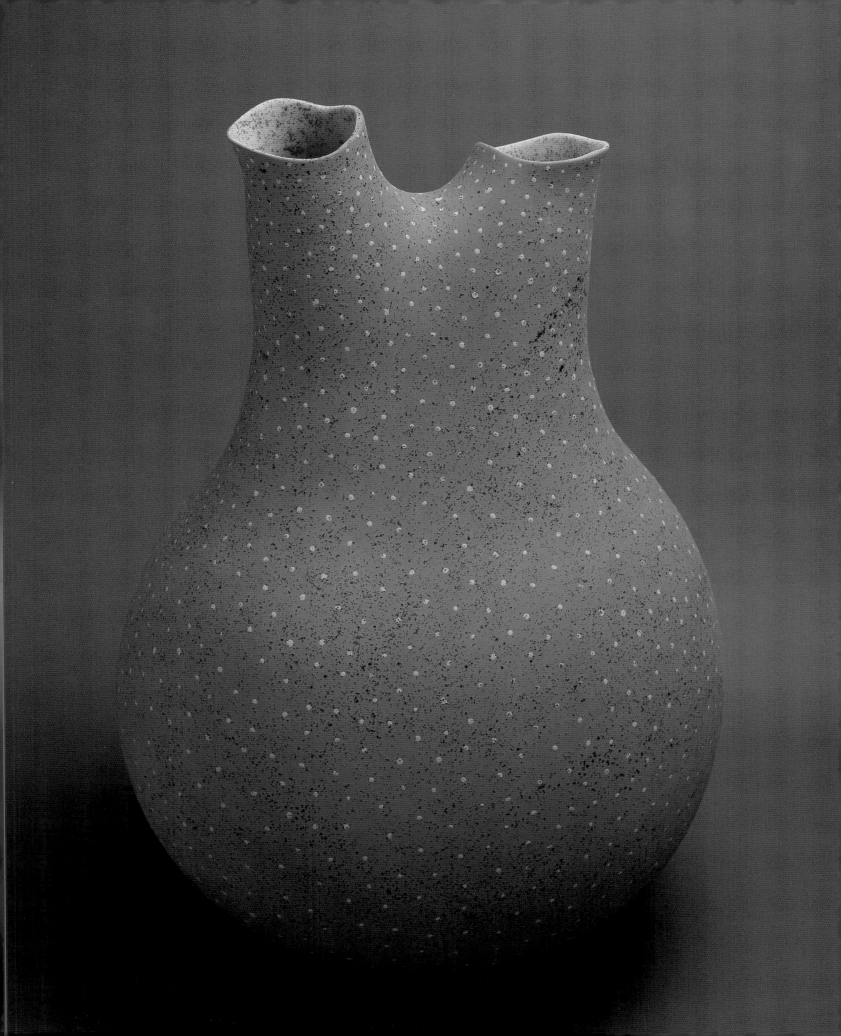

Elsie Holiday

Born 1964, Monument Valley, New Mexico; lives Monument Valley,
New Mexico

Elsie Holiday is a member of the famous Douglas Mesa weavers, who
have been responsible for a virtual renaissance in Navajo basketry and
fiber arts. Holiday began as a traditional rug weaver but soon found her
niche as an innovative basketry artist, producing works with striking color
combinations, abstract patterns, and subtly modulated pictorial imagery.

"The artist Damian Jim designed the black basket in this set as a free-
standing piece, but I added a white one to represent positive/negative
aspects of Navajo culture. Then the work turned into the four directional
colors (black-north, blue-south, white-east, yellow-west), with the last
being a central basket to show the element of rebirth. The set now
evokes a Navajo myth about the origins of echoes in which the Monster-
Slayer destroyed the Kicking Rock Monster. The monster's last breath
introduced the echo into the world."

Set of Trays:
Kicking Rock Monster – Echo, 2001
Natural and dyed sumac
Diameters: 14–16 (35.6–40.6)
Courtesy Twin Rocks Trading Post

Nathan Youngblood

Born 1954, Fort Carson, Colorado; lives Santa Fe, New Mexico

The grandson of potter Margaret Tafoya and the son of Mela Youngblood, Nathan Youngblood began making pottery in 1972. He has won numerous prizes for his work, and has collectors in many parts of the United States. His motifs look back to traditional pottery made by members of his family, but he has given this style a contemporary edge by juxtaposing slip colors on the pots, and by his high-relief carving and superb polish.

Tear-shaped Plate, 1998
Polychromed earthenware
15 x 14 (38.1 x 35.6)
Collection Dan Checki

"I've enjoyed this piece because it reminds me of a mountain standing tall and proud on a flat horizon. The design was inspired by an eclipse of the sun. The round designs represent the position of the sun, moon, and earth at the occurrence of a solar eclipse."

Dylan Poblano

Born 1974, Gallup, New Mexico; lives Zuni, New Mexico

Dylan Poblano is the son of noted jeweler Veronica Poblano, and the grandson of legendary Zuni mosaicist and carver Leo Poblano. He began creating jewelry at the age of eight. Although learning traditional techniques and styles, Poblano began experimenting with unusual designs and a wide range of materials. Poblano is known for his unorthodox forms and construction techniques, which include distinctive "scratched" surfaces, multi-part jewels held together with monofilament, and designs that blend precious and semi-precious materials with alternative materials and found objects.

"This piece is made up of the oddest forms from my 'what if . . .' series. The neckpiece has removable parts: a pair of stick earrings, a double ring, an inlay pendant, two additional rings, a long 'wavelength' pin, and an extra-long single-crystal earring."

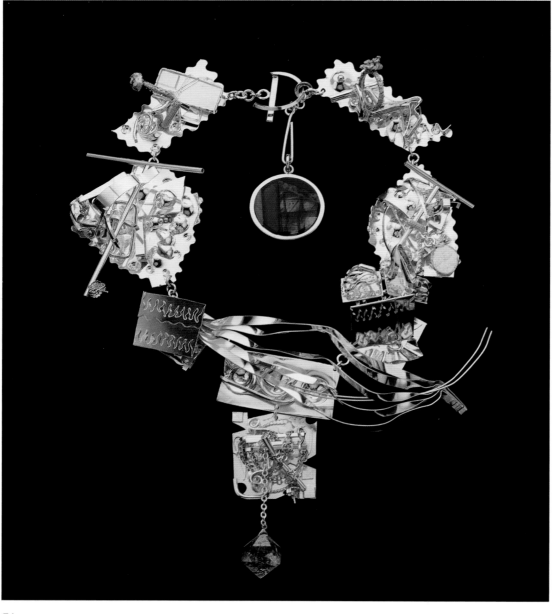

21st Century Neckpiece, 2002
Sterling silver, crystal, spectrolite, moonstone, glass, red obsidian, monofilament
12½ x 6 (31.8 x 15.2)
Collection of the artist

"My work has a lot to do with today's society and life in this country, particularly in its diversity. Basically, my work is inspired by the younger generation. I try to fill in the gap where non-traditional things appeal to people my own age."

"This ring is like a small-scale sculpture. I was trying to modern-ize turquoise, combining it with crystal and monofilament. It's a new look."

"The vibrant use of color and color combinations has always appealed to me, but my jewelry designs span a wider range of possibilities. Some of my designs are monotone or composed of extremely simple elements, while others are complex structures that integrate mechanical features."

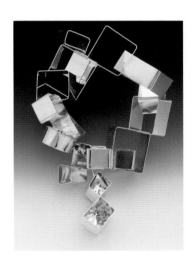

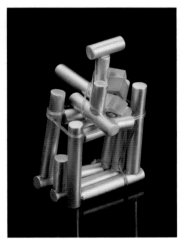

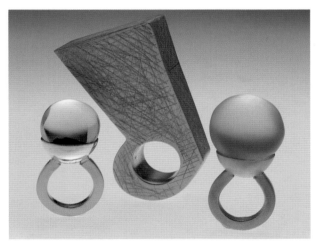

For Those Who Dare Bracelet,
2002
Sterling silver
8 x 5½ (20.3 x 14)
Collection of the artist

Mondrian Stackable Ring, 2001
Sterling silver, turquoise, quartz
crystal, monofilament
1¾ x 1⅛ (4.4 x 2.9)
Collection of the artist

*Two Glass Bauble Rings and
Hollow Box Ring*, 2001
Sterling silver, glass
Heights: 1¾ (4.4); 3¼ (8.3); 2⅛ (5.4)
(left to right)
Collection of the artist

Veronica Poblano

Born 1951, Zuni, New Mexico; lives Zuni, New Mexico

Veronica Poblano, daughter of famed Zuni carver and stone-inlay artist Leo Poblano (1905–1958), began making sculpture and carvings at the age of fourteen and immediately specialized in detailed figures of animals in a variety of stones. While living in California and caring for her two children, she began making jewelry that attracted a wide clientele. She returned to Zuni in 1992, and turned full time to jewelry making. Her work is collected internationally. The artist is actively involved in her tribal organizations and with various museum boards, and in conducting workshops. She has also established the Leo Poblano Memorial Mentorship Program in honor of her father.

"Being a jeweler who is self-taught all these years, I am inspired by many things. My late father, Leo, was so innovative in so many areas, and his spirit lives on in me."

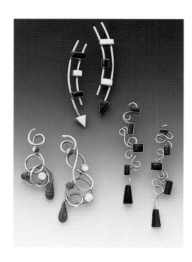

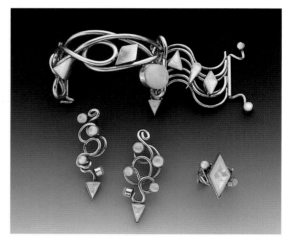

Three Pairs of Earrings, 1999
Sterling silver, sugulite, shell, black marble
Lengths: 3⅜ (8.6); 3⅜ (8.6); 2¾ (7)
Collection Lowell and Penny Dreyfus

Bracelet, Ring, and Earrings, 2000
Sterling silver, mother-of-pearl, moonstone
Bracelet: 2 x 3 (5.1 x 7.6)
Collection Lowell and Penny Dreyfus

"My work is given energy by my memories of my father and also by the special qualities of the gems and minerals I work with. They have a lot of energy in them, and that inspires me to put them where they belong."

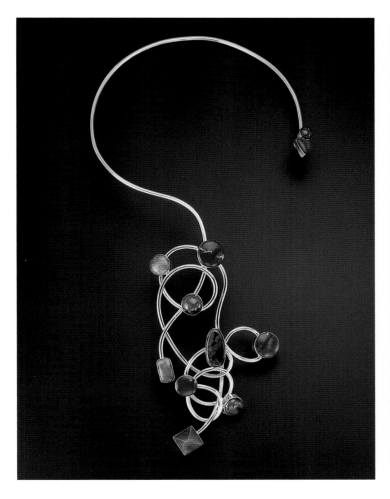

Torque Necklace, 2001
Sterling silver, sugulite, lapis lazuli,
chrysocolla
Length: 13 (33)
Collection of the artist

Torque Necklace, 2001
Sterling silver, Nevada web,
Morency and Kingman turquoises,
Penn shell, coral
Length: 10⅜ (26.4)
Collection of the artist

Norbert Peshlakai

Born 1953, Fort Defiance, Arizona; lives Gallup, New Mexico

Norbert Peshlakai grew up in Colorado, in a family who raised sheep and used the wool for their rugs. While in high school, Peshlakai developed a love of drawing and sketching, and was a member of the cross-country track team. His studies at Haskell Indian Junior College in Lawrence, Kansas, gave him the opportunity to develop as a painter. He took his first jewelry class as an elective subject and discovered his talents in that field. By the late 1970s he had emerged as one of the most innovative of metalsmiths and jewelry artists. Peshlakai's reputation and influence among subsequent generations of Southwestern jewelry artists cannot be overstated.

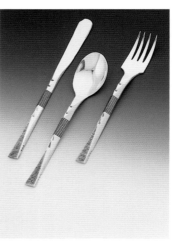

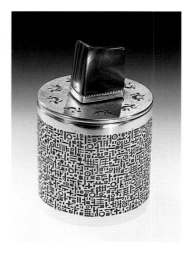

Hinged Buckle, 1984
Sterling silver, coral, ivory, hardwood
2½ x 1¾ (6.4 x 9.5)
Collection Van Zelst Family

Three-piece Flatware Setting, 1985
Sterling silver
Knife length: 7 (17.8)
Collection Van Zelst Family

Covered Box, c. 1992
Sterling silver, malachite
Height: 3⅜ (8.6)
Collection Van Zelst Family

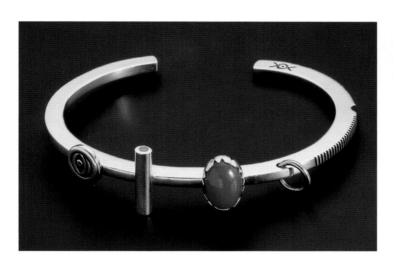

Bracelet, 2001
Sterling silver, 14k gold, turquoise,
coral
Width: 3¼ (8.3)
Private collection

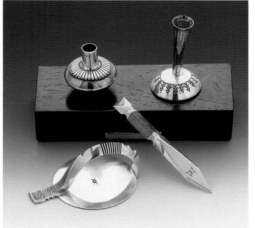

Secretary's Best Friend Desk Set,
c. 1985
Sterling silver, hardwood
3⅛ x 5 (7.9 x 12.7)
Collection Van Zelst Family

Richard I. Chavez

Born 1949, San Felipe, New Mexico; lives Algodones, New Mexico

Richard Chavez began his professional career as an architectural draftsman for Harvey S. Houshour, who had earlier worked for Mies van der Rohe. While employed in the Houshour office, Chavez also studied architecture at the University of New Mexico. By 1976, and after making jewelry as a sideline, Chavez shifted to becoming a full-time jeweler. His metalworking heritage from his family at San Felipe Pueblo and his background as an architect have informed much of his jewelry design. Architectonic forms, disciplined lines and silhouettes, and graphic clarity of form are typical of a Chavez design. His meticulous attention to detail is seen, as well, in the precise lapidary work that distinguishes his pieces.

"A lot of time is invested in making any piece of jewelry well. This particular piece was especially labor-intensive because each open ring was separately fabricated. I wanted to make this piece open and filled with air and light, rather than solid. This is the longest necklace I have made in this particular style."

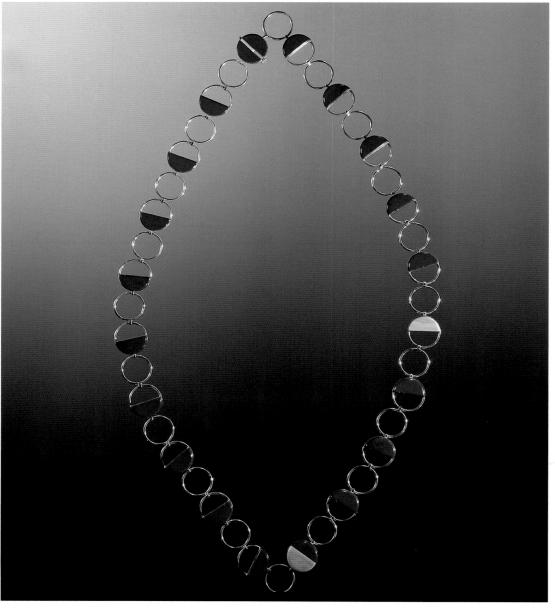

Necklace, 1996–97
14k gold, lapis lazuli, coral
Length: 30¼ (76.9)
Collection Valerie T. Diker

"The design for this piece goes back to my earlier works. When I first started making jewelry I made large bracelets such as this one. I was particularly interested in setting off the beautiful pure white of the dolomite, which has been ground entirely flat and smooth. I began to think of this piece as an abstract painting, using the colors of natural stones as my paint, and the bracelet format as my canvas."

"This bracelet is really a small piece of architecture. The idea of having two structural bands that create an open area in which to suspend the stone was based both on aesthetic and practical concerns. Not only was the design engineered to create a visually light form, it also made the bracelet itself much less weighty and easy to wear."

Bracelet, 2001
Sterling silver, dolomite, coral, turquoise, black jade
Width: 2¾ (7)
Collection Dr. Elizabeth A. Sackler

Open-work Double-band Bracelet, 2001
Sterling silver, coral, turquoise, lapis lazuli
Width: 2¾ (7)
Courtesy Lovena Ohl/Waddell Gallery

Dan Namingha

Born 1950, Keams Canyon, Arizona; lives Santa Fe, New Mexico
Dan Namingha's career spans over three decades. He studied at the University of Kansas in Lawrence, Kansas, at the Institute of American Indian Arts in Santa Fe, New Mexico, and at the American Academy of Art in Chicago, Illinois. The artist first showed his work in a museum in 1972; since that time he has participated in well over fifty one-person and group exhibitions. His works are collected in museums in the United States, and also in Germany, England, and Slovakia, and are found in American embassies in Brazil, Denmark, Senegal, Bolivia, Africa, and Switzerland. His awards include one from the Harvard Foundation, Fogg Art Museum, Harvard University, and the Visionary award from the Institute of American Indian Arts Foundation. Namingha was the subject of a monograph (2000) written by Thomas Hoving, former director of the Metropolitan Museum of Art, New York.

"Katsinas represent intermediaries between the physical and spirit world. They bring moisture, in the form of clouds, for all life. The subjects in this work are fragmented katsina images that are metaphors for the fragmentation of Native American culture as changed by Western society. They also make a universal statement about how all the world's people have been fragmented by time and change over the centuries. We receive only glimpses into one another's cultures."

Cloud Image, 1996
Acrylic collage on wood
49 x 26 x 24½ (124.5 x 66 x 62.2)
Collection Phyllis and Walter Loeb

Cloud Image, 1996
(reverse)

Christine McHorse

Born 1948, Morency, Arizona; lives Santa Fe, New Mexico
Christine Nofchissey McHorse is both a silversmith and a ceramist.
At the age of fourteen, she attended the newly founded, experimental,
and somewhat controversial Institute of American Indian Arts in Santa Fe,
New Mexico. There she studied with some of the most influential
Southwestern artists active in the 1960s: ceramist Ralph Pardington,
jeweler Charles Loloma, sculptor Allan Houser, and designer and painter
Fritz Scholder. McHorse began using micaceous clay in 1969 after
meeting Lena Archuleta of Taos Pueblo, a major center for micaceous
ceramics. McHorse's awards are numerous, and her work is widely and
avidly collected. She is also active in her community and was among the
organizers and founders of the Council of Artists of the Southwestern
Association for Indian Arts.

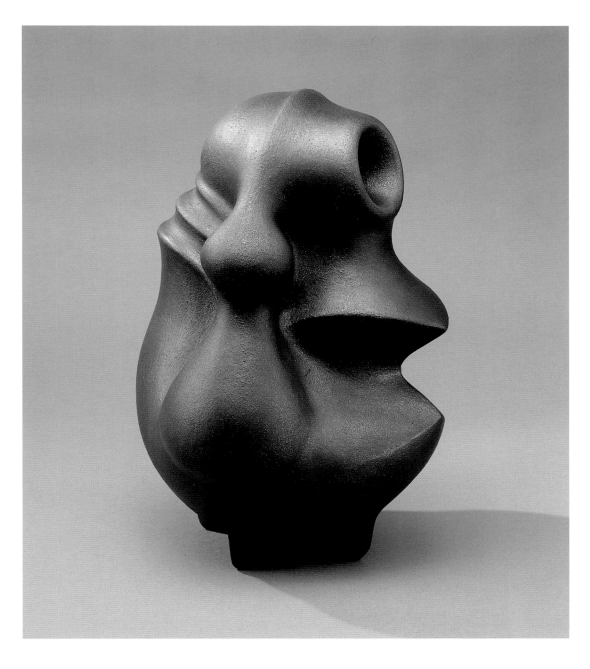

Sculpture, 2001
Micaceous earthenware
12 x 6 (30.5 x 15.9)
Private collection

Cheyenne Harris

Born 1963, Phoenix. Arizona; lives Tempe, Arizona

Cheyenne Harris is a fourth-generation silversmith who has learned from her family, as well as formally. She is a candidate for a master of fine arts degree in metals from the University of Massachusetts in North Dartmouth, following receipt of a bachelor of fine arts degree in jewelry and metalsmithing from Northern Arizona University in Flagstaff. Harris's work—which combines traditional Western techniques such as raising and casting with specialized techniques inspired by Asian metalwork-ing—has been shown in over twenty invitational exhibitions and over thirty juried exhibitions. Most recently, her work was shown in *Objects for Use: Handmade by Design* at the American Craft Museum (2001). Harris has received fellowships and grants from Haystack Mountain School of Crafts in Deer Isle, Maine, the American Indian Graduate Center in Albuquerque, New Mexico, and the Southwestern Association for Indian Arts in Santa Fe, New Mexico. Harris's work is found in public and private collections throughout the United States.

"This was the first set of flatware I designed and constructed while in graduate school. It occurred to me that we often take the process of eating for granted; we sometimes don't have or give the time needed to this activity. The extra gold tine on the fork was intended to be a visual and physical reminder of what we eat and of how we eat. This detail and the overall design bring one's attention back to the process of eating."

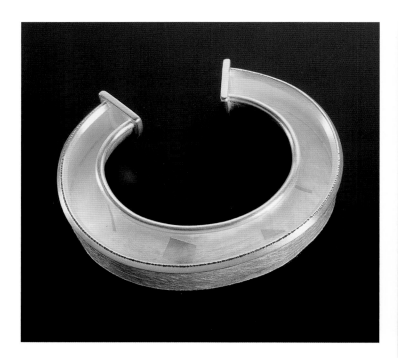

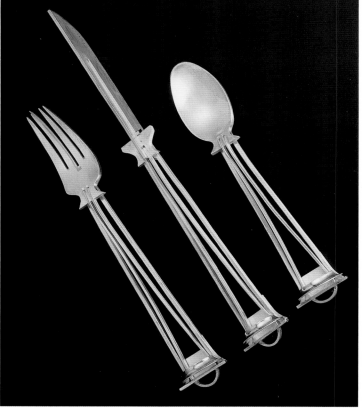

Hollowform Bracelet, 2000
Sterling silver, 24k gold
Width: 3¼ (8.3)
Private collection

"This piece is a combination of European and Korean metal-working techniques that I learned from Finnish silversmith Heikki Seppa and Korean metalsmith Komelia Okim, with whom I studied. I combined what I learned from them with my own design concepts and knowledge of traditional Navajo silversmithing. I enjoy creating bracelets and am constantly searching for new and innovative ways of using them as markers of identity."

Flatware Set #1, 1999
Sterling silver, 14k white and yellow gold
Knife length: 10 (25.4)
Collection Tony Abeyta and Patricia Michaels

Edison Cummings

Born 1962, Keams Canyon, Arizona; lives Mesa, Arizona

Edison Cummings was interested in art at an early age, but primarily in drawing and painting. After high school, he studied at the Institute of American Indian Arts in Santa Fe, New Mexico, where he graduated with a specialty in sculpture. At Arizona State University, Cummings took a metals course and found his artistic niche. He apprenticed at a local jewelry studio to learn more techniques. In 1995 he began working independently. He showed to great success at Indian Market in Santa Fe, New Mexico, that year. His works have been collected by major museums in New Mexico and Arizona.

"Concave shapes are familiar in my work, but this piece took the idea further than any other. For me the best part of making jewelry is in the challenges it brings me. My ideas come from my awareness of things around me—buildings, shapes, and landscapes. I use sketching to work out my ideas; my sketches become a record of my process."

Bracelet, 2001
Sterling silver, gold, coral
Width: 3 (7.6)
Private collection

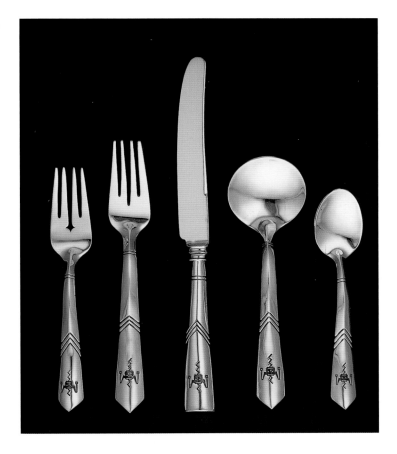

Five-piece Place Setting, 2000
Sterling silver
Knife length: 10 (25.4)
Collection Jan Bischoff

Harvey Begay

Born 1938, Tuba City, Arizona; lives Steamboat Springs, Colorado

Harvey Begay is the son of the renowned silversmith Kenneth Begay (died 1977), a luminary Navajo silversmith in the 1940s and 1950s. Kenneth Begay, along with the legendary Charles Loloma, helped forge a new path for Indian jewelers. Their influence has made itself felt in the work of Harvey Begay, who, as a young man, worked in his father's studio before going on to receive a bachelor of science degree from Arizona State University. Begay also served in the U.S. Navy and flew many missions in Vietnam. After a career as a test pilot for McDonnell Douglas, Begay returned to jewelry design in 1970. Studies with the French jeweler Pierre Touraine, who was then living in Scottsdale, gave Begay the opportunity to learn diamond setting, as well as other specialized techniques. The artist makes use of a broad range of techniques to produce his distinctively bold designs, which incorporate coral, turquoise, and lapis lazuli.

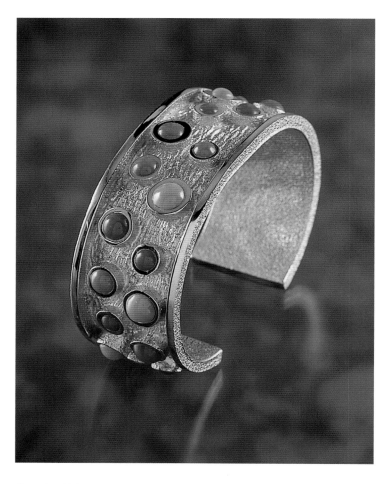

"This is a piece that I have wanted to make for nearly twenty-five years. While it would have been simple to make the work in wax, I wanted to return to the traditional Navajo technique of tufa carving, which results in a unique surface texture. It is this combination of tradition with a very contemporary composition of color, texture, and form that I wanted to capture in this bracelet. My work is speculative because I reach out where others won't go. My task is to explore new ideas and ways to work the metal."

Bracelet, 2001
14k gold, coral
Width: 2⅝ (6.7)
Collection of the artist

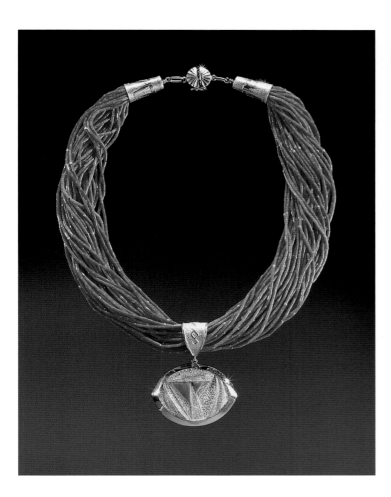

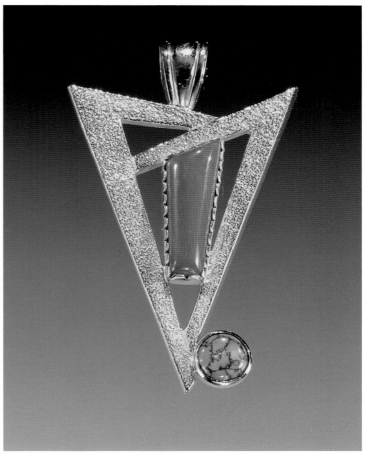

Necklace and Pendant, 2001
Coral, 14k gold
Length: 12¼ (31.1)
Pendant length: 2⅜ (6)
Collection Juanita Eagle

Pendant, 2001
14k gold, coral, turquoise
Length: 2⅜ (6)
Collection Juanita Eagle

David Gaussoin

Born 1975, Santa Fe, New Mexico; lives Santa Fe, New Mexico
David Gaussoin was born into a long line of silversmiths, painters, weavers, and sculptors on his mother's side. The artist acknowledges his mother, Connie Tsosie Gaussoin, as his primary teacher of metalworking techniques. The artist has studied art at the University of New Mexico (where he also received a bachelor's degree in business administration) and the Institute of American Indian Arts, Santa Fe, New Mexico.
In addition to domestic studies, Gaussoin has traveled extensively in Europe, notably in Norway, Finland, and Italy, all centers of jewelry design. Gaussoin's award-winning jewelry (the artist has received over thirty-five awards, his first at age eleven) is most often made of silver and gold, but he also works in steel and other non-traditional materials.

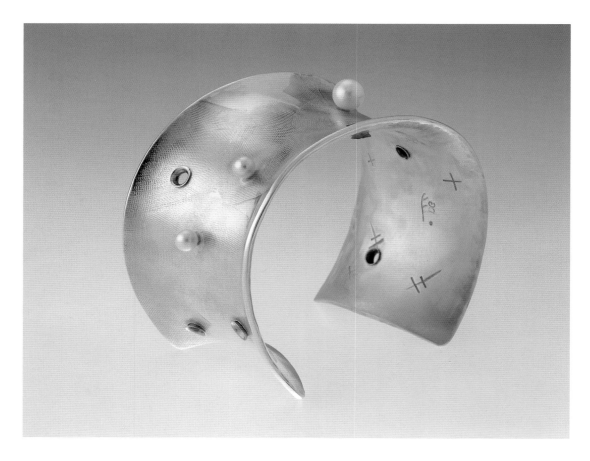

Midnight Surrealism, 2001
Sterling silver, cultured pearls,
14k gold rivets
Width: 3 (7.6)
Collection of the artist

Linda Lou Metoxen
Deer Hunter Coffee Service, 2001
Sterling silver
Teapot height: 10 (25.4)
Tray width: 18 (45.7)
Collection of the artist

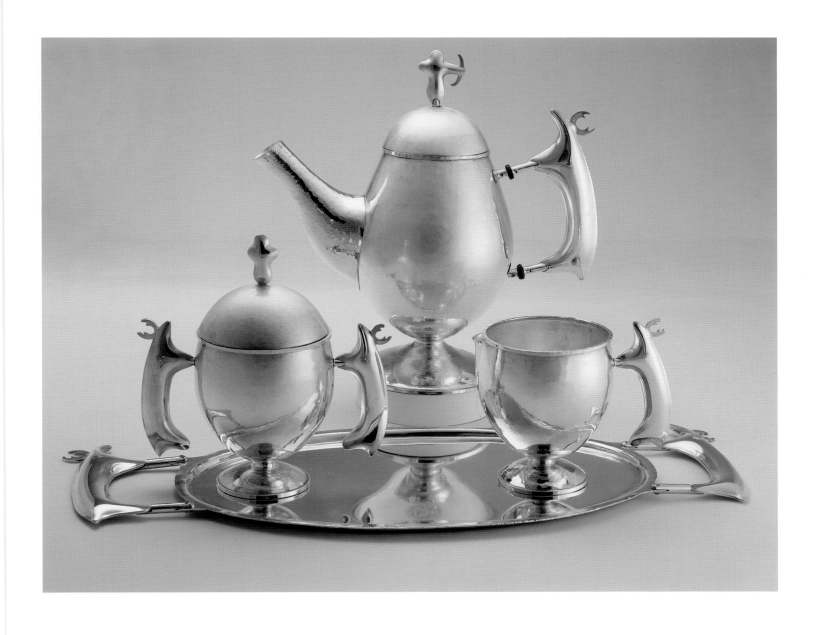

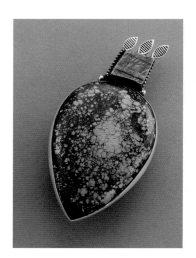

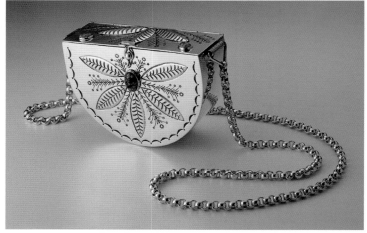

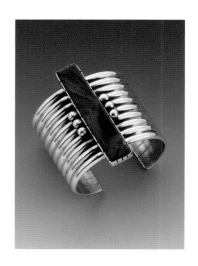

Mike Bird-Romero
Brooch, 2001
Sterling silver, turquoise, opal
matrix
3 x 1½ (7.6 x 3.8)
Courtesy Blue Rain Gallery

Mike Bird-Romero
Opera Bag, 2001
Sterling silver, turquoise
3½ x 4¾ (8.75 x 12.1)
Private collection

"Gail is my wife, but also my
partner in creating new designs.
This piece was inspired by an
old-fashioned canteen, and the
shape intrigued me. When Gail
suggested a new use for the
shape, something wonderful
emerged. Our conversation turned
into a new design."

Mike Bird-Romero
Cuff, 2001
Sterling silver, opal matrix
2⅝ x 2⅜ x 2 (6.7 x 6 x 5.1)
Collection Allison Bird-Romero

Mike Bird-Romero
Brooch, 2001
Sterling silver, gold, psilomelan,
peridot, pearls
2¾ x 2 (7 x 5.1)
Collection American Craft
Museum; gift of Allison and Mike
Bird-Romero, 2002

"The combination of the black
stone and the brilliant green
peridot appealed to me. The work
was also influenced by my interest
in the structures that hold jewels
together. I remember the words of
an old Navajo silversmith who
said that 'illusion is part of making
jewelry.' I feel the same way, but I
work in a contemporary style."

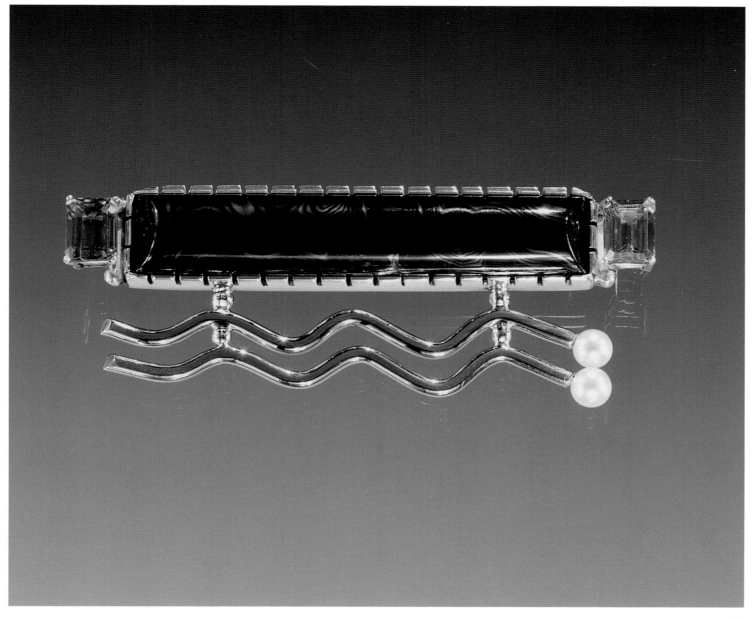

Mary Duwyenie

Born 1968, Phoenix, Arizona; lives Phoenix, Arizona

Mary Duwyenie received her bachelor of fine arts degree from Colorado State University in 1990. In 1997, she graduated from Arizona State University with a master of fine arts degree. She currently teaches at Hope Junior/Senior High School in Keams Canyon, Arizona. In addition to being a weaver, Duwyenie is an accomplished silk-screen artist. She acknowledges the influence of Ramona Sakiestewa (p. 94) and early Navajo and Hopi weavings in her work. Her designs are often highly abstracted images drawn from the landscapes around her. Her colors are dramatic and bold, particularly when used in her geometric designs.

L. Eugene Nelson

Born 1954, Ogden, Utah; lives Albuquerque, New Mexico

L. Eugene Nelson studied drafting, mechanical drawing, and architecture at the Southwest Indian Polytechnic Institute in Albuquerque prior to further studies in art history, engineering, and geology at the University of New Mexico. Nelson began showing his work in 1988, and by 1989 was included in the exhibition *Treasures of Earth, Sea, and Sky* at the San Diego Museum of Man in California and, in 1997, at the British Museum, London. The artist has received numerous awards at many major Native American markets and festivals. Nelson's work is informed by technology and engineering, and translates traditional techniques and materials into a contemporary mode.

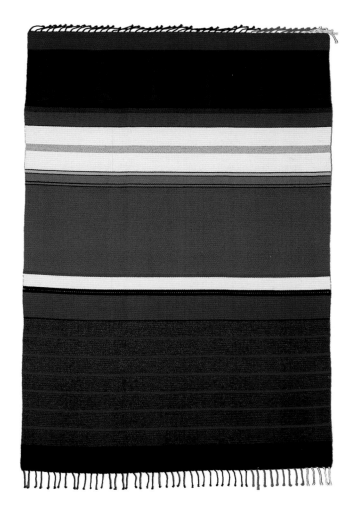

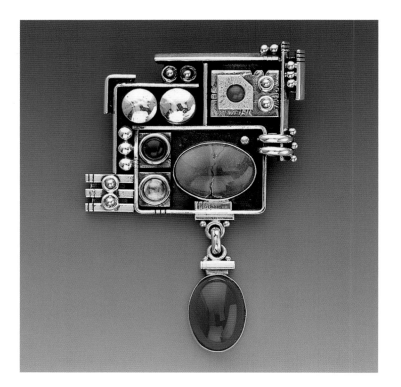

Computer Chip Brooch, 2000
14k gold, sterling silver, turquoise, coral, peridot, sugulite
2¼ x 1⅝ (5.7 x 4.1)
Collection Valerie T. Diker

"Being self-taught has allowed me the freedom to design without the boundaries that might otherwise have been present. My goal is to produce works of art that are uniquely individual and distinctly my own."

Striped Weaving, c. 1999
Wool, natural and aniline dyes
70 x 46¼ (179.1 x 117.5)
Collection Dr. and Mrs. E. Daniel Albrecht

"My weaving is culturally inspired, but it is unusual for a Hopi woman to become a weaver because this was traditionally a man's occupation. My colors come from within my own imagination and sometimes reflect the landscape or the cardinal directions."

Preston Duwyenie ✕

Born 1951, Hotevilla, Arizona; lives Española, New Mexico

Preston Duwyenie moved to Phoenix, Arizona, as a young boy. In 1978, on a trip through Santa Fe, Duwyenie learned about the Institute of American Indian Arts and enrolled. After graduation he went on to further study in the arts at Colorado State University in Fort Collins, Colorado, graduating with honors in 1984. Postgraduate work was followed by an appointment as professor of traditional pottery and jewelry at the Institute of American Indian Arts. Duwyenie taught until 1996, when he began to devote his time entirely to his art. While studying metalsmithing and ceramics at Colorado State University, Duwyenie learned cuttlefish-bone casting, and used the technique to produce what the artist calls "shifting-sands" jewelry. By the late 1980s, he was combining metal and clay in a distinctively elegant and refined series of non-traditional vessels carried out in a wide range of pastel, gray, and white micaceous clays.

"My vessels are intended to be non-functional. For me, they are bridges between painting and sculpture in the variety of colors, textures, and surfaces that they present. Their simple and generous forms are also metaphors for bridges between the life forces of the sky and the earth. That's what you see in my vessels—the nurturing aspect of Mother Earth and the beneficial qualities of the heavens."

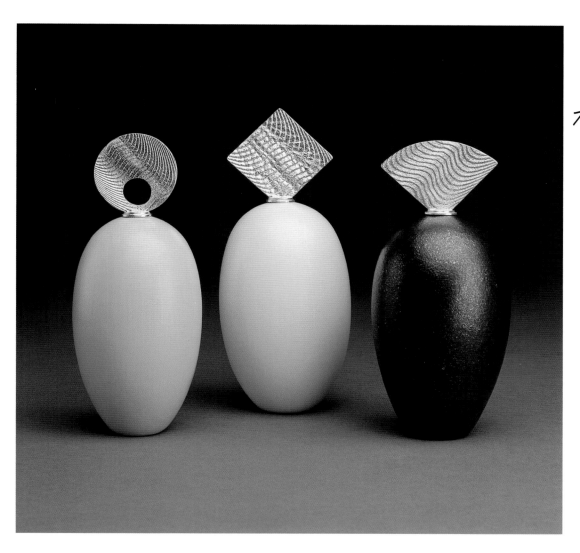

Three Vases, 2002
Micaceous earthenware, sterling silver
4½ x 2½ (11.4 x 6.4) (each)
Collection of the artist

✕

Ramona Sakiestewa

Born Albuquerque, New Mexico; lives Santa Fe, New Mexico

Ramona Sakiestewa has received international recognition for her superbly designed and woven tapestries. Born of Hopi ancestry, the artist taught herself to weave by adapting and evolving techniques derived from prehistoric pueblo weaving. The artist has served as chairperson of the New Mexico Arts Commission, has received commissions to weave the works of such artists as Frank Lloyd Wright and Kenneth Noland, and is one of the design consultants for the National Museum of the American Indian of the Smithsonian Institution in Washington, D.C., which is currently under construction. The artist has traveled and worked internationally, and her work can be found in numerous museums throughout the United States. Five one-person exhibitions of her work have been organized to date.

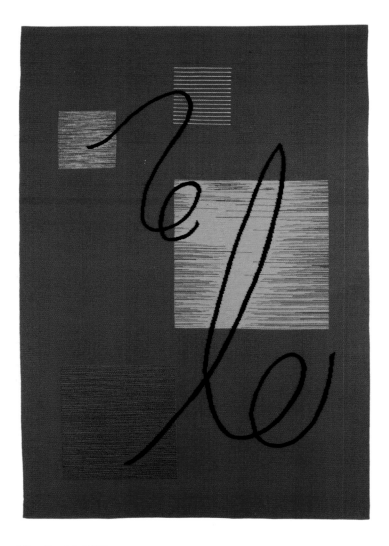

Migration 14, 2000
Wool
65 x 45 (165.1 x 114)
Collection of the artist

"Since the 1950s we have been experiencing the equivalent of the 'Big Bang' in Indian art and craft. The expansion of media and visual vocabularies is contributing to the galactic explosion of Native American artists as individual artists. Indian people are no longer tied to form, function, and tribal affiliation as the exclusive definition of what Indian art is."

Migration 15, 2000
Wool
65 x 45 (165.1 x 114)
Collection of the artist

"The majority of my tapestries are a synthesis of the colors, landscapes, and cultural icons I have grown up with in the American Southwest. Other tapestries combine the essences of other cultures' color, architecture, and design. All these elements are then abstracted for the final weavings. My current work explores the concept of migration—of ideas, animals, and humans. These ideas are born out of where I have grown up and places I have traveled."

Jacquie Stevens

Born 1949, Omaha, Nebraska; lives Santa Fe, New Mexico

Born in Nebraska of Winnebago heritage, Jacquie Stevens has become
a major figure in Southwestern ceramics, having lived in Santa Fe since
1975, when she came to New Mexico to study at the Institute of
American Indian Art. It was while at the Institute that Stevens discovered
her talent for making ceramics. Her innovations have been in form—
unusual free-form shapes—as well as in her unique surface textures and
bold use of color. She often incorporates other materials in her designs,
ranging from fiber and wicker to stone and leather. While maintaining her
contemporary approach to pottery, Stevens also references her ancestry
in designs that evoke the spirit of Winnebago baskets.

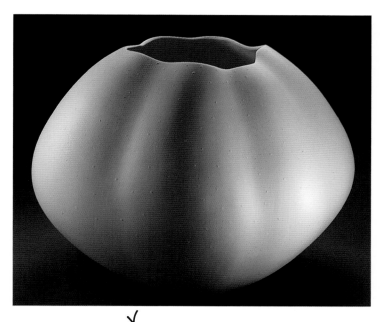

Vessel, 2001
Earthenware
14½ x 18⅝ (37.5 x 47.3)
Courtesy Four Winds Gallery

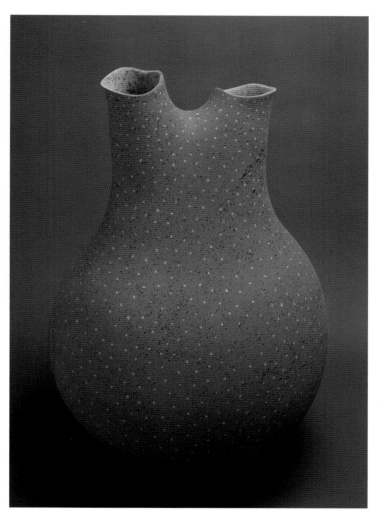

Double-spouted Jar, 2001
Polychromed earthenware
26 x 15 (65 x 37.5)
Collection Sara and David Lieberman

"This piece was inspired by sculpture by Alexander Calder and also by early American duck decoys. I use the bird motif quite a bit in my work; it is an old Hopi motif, but one that is really timeless."

"When my son Joseph, who was born in 2000, was four or five months old, I would take him into the garden. From infancy he was very interested in the outdoors, especially the birds, flowers, and trees. This pot expresses his joy in nature, and my joy in him."

Les Namingha
Bird House, 1999
Polychromed earthenware,
acrylic paints
11¼ x 10¼ (28.6 x 26)
Collection Fred Silberman

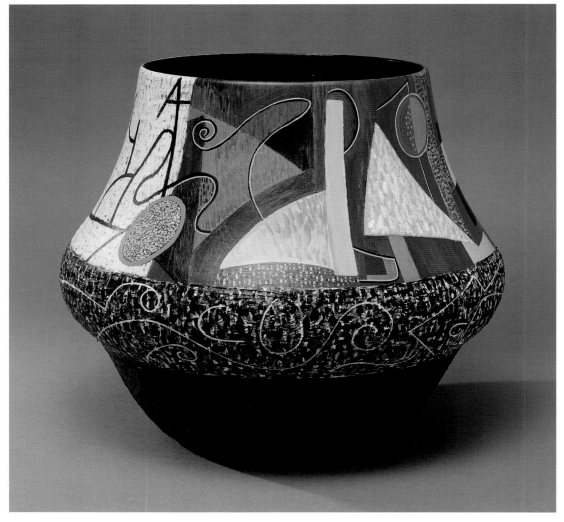

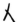 **Les Namingha**
Joseph's Trip to the Garden Vase, 2000
Polychromed earthenware, acrylic paints
14½ x 12½ (36.8 x 31.8)
Collection Rachel and Charles Shotland

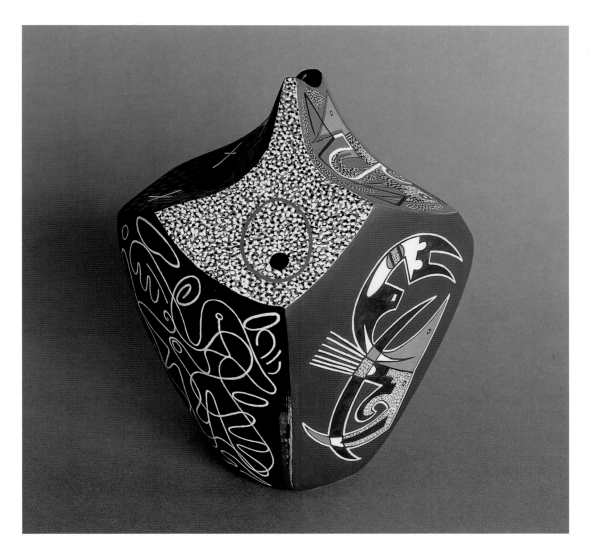

Les Namingha ✗
Faceted Vase, 2001
Polychromed earthenware
7¼ x 6½ (24.5 x 22.7)
Collection Margot and
Richard D. Zallen

Dorothy Torivio

Born 1946, Acoma, New Mexico; lives Acoma, New Mexico

Dorothy Torivio has been active as a ceramist for over twenty years and is best known for her exaggerated forms and her extremely detailed painting. Painting freehand with the traditional yucca brush and the Acoma palette of white, black, and red, she creates hypnotic patterns that suggest dynamic movement in the spirit of Op Art.

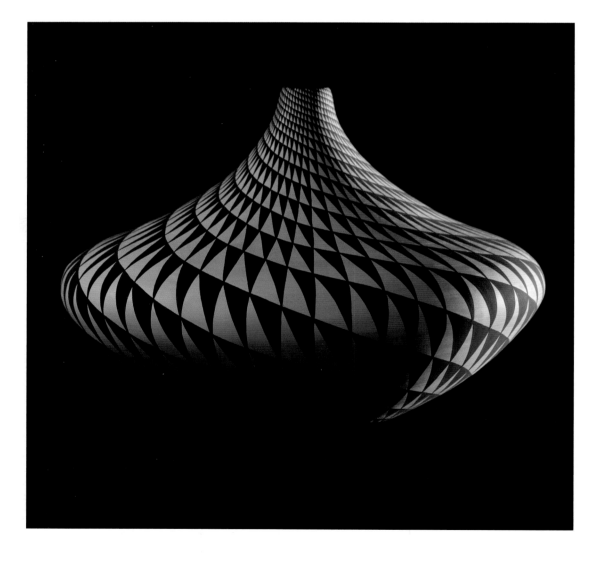

Seed Jar, 2001
Polychromed earthenware
6¼ x 8¼ (15.9 x 21)
Peabody Essex Museum; purchased with matching funds provided by Margie and James Krebs

Hubert Candelario

Born 1965, Albuquerque, New Mexico; lives Albuquerque, New Mexico

Hubert Candelario studied architectural drafting and design at the Phoenix Institute of Technology, Arizona. In the mid-1980s, he became interested in clay, a material entirely new to him. The artist experimented with a wide range of clay bodies and techniques based on his fascination with the forms and decorations of ancient Native American pottery. After learning basic techniques of hand building, burnishing, and firing, the artist's interest in design and engineering came to the fore in a series of vessels that explored new possibilities of structure. Since that time, Candelario has evolved a unique series of designs that merge sculptural form with structural components.

Holy Pot, 2001
Micaceous earthenware
9⅜ x 10½ (23.8 x 26.7)
Collection Rutt Bridges and Ilene Brody

"I have always loved structure and design, fields that I originally studied at school. While making this pot, I thought about ways to incorporate structural principles into the design. I began cutting away holes in a traditional pot to see how far I could push the limits of the structure. It was a technical challenge that succeeded. Since that time I have explored this aspect of structure in pieces that look different and, when tapped, sound more like metal than clay."

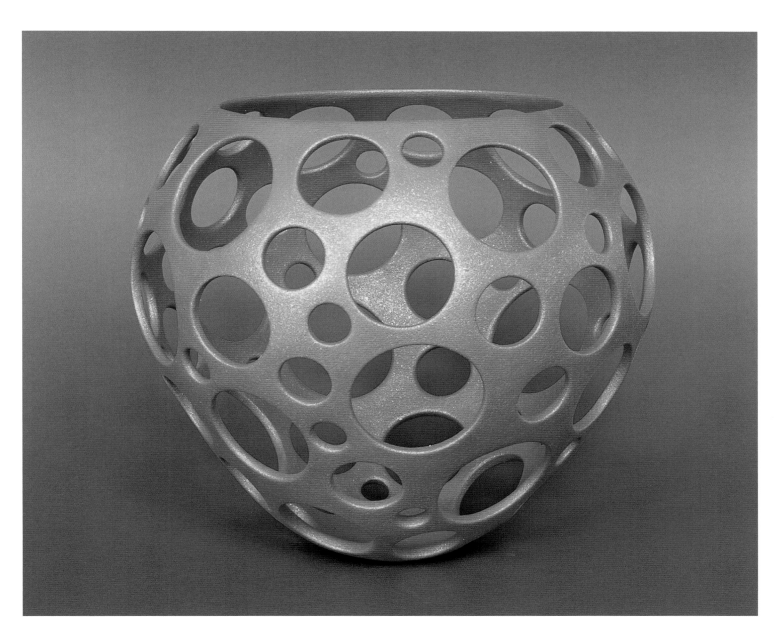

Nancy Youngblood

Born 1955, Fort Lewis, Washington; lives Española, New Mexico

Granddaughter of the legendary potter Margaret Tafoya, Nancy Youngblood claims a place of prominence in the field of ceramics, and has been the recipient of over 250 awards and honors. As a child the artist traveled extensively with her father during his military career, but she returned to the Santa Clara Pueblo as a young woman. Her tutelage with her grandmother established the artist as a skilled practitioner and inventive designer of unique forms with exceptionally radiant burnished surfaces. She is best known for her swirling, ribbed, "melon"-form jars, which are dramatic and sculptural. Youngblood's work forms a powerful visual and aesthetic bridge between the rich pottery traditions of the Southwest and the memorable and sensual quality of the finest contemporary pottery.

Red Swirl Vase, 2001
Earthenware
Diameter: 10 (25)
Collection Dennis and Janis Lyon

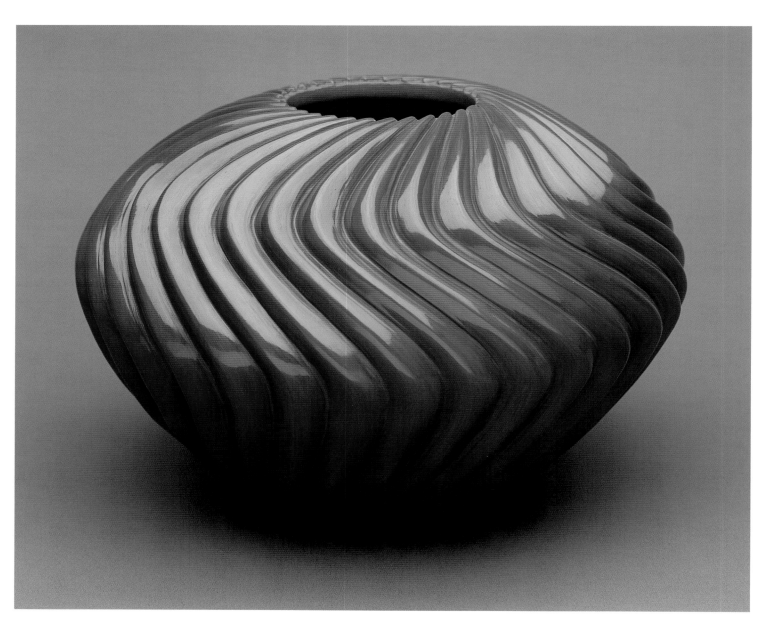

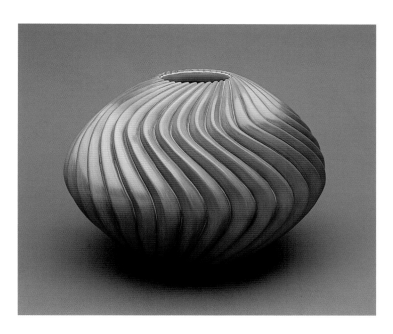

Sienna Swirl Vase, 1999
Earthenware
Diameter: 8½ (21.2)
Collection Dennis and Janis Lyon

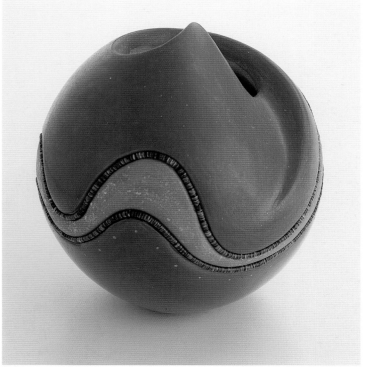

Russell Sanchez
Miniature Vase, 2001
Polychromed earthenware, shell
heishi
2¾ x 2¾ (7 x 7)
Private collection

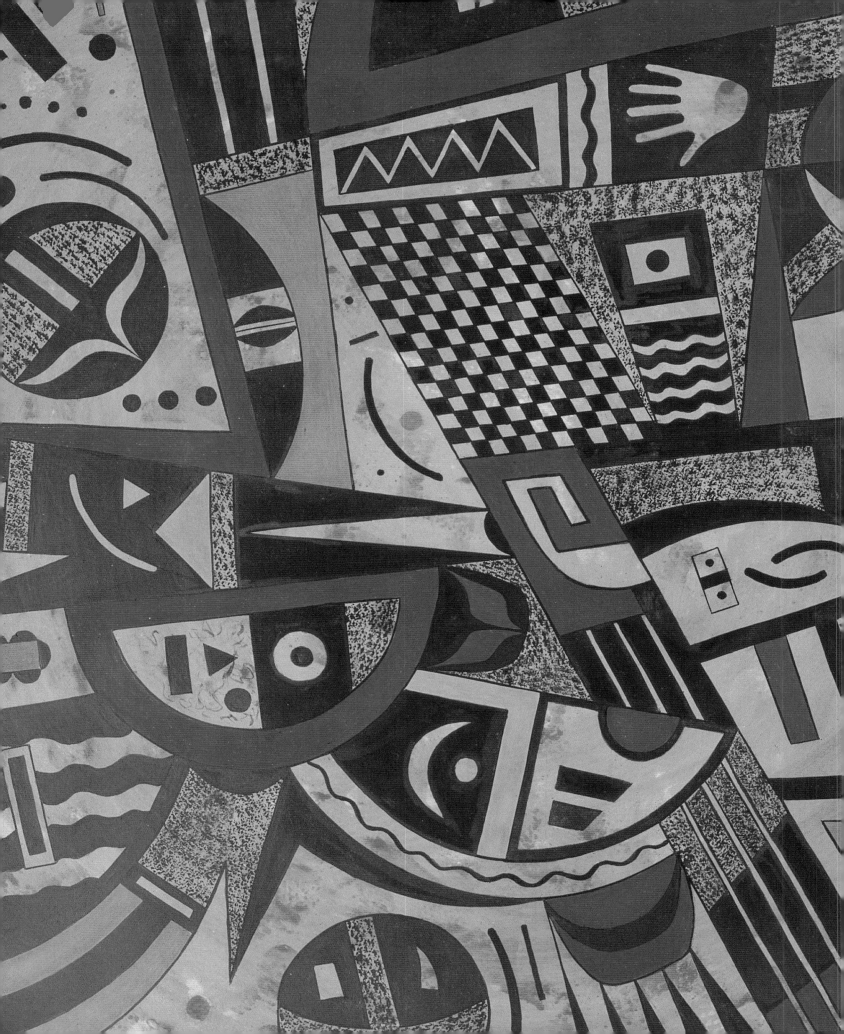

A Story of Creation: Tradition and Authenticity at Santa Fe's Indian Market

Bruce Bernstein

If Southwestern Indian art is being discussed, Santa Fe Indian Market is part of the conversation.

Santa Fe Indian Market is the largest and most important venue for Southwestern Native American art. Each third weekend of August, the annual event attracts most of the best artists, as well as legions of admirers and collectors. Indian Market is also the biggest event of the year in the city of Santa Fe, taking over the entire downtown. The Southwestern Association for Indian Arts (SWAIA) sponsors the annual event, selecting and vetting the fifteen hundred participating artists and judging and awarding prize money of $60,000 for over three hundred categories of entries. Organized and managed by SWAIA, the two-day event attracts an estimated 75,000 people and brings over $20 million in revenue to the artists, the city, and its businesses. Indian Market is not just a two-day event; it now starts almost two weeks in advance with antique Indian art shows and auctions, gallery and museum openings, as well as two weeks of 100 percent bookings at local hotels and restaurants.

Indian Market organizers use extensive formal and informal rules to select and vet participating artists as well as to provide guidelines for judges. Pottery, for example, is divided into nine classifications roughly based upon village styles ("Division C: Traditional Pottery, Carved or Incised. In the style of San Juan, San Ildefonso, Santa Clara and other tribal styles"). Each classification is further broken down into divisions (ninety-six in all) that are primarily based on size.

These rules were largely informal until the 1980s, when Indian Market enjoyed exponential growth. A cadre of close friends with fierce loyalties to the artists and to the principles of Indian Market began recording and refining what are now known as the Indian Market Standards. These standards exist for all of the classifications and are used in judging as well as evaluating each booth at Indian Market to ensure that only authentically made Indian art is being offered for sale.

SWAIA did not "make up" these conventions, but rather sought to clarify the types of criteria that judges and collectors had long used to judge a good from a not-so-good pot, painting, sculpture, basket, textile, or piece of jewelry or diversified art. The prizes awarded at Indian Market permanently signify an artist's ability or standing in the eyes of the judges. Arguably, it can be said that the winning of prizes at Indian Market has become the most important measure of an artist's success. It is not the prize money *per se* that an artist desires—it represents but a fraction of the value of the award-winning piece. Winning prizes brings an enhanced reputation. Winning the highest awards virtually assures an artist of long-term success, since many buyers collect these art forms on the basis of the Indian Market awards.

Today's Santa Fe Indian Market has two direct lines of ancestry, both of them rather modest. First, in 1922, the Museum of New Mexico introduced an indoor Indian Fair, as much as a means of self-promotion as to encourage tourism in the Santa Fe area. This tourism was largely fueled by people's interest in Pueblo Indians, an idea further promulgated by the men and women of the museum and its supporters. Pueblo art offered the perfect embodiment of the public romanticization of Pueblo life and also of the Pueblo people's increasing longing for their own past glory, both actual and mythological. The Museum of New Mexico's first Indian Fair was a conscious attempt to encourage the fine-

art pottery traditions of the Pueblos. It was believed that a market for fine pottery would ensure its continuance, as well as allow Pueblo culture to thrive. Pueblo art was, then, inextricably linked with Southwest tourism, the success of local museums, and the survival of Pueblo life and culture.

Southwestern Indian arts have changed over the centuries as the culture itself has evolved and borrowed and adapted elements of other Native and non-Native cultures. Changes brought by the European settlement of New Mexico in 1598 can be seen in the art, as artists modified forms and design motifs. The Indian arts in the Southwest were further changed in the 1800s by the introduction of manufactured wares such as enamelware, metal buckets, porcelains, and commercially manufactured blankets, which were used alongside or in place of traditional items.

At the same time, a new market for inexpensive souvenirs to sell to tourists offered much-needed cash. The arts had, since the 1870s, been collected by visitors to the Southwest in hopes of bringing home some of the enchantment of New Mexico's vast landscape, vistas, mythic archaeological sites, and living tribes. The demand for these quickly manufactured souvenirs further undermined an almost two-thousand-year-old pottery-making tradition. The arts continued to degenerate in the late nineteenth century as poverty and declining populations further ruptured Pueblo lives. The arrival of the railroads and the influx of settlers accelerated the theft of Native lands and water rights, further disrupting a centuries-old pattern of survival and life.

Indian Fair was specifically intended to reverse the trends of the declining quality of pottery and the dwindling numbers of Pueblo artists. Indian Fair

organizers sought to remove the influences of four hundred years of Euro-American contact. Through a return to pre-1500 motifs, it was reasoned that Pueblo pottery could regain its aboriginal wholeness and purity. This "authentic" art, it was reasoned, would sell better, because it was a pure product without the debasing, intrusive, and unattractive elements of what Indian art forms had become through hundreds of years of contact with the West. In order to impress this upon potential buyers and the artists themselves, the Indian Fair organizers interspersed older pottery from the museum's collection with the juried pottery entries. The old art forms were to offer a standard against which current, but traditional, pottery would be measured.

The second genesis of Indian Market occurred in 1936, three years after the end of the Museum of New Mexico's Indian fairs. The New Mexico Association for Indian Affairs (NMAIA, today known as the Southwestern Association for Indian Arts, or SWAIA) developed and implemented a summer Saturday series of Pueblo art fairs under the Palace of the Governor's Portal, which forms the north side of Santa Fe's plaza. The inspiration was Saturday markets in Mexico. The NMAIA was an Indian advocacy organization that had successfully won land and water rights back for Pueblo people. The organization now sought ways to better the Pueblo condition through education, healthcare, and economics. The NMAIA was not interested primarily in promoting art for art's sake, but rather in developing an economic vehicle to bring much-needed cash into the communities (but certainly there were members who were interested in art). Through the establishment of Saturday markets, the NMAIA provided the Pueblo villages and artists a means of earning money and entering the broader regional economy; and importantly, this could all be accomplished

without abandoning the Pueblo villages and Pueblo culture.

On Saturday mornings, the NMAIA bused the potters and their families from their villages to the Santa Fe Plaza. Each artist was allowed to sell whatever he or she had brought; however, the NMAIA placed stickers on the pots judged to be of better quality and awarded prize money to the "best." In a further effort to promote improved pottery making, buses would take the potters from Saturday markets to the Laboratory of Anthropology, where the potters were allowed to view their ancestral pottery in the museum's collections.

Indian Market was not always the most significant venue for contemporary Southwestern art. Until the early 1970s, the Gallup Inter-Tribal Ceremonial and Fair was the primary place to find buyers. While there were some artists selling their work directly to the collector, the Gallup Fair allowed traders and dealers (middlemen) to enter and sell an artist's work. In the late 1960s and early 1970s, as buyers began coming to the Southwest to meet Indian people firsthand, they discovered an August art market of about one hundred artists staged under the Palace of the Governor's Portal and on the adjoining portion of Palace Avenue, where buyers could purchase directly from the artists. There was no filter or middleman, and therefore collectors began flocking to Santa Fe for the more "authentic" experience of buying directly from artists. It was also deemed eminently more fair to purchase directly from an Indian artist rather than a middleman. A buyer might also create a "personal relationship" with the artist.

There is a strong desire to prevent commercialization from creeping into Indian Market. It is supposed to be a refuge from the vicissitudes of American life, with negotiations taking place directly between the artist and the patron. In addition, Pueblo culture has come to stand for what is good in humankind and for much of what is thought to be missing in modern American culture. Certainly, during Indian Market's genesis in the 1920s and 1930s, organizers wished to remove the influence of Indian arts-and-crafts shop owners, or Indian traders, whom they viewed as promoting a crass commercialization of Indian art. The original Indian Fair and Market organizers perceived traders as interested only in making money and as appealing to the lowest common denominator of the marketplace, without any consideration for quality or aesthetics. When Indian Market was moved to the Palace of the Governor's Portal in 1936, the organizers emphatically removed the middlemen; there were neither curators vetting every entry nor the traders who had sent some of the displays and entries for the first Indian Fairs.

Today, arriving at an artist's booth at dawn on Saturday morning with the intention of purchasing the Best of Show, Best of Classification, and first-place ribbon winners is not early enough. Judging provides the official recognition at Indian Market. In addition, in the last decade the emergence of the practice of waiting for twenty-four hours or more in an artist's booth in order to be first in line to purchase an award-winner's piece is another way the best artists of Indian Market are denoted. The importance of booth-sitting is confirmed by the fact that some collectors now hire surrogates to spend the arduous night on the Santa Fe Plaza.

Twenty-eight of the twenty-nine potters included in *Changing Hands: Art Without Reservation* either currently participate or once participated in Indian Market. As a group they won a disproportionately high number of prestigious first-place ribbons, Best

of Classification, and Best of Show awards. These awards help ensure their continued success as important Indian artists. Of course, this argument is circular, because it is exactly because they are good potters that they achieve such high levels of success at Indian Market. In addition, every one of the artists in *Changing Hands* who participates in Indian Market is further marked out by the presence of booth-sitters on Friday night. Many of the artists are sold out within hours of the opening of Indian Market at seven o'clock on Saturday morning.

Tourism advertisements for the Southwest and Santa Fe continue to emphasize Indian culture as enduring, ancient, and beautiful. Native art is about continuity, and indeed there is an unbroken, two-thousand-year-old line between the works of yesterday and today. In recent years, however, many artists have tended to duplicate or replicate older styles, as well as the forms and designs of other successful artists, rather than using them as inspiration for their art. Replication of previously made forms ensures that the newly made art will be viewed as traditional. However, it is important to note that there are also great innovators within the Indian art traditions, and that there is room for them at Indian Market, as well. They are the ones who bring change to Indian Market, along with a continual adjustment of the standards.

Thousands of friendships among Natives and non-Natives alike have evolved from encounters at Indian Market and are maintained through annual Indian Market visits. The art is what binds people together. While there are still some unavoidable interstices, where our worldviews will never meet, the various art forms have served both groups rather well in developing an appreciation of Indian life and ensuring a continuing vibrancy to Indian cultures.

Southwest Weaving

Ramona Sakiestewa

In the 1500s, Spanish explorers in the American Southwest witnessed an extensive array of embroidered and painted shirts, breechcloths, mantas, kilts, and sashes. In 1583, a member of Antonio de Espejo's expedition to the Pueblo village of Awatovi wrote: "Hardly had we pitched camp when about a thousand Indians came laden with maize, ears of corn, pinole, tamales, and firewood, and they offered it all, together with six hundred widths of blankets small and large, white and painted, so that it was a pleasant sight to behold." (Hammond and Rey, 1929, p. 98)

The oldest examples of Pueblo textiles date from A.D. 200 to A.D. 600. Finger-woven textiles were made from rabbit fur, turkey feathers, native hemp, and yucca. Cotton and the loom seemed to have arrived from Mexico around A.D. 600.

Men did the weaving in ancient Pueblo culture. In addition to finger-woven tumplines, complex knotted sandals, netting, sprang, and feather and fur blankets, Pueblo weaving included plain weave, twills, twill tapestry, weft float patterns, and semibrocade.

Although Navajos believe they learned to weave from Spider Woman on a loom provided by Spider Man, they also learned from Pueblo weavers. They produced blanket-style dresses, shirts, breechcloths, belts, gaiters, wearing blankets, and, eventually, rug-size weavings.

Indians traded and sold Pueblo textiles among themselves, but Navajo weavers developed a wider and more diverse market from the beginning. They traded to Spaniards as well as to other tribes. After the opening of the Santa Fe Trail in 1821, they wove less of their own clothing and produced more for an open market. Traders became the catalyst for Navajo weaving in the 1870s, when nearly twenty licensed traders occupied the Fort Defiance area in Arizona. Navajo weaving is categorized into three periods: the Classic Period, from 1650 to 1865; the Transition Period, from 1865 to 1895; and the Rug Period, from 1895 to the present. The Rug Period needs to be redefined because it encompasses many changes in design and techniques, the most important of them being the recognition of the maker as an individual artist.

Contemporary Pueblo and Navajo weaving has made two steps forward, one step back. For every advancement there has been a revival period in which the older designs have been reworked—an enduring testament to the fact that Indians and non-Indians still value traditional aesthetics and the art of weaving.

In the 1970s I repaired both Pueblo and Navajo textiles. Even though the names of the makers of these textiles were unknown, endless discreet signatures appeared in the plies of the selvages, the colors of end cords, the plying and knotting of corners, and the combinations of yarns and colors. Weaver to weaver, artist to artist, the nuances of others' work are fascinating, regardless of the age of a weaving.

The twentieth century has seen Pueblo weaving by both men and women. While the vision of women has been the creative force behind Navajo textiles, a few Navajo men have entered into weaving (Hedlund, 1992, p. 38).

Artists value collectors, whether private or museum. Good reasons to collect include visual impact, historical and cultural significance, technique, and the personality of the maker. While Pueblo weaving and embroidery are beautifully designed and executed,

they exhibit little change over time. For ceremonial use, it is important to preserve ritual visual vocabularies. Pueblo embroiderers Isabel Gonzales (of Jemez and San Ildefonso Pueblo), and Ramoncita Sandoval and Lorencita Bird (of San Juan Pueblo) are the modern masters.

On the other hand, Navajo weaving has been like a bronco out of the chute, going in all directions at once. Talented weavers who once wove only in a single, regional style now include Two Grey Hills, Ganado, Crystal, and so on as part of their personal repertoire. We have seen pictorial weaving evolve from a "naïve" style into near photo-realism. There are numerous stars, but three stand out: Rose Owen's technical proficiency has brought us the "round rug"; Daisy Tauglechee's simple and elegant Two Grey Hills has set the highest standard for fineness of spinning and weaving; and Blanch Hale's superb color, design, and weaving are like one's breath on a cold morning. One first sees the whole composition, but upon closer examination, the color and design transitions seem to disappear.

In recent history, two important collections have documented individual weavers. Edwin Kennedy's collection now resides at Ohio University's Kennedy Museum of Art in Athens, Ohio. This collection spans several decades and includes the work of known Pueblo and Navajo weavers. The Gloria F. Ross Collection of contemporary Navajo weaving resides at the Denver Art Museum. It includes the tapestries of thirty-two women and one man. While these are both wonderful collections, there is still a need for additional and ongoing collecting. Collecting begins with educating the public. *Changing Hands* showcases important work of Southwestern artists and craftsmen and just may start the next cycle.

Larry Golsh
Morning Star Brooch, 2001;
see p. 135

III Nature and Narrative

Nature has provided a rich visual library of shapes, patterns, and colors that have been used by artists since the beginnings of human culture. Nature as flora, fauna, and landscape has also been the source of powerful visual images that serve as metaphors for spiritual and cultural values. Native artists in the Southwest work within a unique ecosystem with an equally unique array of natural phenomena. Closely linked to the use of nature as a source of artistic ideas is a parallel use of narrative and storytelling. A proud heritage of song, dance, and oral history is shared in the region. The contemporary artists showcased in this section of *Changing Hands* interpret nature and narrative in their works and use images of both to record their own lives, highlight their relationships with others, and comment on shared interests and concerns.

Jesse Monongye

Born 1952; lives Scottsdale, Arizona

Jesse Monongye is a highly accomplished jeweler who is best known for his extremely refined and elaborate inlay work, in which he uses a wide range of precious and semi-precious materials. Son of the noted jeweler Preston Monongye, Jesse grew up at Two Grey Hills on the Navajo Reservation, a very important weaving center, where he observed the technical perfection of the weavers. This was a formative influence on his work, as was his father. Monongye's style results from the careful cutting of hundreds of small stones to create memorable landscapes and vistas of the night sky on his buckles, bracelets, rings, and pendants.

Landscape Belt Buckle, 2001
Gold, lapis lazuli, pearl, opal, coral, obsidian, sugulite
3 x 2 (7.6 x 5.1)
Collection Larry Calof

Martha Smith

Born 1945, Ganado, Arizona; lives Sanders, Arizona

Martha Smith learned weaving from her mother when she was eight years old and became a full-time weaver in 1970. She has specialized in weaving in a contemporary Navajo style, with intricate patterns and complicated designs, and her works are often done as commissions. This is the artist's first pictorial rug, a special challenge owing to the emotional nature of the subject and Navajo taboos regarding death. The work was sold through the Internet to raise funds for the education of children affected by the September 11 tragedy.

United We Stand Skyline Rug, 2001
Wool, aniline and vegetal dyes
104 x 186 (126.4 x 218.4)
Courtesy Ellis Tanner Trading Company

"This was the hardest rug I've ever done. It was tough to rebuild the Twin Towers in this rug because there was a lot of death involved in those buildings. I'm a superstitious person, so it took a lot of discipline to weave it. The only reason I did it was to support education. I donated a lot of my time to help the children of the victims."

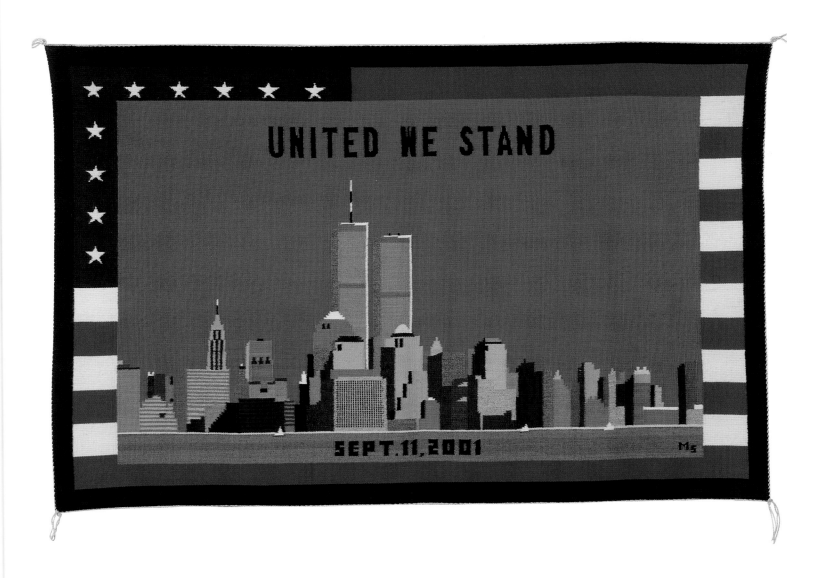

Tammy Garcia
Fisherman's Dream Vase, 1999
Earthenware
14 x 8 (35.6 x 20.3)
Collection Judith Richard and
Martin Madorsky

Tammy Garcia
Rains for the Harvest, 2001
(view 1)
Bronze (edition of 8)
72 x 26 x 8 (162.4 x 65 x 20.3)
Courtesy Blue Rain Gallery

"I became very familiar with this story when my husband and his brothers would come home from fishing. With their arms stretched out wide, they would say, 'You should have seen the one that got away.' Next to the fisherman on this pot is a basket of small fish, but he is dreaming about the big prize he might catch."

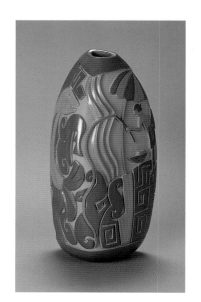

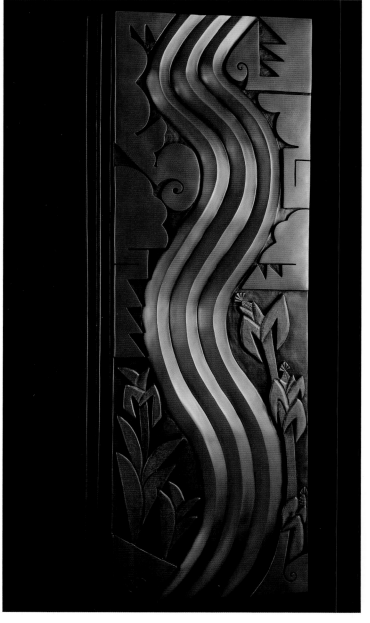

"The imagery on this piece represents how the physical world of the Pueblo peoples is tied to the spiritual world. One side is adorned with elements of nature that help corn to grow—clouds, lightning, and water. The other side depicts a woman in ceremonial vesture prepared to participate in the Corn Dance, which gives thanks to the Creator for the harvest."

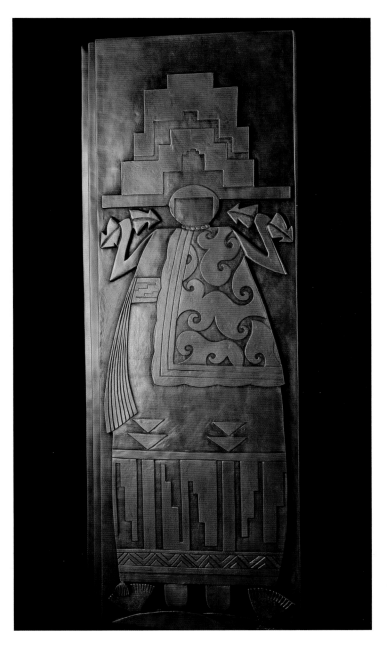

Tammy Garcia
Rains for the Harvest, 2001
(view 2)

Hubert Candelario
Puzzle Pot, 1997
Micaceous earthenware
8½ x 7 (21.6 x 17.8)
Collection Rutt Bridges and
Ilene Brody

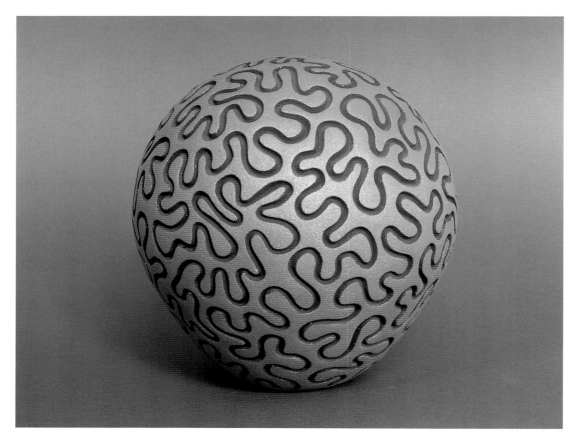

"When I made this piece, I was suffering from a potter's version of 'writer's block.' I was at a loss as to where to go, and I began doodling. What emerged was a meandering pattern that reminded me of a puzzle or of the path created by a river winding its way through a landscape. The pattern also became a metaphor for a life path, which winds back and forth, and ultimately returns to the point where it began."

Susan Folwell
Harry Potter Vase, 2000
Polychromed earthenware, acrylic
and metallic paints
10 x 8¼ (25.4 x 21)
Collection Judge Jean S. Cooper

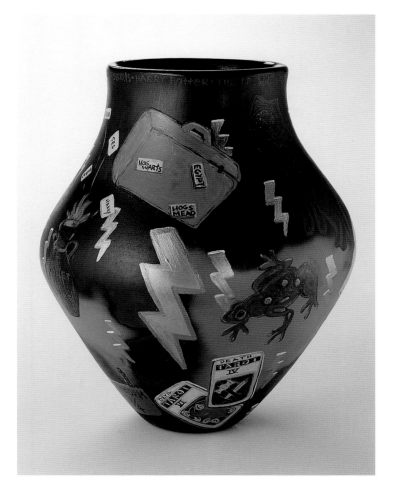

"This pot has a funny history.
I made a vase-shaped pot, which
is unlike me. I had no idea what
the decoration would be, but I
fired it anyway. When I pulled the
pot out of the charcoal-and-
sawdust fire, I knew it was the
'goblet of fire' from the fourth
Harry Potter book! I love the idea
of bright acrylic pop-culture images
floating aimlessly on the sides of
a humble and grounded pot."

Christine McHorse
Gourd Vessel, 1999
Micaceous earthenware
16¼ x 10 (41.9 x 25.4)
Collection Barbara and Eric Dobkin

Christine McHorse
Gourd Sculpture, 1996
Micaceous earthenware
19 x 9 (48.3 x 22.9)
From the private collection of
Constance and Malcolm Goodman

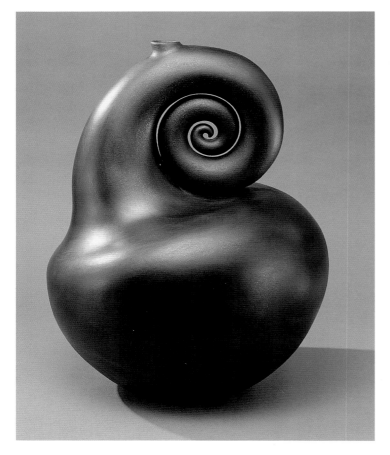

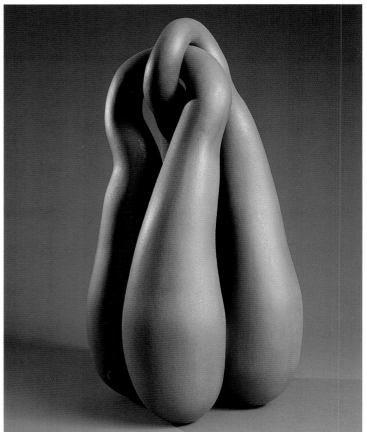

"My interest lies in the beauty and
purity of form, in the endless
possibilities that my experience
and technical skills allow."

Charles Supplee

Born 1959, Flagstaff, Arizona; lives Scottsdale, Arizona

Charles Supplee learned the art of jewelry making from his father, who made jewelry as an avocation. At a young age, the artist moved to Phoenix, Arizona, where he took a job in a commercial jewelry shop. His work brought him to the attention of French-born jeweler Pierre Touraine, who took Supplee on as an apprentice. During two years of apprenticeship, Supplee learned a wide variety of techniques and began to produce significant work with his own individual stamp. His ability at lapidary work combines gracefully with his talents in such metalsmithing techniques as casting, engraving, and etching. His sculptural works merge his Native heritage as a Hopi with his Franco-Austrian background.

Necklace with Pendant, 2001
14k gold, red coral, turquoise, sugulite, diamonds
9½ x 5¼ (24.1 x 3.2)
Collection American Craft Museum; gift of Hope Byer, 2001

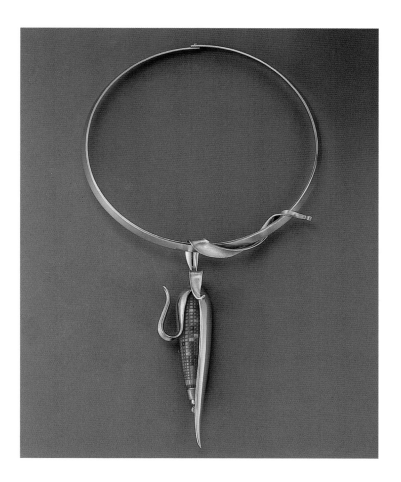

Joann Johnson

Born 1964, Monument Valley, New Mexico; lives Douglas Mesa, Utah

Joann Johnson learned basket making from her mother, who learned it from her own mother. Johnson received a degree in business from Central East Utah University but went on to study American and Indian history at Southern Utah University. In these studies, she became aware of the rich visual history of the region and its people. The images that she saw formed a visual library of ideas that appear in her work. Her basketry is noteworthy for its use of brilliant colors. Inspirations have come from sources such as mosaic patterns, but also from direct observation of nature. Johnson dyes all of her own materials.

"This set was inspired by many sources, including Ed Mell's landscape paintings, a 1930s pictorial weaving of Shiprock featured in an advertisement in *Southwest Art* magazine, and the unique landscapes of the Southwest. A local Navajo artist, Damian Jim, used computer software and replicated the weaving design five times on a basket. From that initial design grew the next two baskets, inspired by Delicate Arch and Monument Valley, and my fondness for sets. Together the set represents the Navajo Nation and the three states in which the Nation is based."

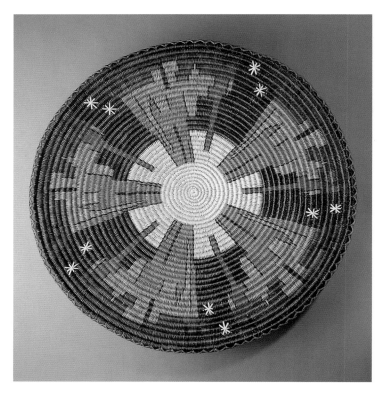

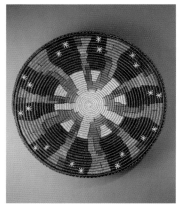

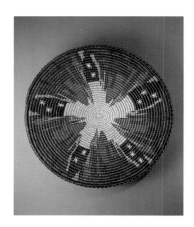

Set of Trays: Shiprock, New Mexico; Delicate Arch, Utah; Monument Valley, Arizona, 2001
Natural and dyed sumac
Largest diameter: 23 (58.4)
Collection the Mooney Family

Margaret Wood

Born 1950, Parker, Arizona; lives Phoenix, Arizona

Margaret Wood studied at Arizona State University in Tempe, Arizona, and received her bachelor of arts degree in 1971. Her graduate degree in library science was awarded by the University of Denver in Colorado. She has studied with sculptor James Schoppert and quilt artist Nancy Crow. Wood began exhibiting her quilts in 1984 and has participated in nearly fifty one-person and group exhibitions across the United States. Her professional work has included lecturing and leading workshops. In 1981, Wood founded Native American Fashions, Inc., as a studio for the design and production of quilts and wearables inspired by Native American clothing and arts.

"My work in quilts and clothing is based on centuries of American Indian art and fiber traditions. I embrace new materials and decorative ideas but also consider my work to be a continuation and evolution of our traditions. This series is based on the many colors of Indian corn, an important diet staple for many tribal groups in the Americas. To indicate the importance of corn to the Indian people, I made the ears human scale, almost six feet tall."

Corn Quilts: Blue, Yellow, Rust, Red, 2001
Cotton
80 x 36 (203.2 x 91.4)
Collection of the artist

Jody Naranjo

Born 1969, Santa Clara, New Mexico; lives Albuquerque, New Mexico
Jody Naranjo is the descendant of a long line of potters from Santa Clara, most notably her grandmother Rose Naranjo, her mother Dolly Naranjo, and artist aunts Jody Folwell and Nora Naranjo-Morse. She began working with clay as a young teenager, and by age fifteen was already selling her work in Santa Fe. While working with traditional materials, her forms and sgraffito designs break with tradition. Motifs and patterns are drawn from historical petroglyphs of animals and human figures, arranged like wallpaper over the surfaces of her pots, and delicately carved using an Exacto knife.

Jar, 2000
Earthenware
10½ x 10 (26.7 x 25.4)
Collection JoAnn and Bob Balzer

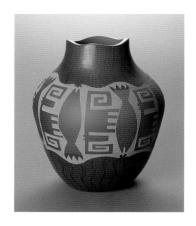

Vase, 2001
Earthenware
10 x 9 (25 x 22.5)
Collection Natalie Fitz-Gerald

"I am fortunate to come from a long line of potters, but I also add my own input through unusual designs, forms, and techniques. I want to do something different. I try not to use the same idea twice, particularly on my pots that tell a story."

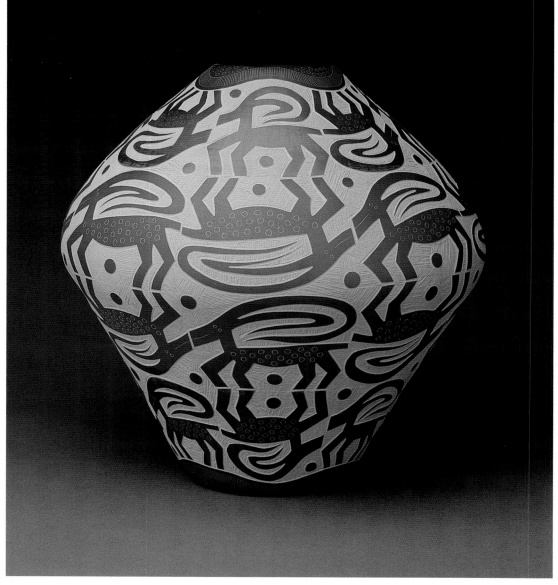

Diego Romero ⅄

Born 1964, Berkeley, California; lives Española, New Mexico

Diego Romero's father was a traditional painter from Cochiti Pueblo. The young artist attended the Institute of American Indian Arts in Santa Fe, New Mexico, where he first began making ceramics. Further study at the Otis/Parsons School of Design in Los Angeles and at UCLA concluded with his receipt of a master of fine arts degree. Diego is among a new generation of ceramists who tackle issues of politics, ethnicity, and multiculturalism in a particularly direct manner. Romero's highly graphic style mixes motifs from ancient pottery with provocative commentary and satirical humor.

"What makes a hero into a hero is a question addressed by this pot. Ira Hayes was from the Pima Reservation in Arizona and served in the Pacific with the U.S. Marine Corps during World War II. Hayes was among the soldiers captured in the legendary photograph of the raising of the flag over Iwo Jima on February 23, 1945. Hayes was an instant hero as the "Indian who raised the flag," even though he considered his role in the event to be minor. Severe depression, isolation, and alcoholism followed, resulting in his death at age thirty-three in 1954."

Iwo Jima Pot from the Never ⅄ Forget series, 2001
Polychromed earthenware
21½ x 11 (54.6 x 27.9)
Collection Peabody Essex Museum; purchased with funds provided by Margie and James Krebs

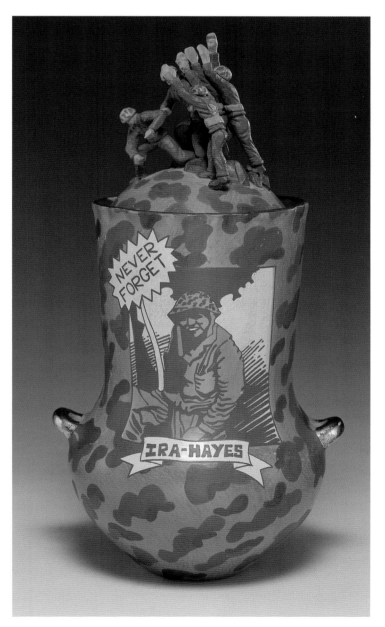

Time Machine Vase from the American Highway series, 1994
Polychromed earthenware
14½ x 14¼ (36.8 x 36.2)
Collection Robert Denison

"This work deals with the concepts of time and the automobile, viewed against the eternal landscape. The Chongo brothers depicted on the pot were inspired by figures from ancient Mimbres pots. They are transported into the modern world on this pot, observers and participants in the process of change. They are constant and inconstant at the same time, just like the landscape."

Nathan Begaye
Snow Cloud Jar, 1998
Polychromed earthenware
13¼ x 9 (33.7 x 22.9)
Peabody Essex Museum;
purchased with matching funds
provided by Margie and James
Krebs, 2001

"This vessel evokes the storm
patterns in the wintertime that
were such an important part of life
in Santa Fe. When I work I love to
be by a window so I can look out
at the landscape. I most often
work spontaneously, without a
preconceived plan. My art grows
out of me like a cloud forming
over the ocean."

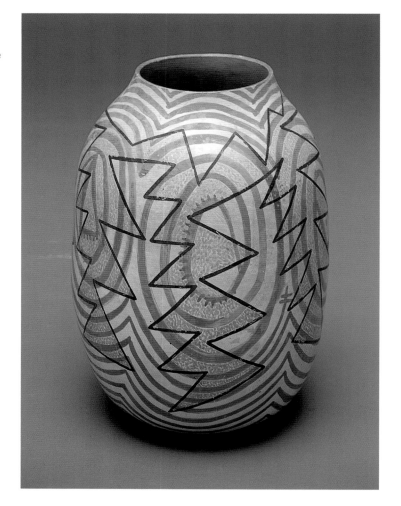

Jennifer Tafoya Moquino

Born 1977, Española, New Mexico; lives Española, New Mexico

Jennifer Tafoya Moquino learned to work with clay from her father, Ray Tafoya, and began exhibiting her works at the Santa Fe Indian Market in 1992. Since that time, she has received numerous awards for her unusual vessels and figures, which are often decorated with a surprisingly rich palette of unfired slip colors made from local clays.

"I have always loved fish and fishing, something I learned to enjoy from my dad, an avid fisherman. I used to go with him fishing for trout pretty much whenever we got a chance. I was always into the wildlife that surrounded us in the great outdoors. What I put on my pottery is simply a reflection of the beauty that I see and appreciate."

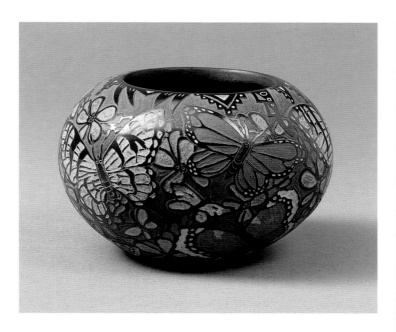

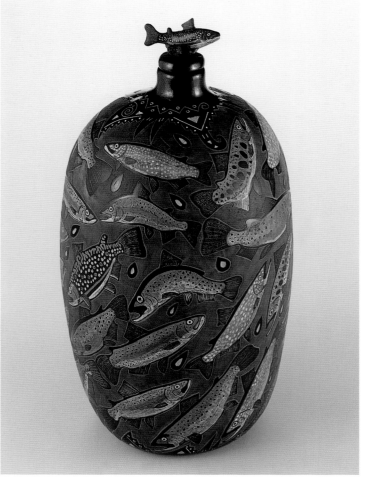

Butterflies Vase, 2000
Earthenware, raw-colored clay slips
2¼ x 3 (5.7 x 7.6)
Collection Lowell and Penny Dreyfus

"My personal interest in wildlife has come from the observation of nature and from the study of books on animals, fish, and insects. The colors of nature appeal to me. Every work I make is unique. Change is very important to me, but I always listen to what the clay tells me it wants to do. My vessels and decorations grow just like nature itself."

Fish Pot, 2001
Earthenware, raw-colored clay slips
9⅝ x 5 (24.4 x 12.7)
Collection Virginia V. Mattern

Yazzie Johnson and Gail Bird
Pearl Necklace, late 1990s
Freshwater pearls, 18k gold, coral,
Mexican lacy agate
Length: 33⅞ (86)
Collection Valerie T. Diker

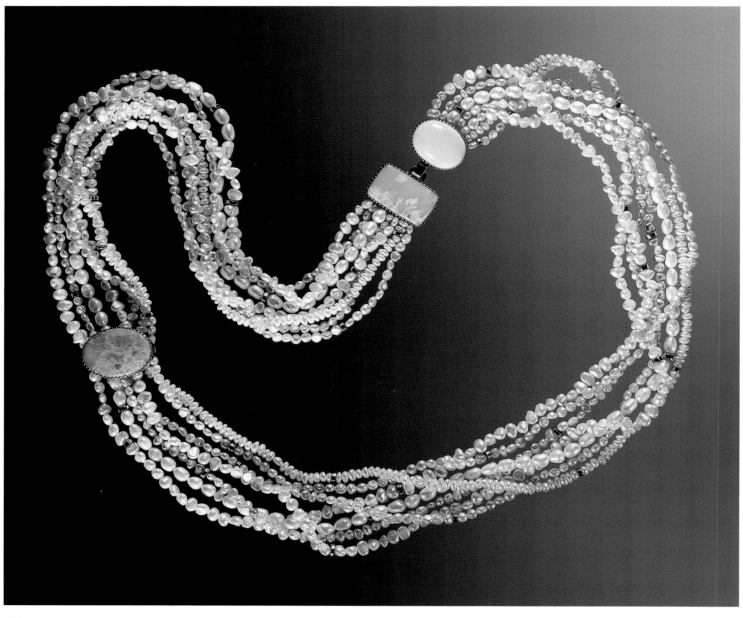

Yazzie Johnson and Gail Bird
Butterfly Brooch, 2001
18k gold, opal matrix
2½ x 3¼ (6.4 x 8.3)
Collection Marcia Docter

Dextra Quotskuyva
Jar with Butterflies, 2001
Polychromed earthenware
11 x 11 (27.5 x 27.5)
Collection Jim and Jeanne
Manning

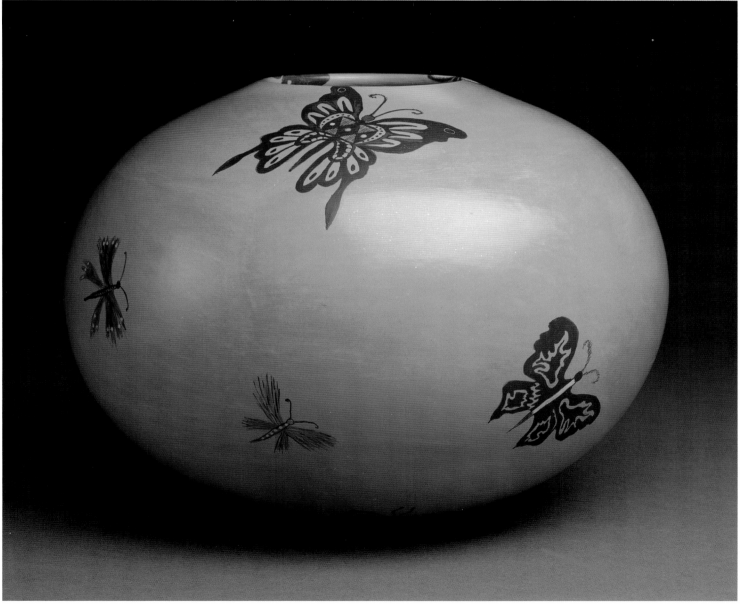

Nathan Youngblood
Vase, 1998
Polychromed earthenware
Height: 14½ (36.2)
Collection Becky and Ralph Rader

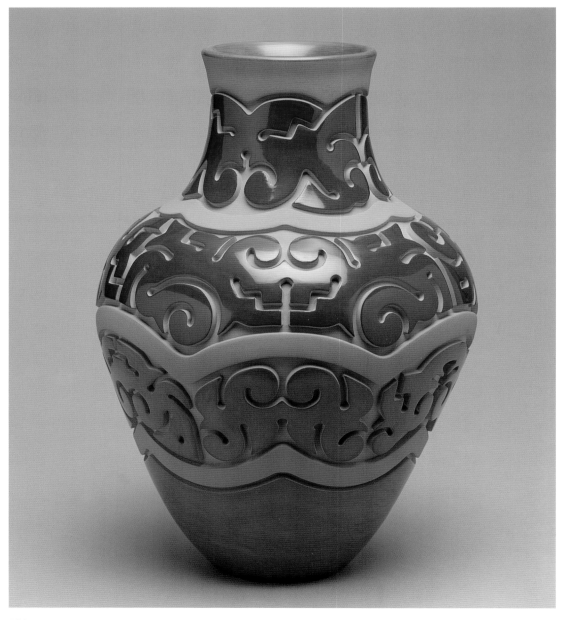

"This is my first success at a large oxidized jar with over 50 percent of its surface fully carved. There is an Oriental influence in both the shape and the design of this piece. This may be a subconscious by-product of my home study and appreciation of Chinese and Japanese ceramics."

Shawn Tafoya

Born 1968, Santa Clara, New Mexico; lives Santa Clara, New Mexico

A member of the Tafoya family of potters, Shawn Tafoya attended the Institute of American Indian Arts in Santa Fe, New Mexico, after completing his high-school education. He has always been interested in the intersection of traditional materials and techniques with contemporary aesthetics, and he draws inspiration from nature, tribal motifs, and American popular culture. He has received numerous awards, and his work has been acquired by many museums. A dedicated teacher, he has taught embroidery and ceramics at the Poeh Cultural Center in Pojoaque, New Mexico, for a number of years.

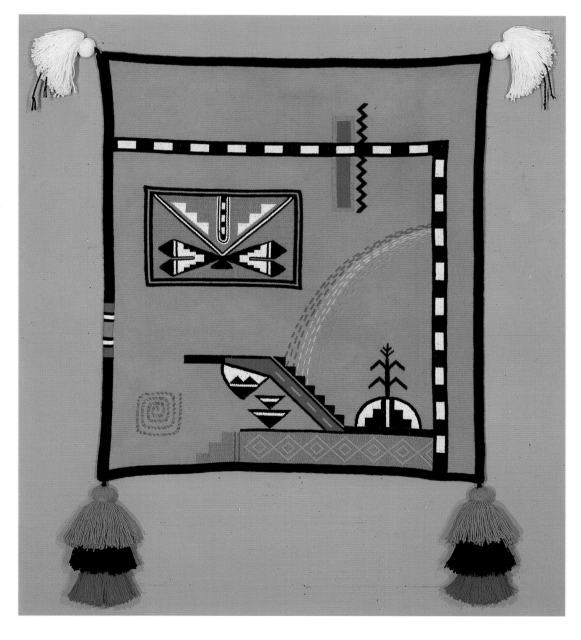

Symbols of Summer, 2001
Monk's cloth, cotton, wool, acrylic yarns
24 x 20 (60 x 50)
Collection Dr. and Mrs. E. Daniel Albrecht

Darrell Jumbo

Born 1960, Crystal, New Mexico; lives Fort Defiance, Arizona
Darrell Jumbo learned silversmithing from his uncle, the renowned jeweler Norbert Peshlakai, beginning his studies in 1991. A quick learner, Jumbo rapidly mastered techniques of stamping, engraving, and soldering, using sheet silver in innovative and unexpected ways. By 1994, Jumbo's animal figures had begun to receive critical acclaim for their imaginative whimsy and humorous reflection of the satire and irony of the human condition.

Imagine Brooch, 2001
Silver, shell, opal
2¾ x 3 (7 x 7.6)
Courtesy of the artist

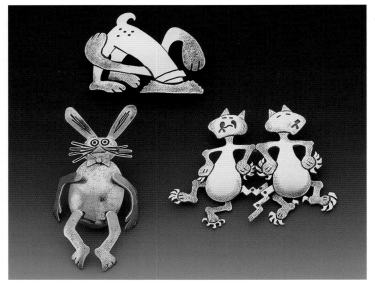

Dog Digging a Bone Brooch, 1999
Sterling silver
1⅝ x 2¼ (4.1 x 5.7)
Private collection

"John Lennon's music was very important to me as a young man. I think he taught us so much about the meaning and value of life, something we learn during difficult time and devastation. The reservation is a ghetto with many problems. Lennon helped me look at the problems with more sympathy and compassion, and taught me the value of getting along with others."

Articulated Rabbit Brooch, 1998
Sterling silver, gold, copper
3 x 1¼ (7.6 x 3.2)
Private collection

"I make deliveries of medical supplies for a living. When I do, I see a lot of pain and frustration among my patients. My way of dealing with the pain is through humor and whimsy. In a way, I hide my own pain through my work."

On Broadway Brooch, 2001
Sterling silver
2¼ x 2½ (5.7 x 6.4)
Courtesy of the artist

"When I heard about the Broadway musical *Cats*, this pin was the result. My animals take on human characteristics. I believe that animals were put on this earth by the Creator for us to admire. My pieces don't make fun of the animals, but of our own human natures through them."

Get Off My Lily Pad Brooch, 2000
Sterling silver, peridot, 14k gold
2¼ x 1½ (5.7 x 3.8)
Collection Martha Hopkins
Struever

"This piece expresses the
distinctive character of someone
who feels they are the big fish in a
small pond. Rather than 'get off
my cloud,' this guy says 'get off
my lily pad.'"

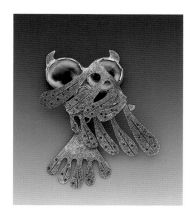

So Shy Brooch, 2001
Sterling silver, coral, sea snail
opercula
2¾ x 3 (7 x 7.6)
Courtesy of the artist

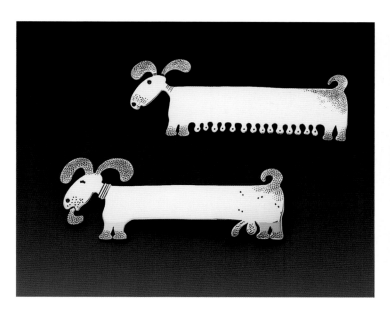

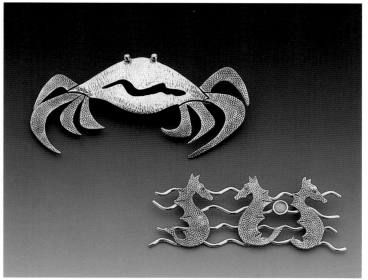

Mrs. Dog Brooch, 2000
Sterling silver
1⅛ x 3 (2.9 x 7.6)
Private collection

Mr. Dog Brooch, 2000
Sterling silver
1⅛ x 3 (2.9 x 7.6)
Private collection

Crab Brooch, 1999
Sterling silver, gold
1½ x 3⅛ (3.8 x 7.9)
Private collection

Neptune's Horses Brooch, 2001
Sterling silver, opals
1 x 2½ (2.5 x 6.4)
Courtesy of the artist

"I have been wanting to go fishing
for years but have been too busy.
I guess this brooch was my way
of compensating."

Ernest Benally

Born 1959, Gallup, New Mexico; lives Gallup, New Mexico

Ernest Benally's introduction to jewelry design came with high-school summer jobs at Ortega's and Sunburst Jewelry, two jewelry firms in Gallup, New Mexico. He began by buffing and polishing finished jewelry and gradually learned more about other techniques of construction, such as soldering, casting, lapidary work, and inlay. Benally specialized in inlay for seven years before branching out on his own with a full range of jewelry designs, many of which reveal his talents in the difficult inlay technique. Benally's work was first shown at the Gallup Intertribal Ceremonials in 1984. In 1999, he began showing at the Santa Fe Indian Market.

"My interest in contemporary jewelry design goes back to my childhood experiences working in a jewelry studio. Since that time faithful attention to construction and finishing has remained important to my aesthetic. I have always been fascinated by the potential of stones, and I like to design settings that can highlight good lapidary work. Learning techniques from the ground up as a young person has continued to influence my approach to design today. Technical skill gives an artist a self-confidence that allows new and innovative ideas to grow."

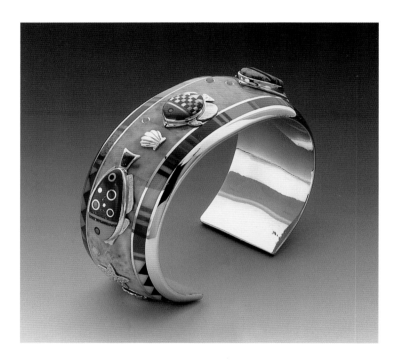

Bracelet, 2001
Gold, larimar (pectolite), lapis lazuli, sugulite, shell, coral, obsidian, opal
Width: 2½ (6.5)
Collection Dr. Elizabeth A. Sackler

Kee Yazzie, Jr.
Bracelet, 2001
Sterling silver, 14k gold
Width: 2½ (6.4)
Collection American Craft
Museum; gift of the artist, 2001

Norbert Peshlakai
The Goat Family, 2001
Sterling silver, coral
2⅜ x 3⅛ (6 x 7.9)
Collection Martha Hopkins
Struever

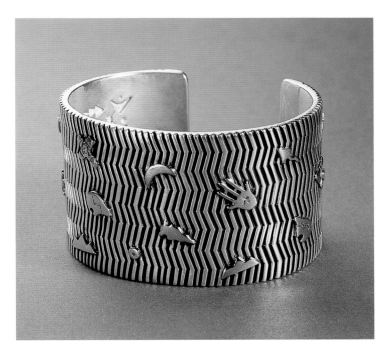

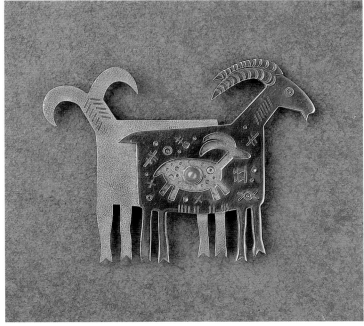

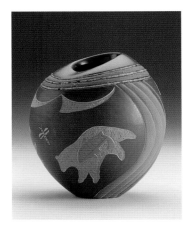

Russell Sanchez
Untitled Vessel, 2001
Polychromed earthenware, shell
heishi
4 x 3½ (10.2 x 8.9)
Collection Robert Chomat

"I am an outdoor guy and do a lot
of kayaking, mountain climbing,
and hiking. I need to be outside to
get my inspiration. My asymmetri-
cal pots are inspired by what I see
around me—the way a river flows,
the face of a cliff."

Ken Romero

Born 1956, Albuquerque, New Mexico; lives Albuquerque, New Mexico
Ken Romero received an associate degree in fine arts from the Institute of American Indian Arts in Santa Fe, New Mexico, and a bachelor of fine arts degree from the California College of Arts and Crafts in Oakland, California. A member of Taos and Laguna pueblos, Romero has devoted the past seventeen years exclusively to jewelry design and has become known for his distinctive and elaborate lapidary work, which he has named "Pueblo Village Design Inlay." His earlier studies as a painter have deeply influenced the artist's approach to color, shape, and pattern, and each work is individually titled to reflect the subject matter that inspired it.

"The design of this belt is an homage to Taos Pueblo. On the buckle, the green serpentine represents Wheeler Peak Mountain watershed, in which the sacred Blue Lake of Taos is located. The small turquoise inlaid sideways represents the river that flows from Blue Lake down to the Pueblo. The intricate coral inlay on the individual conchos symbolizes Taos Pueblo and the people. Larger pieces of coral represent the red earth, and a single turquoise on each represents Father Sky, with silver slivers for prosperity. Only one concho does not have any silver highlights: this represents and honors the old way, olden days, hard times, good times, and our family and ancestors from the pueblo."

Belt, 1998
Sterling silver, coral, turquoise, serpentine, mounted on leather
Length: 34 (85)
Collection Thomas and Nancy Martin

far right:
Belt (detail)

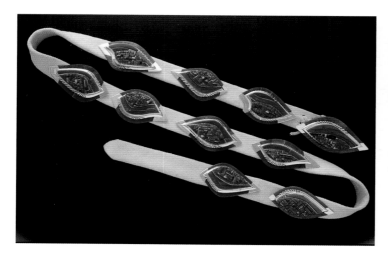

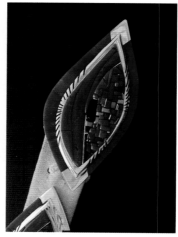

Winter's First Snow at Taos Bracelet, 1999
Sterling silver, fossilized walrus ivory, Sleeping Beauty turquoise, coral
Width: 3½ (8.9)
Collection of the artist

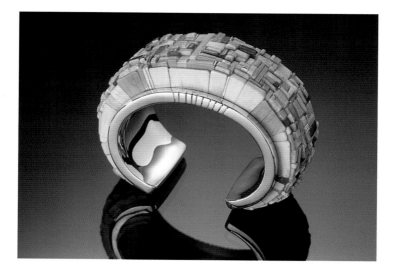

"This bracelet took one year to create because of the number of stones—589—needed to produce the design. I made this work as a visual translation of my memories of Taos Pueblo in the snow—the white of the freshly fallen snow combined with the soft brown of the adobe buildings. This image of Taos Pueblo stayed in my mind as I worked to capture the atmosphere and color of this special place."

D. Y Begay
Tselani Weaving, 2000
Wool, aniline dye
18 x 38 (45.7 x 96.5)
Collection Robert Cowie

"I enjoy looking at the landscape near my home in Tselani. I love the variegated colors of the plateaus and the subtle hues of the dirt and sand. The shades in this rug depict the colors of the numerous mesas that are visible from our hogan."

Larry Golsh
Morning Star Brooch, 2001
Carnelian, 18k gold
1½ x 1½ (3.8 x 3.8)
Collection of the artist

"This brooch has a special meaning for me. It was inspired by a vista at Mount Palomar, north of San Diego, where one of the largest telescopes in the world is installed. The sky in the area at night is dark and the stars brilliant, unless there is a mist or fog rolling in from the ocean. This carved carnelian gem evokes the luminescent morning star viewed through the mist."

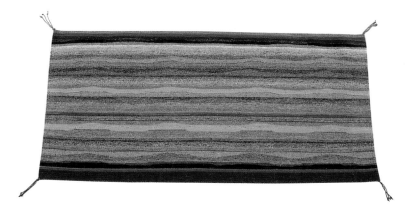

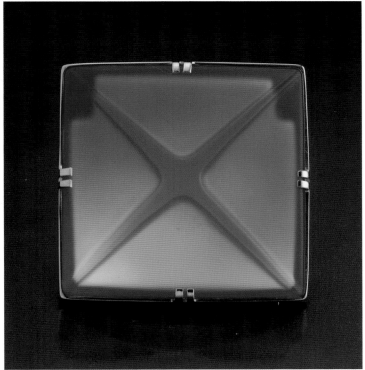

Lance and Wilfred Cheama

Born Zuni, New Mexico; live Zuni, New Mexico

The Cheama brothers have been at the cutting edge of non-traditional Zuni fetish carving and have moved towards a greater realism in their works. The family includes eldest brother Dan Quam, who began carving in 1982, and brothers Wilfred and Lance. Dan Quam's wife, Karen Zunie, works collaboratively with him on their sculptures. The brothers use books on animals as their reference, both for inspiration and for details. As a result, their animals are often of exotic, as well as regional, origins.

Dan Quam

Born 1952, Zuni, New Mexico; lives Zuni, New Mexico

Dan Quam is self-taught as a carver. His fame rests on his photo-realistic approach to his sculpture. He has favored animals indigenous to the Pueblo lands as subjects.

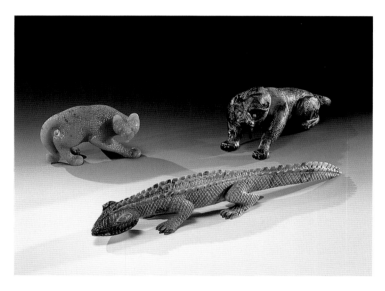

Right:
Dan Quam
Sabertooth Tiger, 1999
Picasso marble, turquoise
Length: 3⅜ (8.6)
Collection Rosie and Peter Wakefield

Left:
Wilfred Cheama
Mountain Lion, 1999
Serpentine, turquoise
Length: 2⅝ (6.7)
Collection Susan H. Totty

Center:
Lance Cheama
Alligator, 2000
Picasso marble
Length: 6¼ (15.9)
Courtesy Blue Sage Gallery

Derrick Kaamasee

Born 1972, Zuni, New Mexico; lives Zuni, New Mexico

Derrick Kaamasee began carving in 1989 simply as a means of earning a living. His work was encouraged by his cousins Pernell Laate and Lance Cheama, who recognized his talent. Kaamasee works in a wide variety of materials and draws inspiration from the world of nature in all its diversity.

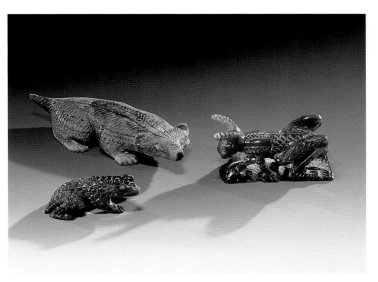

Derrick Kaamasse
Monkey with Bananas, 1999
Fossilized ivory
Height: 1⅜ (3.5)
Collection Mavis Shure and Lanny Hecker

Lance Cheama
Top left:
Badger, 2001
Serpentine, turquoise
Length: 1¼ (3.2)
Courtesy Blue Sage Gallery

Bottom left:
Frog, 2000
Serpentine
Length: 1¼ (3.2)
Courtesy Blue Sage Gallery

Right:
Derrick Kaamasse
Grasshopper, 2000
Serpentine, turquoise
Length: 1⅞ (4.8)
Collection Mr. and Mrs. William Stuber

Gibbs Othole

Born 1960, Zuni, New Mexico; lives Zuni, New Mexico

Lena Boone

Born 1946, Zuni, New Mexico; lives Zuni, New Mexico
Granddaughter of carver Teddy Weahkee and daughter of Edna Leki, Lena Boone did not take up carving until later in her life. After living in Ohio, where she worked as a bookkeeper, she returned to the Pueblo in the late 1960s. Around 1971, she took up carving while staying at home to care for her children. Her fame rests on her use of exotic materials for her carvings.

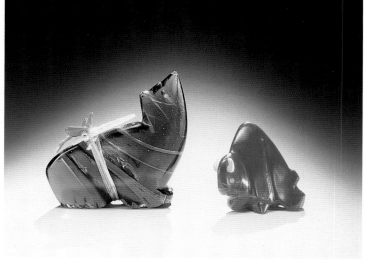

Rabbit with Carrot, 2001
Amber, coral, malachite, sinew
Length: 3¼ (8.4)
Courtesy Blue Sage Gallery

Left:
Lena Boone
Bear, late 1990s
Gold slag
Height: 2½ (6.3)
Collection Dr. Stephen
Schreibman and Judy Schreibman

Right:
Gibbs Othole
Buffalo, 2000
Gold slag, turquoise, shell
Height: 1¾ (4.5)
Collection Susan H. Totty

Michael Coble

Born Los Angeles, California; lives Zuni, New Mexico
Michael Coble's work is noteworthy for its intricacy and fine detail, and most often depicts the ordinary animals or insects that live at the Pueblo.

Max Laate

Born 1963, Zuni, New Mexico; lives Zuni, New Mexico

Florentino Martinez

Born 1973, Gallup, New Mexico; lives Zuni, New Mexico
As a young man, Florentino Martinez was trained to become a jeweler by his mother, Regina Laate, but he was inspired by the work being done by his carver uncles Pernell and Max Laate. In 1992 he began carving traditional fetishes with his wife, Harrietta Byers. He also creates non-traditional subjects and intimate studies of nature.

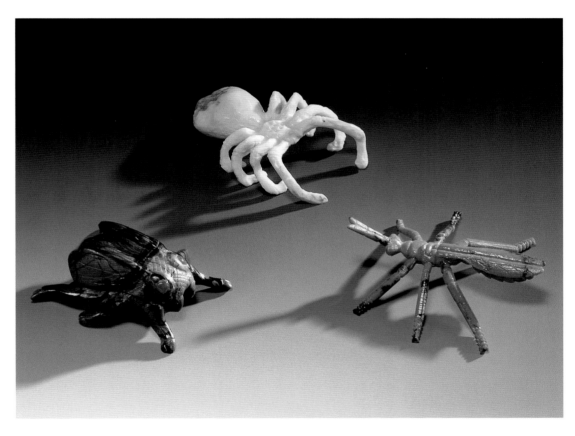

Right:
Florentino Martinez
Wasp, 2000
Turquoise
Length: 1⅝ (4.1 cm)
Collection Mavis Shure and Lanny Hecker

Left:
Michael Coble
Fly, 1999
Picasso marble, coral
Length: 1¼ (3.2)
Collection Mr. and Mrs. William Stuber

Top:
Max Laate
Black Widow Spider, 2001
Fossilized ivory
Length: 1⅝ (4.2)
Courtesy Blue Sage Gallery

Lewis Malie

Born Black Rock, New Mexico; lives Black Rock, New Mexico

Lewis Malie is the nephew of Max and Pernell Laate, from whom he learned to carve. Malie's preferred material is antler, and his subject matter is drawn from a wide variety of sources, both local and international.

Ricky Laahty

Born 1962, Zuni, New Mexico; lives Zuni, New Mexico

Ricky Laahty has specialized solely in the carving of frogs. The artist works with a wide variety of stones, shells, and minerals, using eyes cut from contrasting material to create astonishing and whimsical figures.

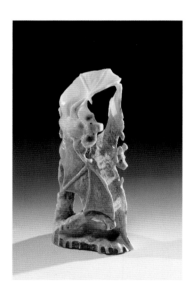

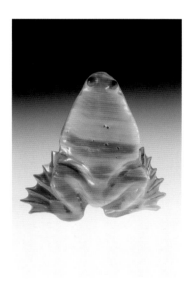

Bats in Flight, 2000
Elk antler
Height: 2⅞ (7.4)
Collection Rosie and Peter
Wakefield

Frog, 2000
Spondylus shell, amber
Length: 1⅝ (4.2)
Collection Susan H. Totty

Pernell Laate

Born 1965, Zuni, New Mexico; lives Zuni, New Mexico

Pernell Laate's career began as a katsina carver, but by 1987 he had turned exclusively to fetish carving. Although he often carves traditional animals indigenous to his region, he also specializes in human figures, including dancers and cowboys.

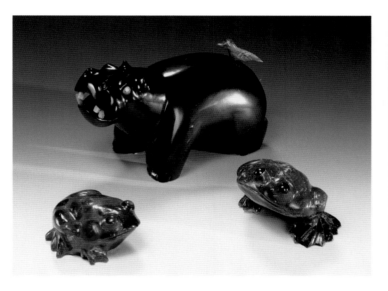

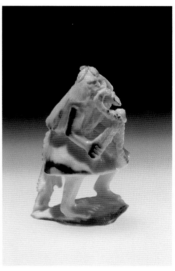

Pernell Laate
Snake Dancer, 2001
Fossilized ivory
Height: 1⅝ (4.2)
Courtesy Blue Sage Gallery

Left:
Ricky Laahty
Frog, 2000
Leopard-skin jasper, shell
Length: 1½ (3.9)
Courtesy Blue Sage Gallery

Top:
Gibbs Othole
Hippopotamus, 2000
Black marble, serpentine,
turquoise, yellow mussel shell
Length: 3⅜ (8.7)
Collection Susan H. Totty

Right:
Ricky Laahty
Frog, 1997
Teal serpentine, black jade
Length: 1⅞ (5)
Collection Mr. and Mrs. William
Stuber

Andres Quandelacy

Born Zuni, New Mexico; lives Zuni, New Mexico

Andres Quandelacy began selling his work while still a teenager. His subject matter is often traditional—animals appear frequently in his work—but they have a stylized and abstract quality that marks them as contemporary.

Esteban Najera

Born 1976, Gallup, New Mexico; lives Zuni, New Mexico

Esteban Najera originally trained as a jeweler but began carving in 1990, after being inspired by observing the work of his uncles Pernell and Max Laate. He was drawn to unusual subject matter; interests in anatomy and mythology have resulted in carvings of skeletons, griffins, and dragons.

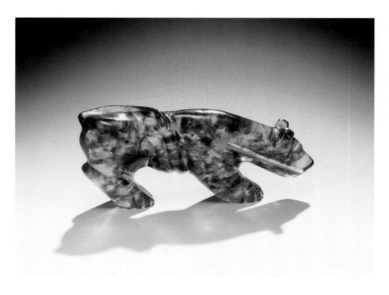

Mountain Lion, 2000
Amber, turquoise
Length: 2¾ (6)
Collection Dr. Steven Schreibman
and Judy Schreibman

Left:
Skeleton with Cross, 1996
Fossilized ivory, turquoise
Height: 1⅞ (5)
Collection Mavis Shure and Lanny Hecker

Right:
Griffin, 1999
Fossilized ivory
Height: 1¾ (4.5)
Collection Rosie and Peter Wakefield

"I love to be challenged by collectors to carve unusual subjects that involve a lot of detail."

Karen Zunie

Born Zuni, New Mexico; lives Zuni, New Mexico
Karen Zunie learned carving by observing her ex-husband Lance Cheama (p. 136). She is among a small number of female carvers working in a photo-realistic style.

Top left:
Michael Coble
Frog with Grasshopper, 1999
Picasso marble, coral
Length: 2¾ (7)
Collection Mr. and Mrs. William Stuber

Top right:
Karen Zunie
Beaver, 2001
Turquoise
Length: 1⅝ (4.2)
Courtesy Blue Sage Gallery

Bottom:
Dan Quam
Badger, 2000
Picasso marble, turquoise
Length: 2⅜ (6.2)
Courtesy Blue Sage Gallery

Florence Riggs

Born 1962, Beryl, Utah; lives Tuba City, Arizona

Florence Riggs was born into a distinguished Navajo weaving family that included her famous grandmother, Laura A. Nez. Riggs began weaving from childhood, learning from her mother, Louise Y. Nez. It was her mother and grandmother who inspired her and who encouraged her to weave larger-scale works. She turned to full-time weaving in 1990. Her works are notable for their fantasy and whimsy.

Dinosaur Rug, 2001
Wool, aniline and vegetal dyes
37 x 43¼ (93.9 x 109.9)
Private collection

"Weaving is hard work—hours of sitting, pounding by hand—and backaches are common. Sometimes I feel as if my brain is drained thinking about the design. I like to think that my weavings are a way of offering tribute to my mother and grandmother, and that makes it all worthwhile."

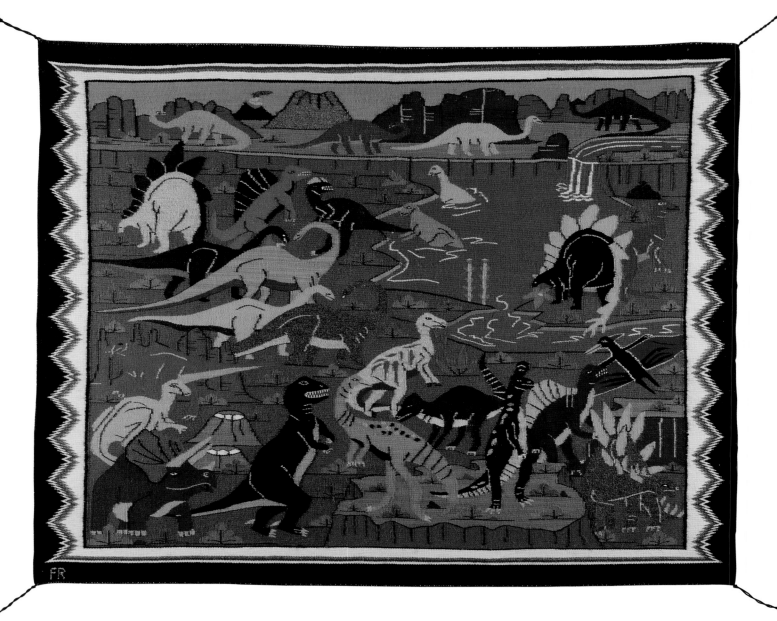

Jody Folwell

Born 1942, Santa Clara, New Mexico; lives Española, New Mexico
Taught by her mother, the distinguished ceramist Rose Naranjo, and a member of a multi-generational family of artists, writers, and scholars, Jody Folwell received her bachelor of arts degree in history and her master's degree in political science. In 1975, she was awarded first prize in ceramics for the Most Creative Design in any classification at the Santa Fe Indian Market, a harbinger of the trajectory to be taken by the artist. While fabricated with traditional materials and techniques, her carved, burnished, incised, painted, and stamped vessels challenge the stereotype of Indian pottery. Motifs and themes depicted on Folwell's pots range from contemporary politics and issues to the explorations of the truths and non-truths of history.

"I became interested in the Buffalo Soldiers of the nineteenth century through my readings in history. It seemed ironic to me that this chapter of our history was almost entirely overlooked. The Buffalo Soldiers were African-American soldiers who defended the nation's border with Mexico. Many of these soldiers were former slaves or children of slaves. This name was given to them by Native Americans because their hair reminded Indians of the rich brown manes of the sacred buffaloes that used to roam freely. It is a fascinating and yet sad piece of history that I wanted to commemorate in this vessel."

Buffalo Soldiers Vase, 1998
Polychromed earthenware
15½ x 15½ (39.4 x 39.4)
Collection Judge Jean S. Cooper

Wilmer Kaye

Born 1952, Tuba City, Arizona; lives Hopi, Arizona

Wilmer Kaye attended Phoenix Indian High School and then went on
to a vocational school in Albuquerque, New Mexico, to study business
administration. Surrounded most of his life by carvers of katsina dolls and
other Hopi ceremonial paraphernalia, he learned to carve by observation
and practice. Around 1986, Kaye decided to become a full-time carver. He
has created a distinctive personal style, and often incorporates personal
stories in his works, which are carved from found pieces of wood.

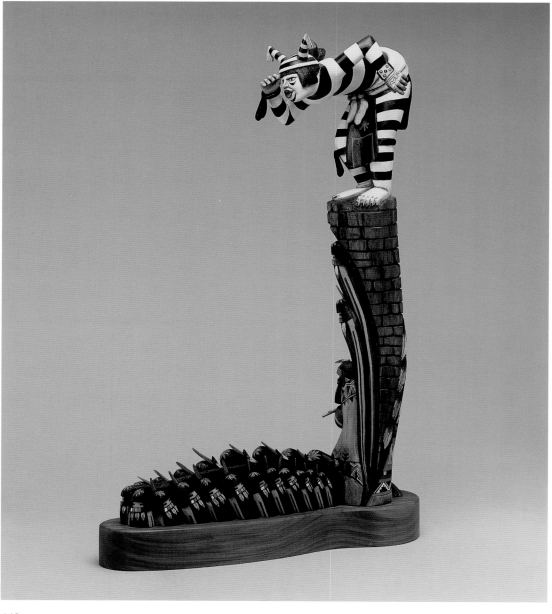

Sculpture, 1997
Cottonwood root, acrylic paints
22 x 15 (55.9 x 38.1)
Collection Becky and Ralph Rader

Jared Chavez

Born 1982, Santa Fe, New Mexico; lives San Felipe, New Mexico

Jared Chavez is the son of Richard Chavez (pp. 80–81). He began making jewelry alongside his father at the age of ten, and soon developed his own personal style. Chavez uses a series of stamps, some of which he inherited from his grandfather, to create rich textures. Combined with oxidization, these textures give his work a painterly quality. At present, Chavez is a student at Georgetown University, Washington, D.C., where he intends to study graphic design.

Eleanor Yazzie

Born 1963, Keams Canyon, Arizona; lives Piñon, Arizona

Eleanor Yazzie learned to weave by watching her grandmother, a skilled traditional weaver. During these early years, the artist mastered all aspects of weaving, from sheep shearing to washing and dyeing wool, and spinning yarn. In her middle teenage years, her weavings took on a more personal style, reflecting her interests and experiences. In her masterful weaving of landscapes, she uses the medium in the manner of a painter, achieving powerful abstract compositions of brilliant color.

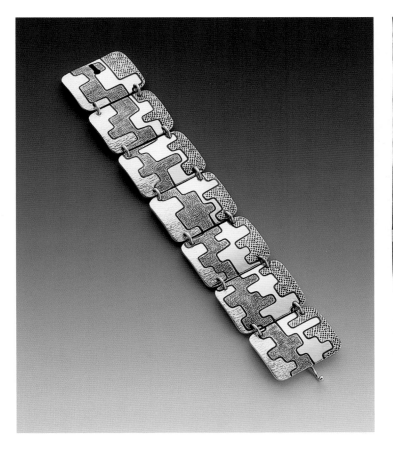

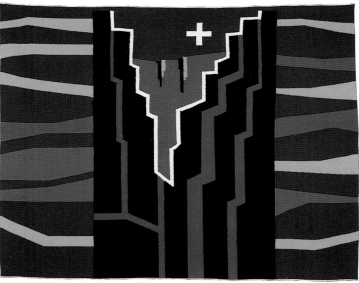

Grand Canyon Weaving, 2001
Wool, aniline dyes
64½ x 53⅛ (163.8 x 135.9)
Collection American Craft Museum; purchased with funds provided by the Acquisitions Committee, 2001

Continuous Design Link Bracelet, 2001
Sterling silver
Length: 7½ (19.1)
Collection Sharon R. Chavez

"I had been doing link bracelets for a while and decided I wanted a change of pace. I was intrigued by the idea of making a bracelet that evoked a complete circle, and this is what emerged."

Autumn Borts

Born 1967, Taos, New Mexico; lives Taos, New Mexico

Autumn Borts grew up in a family of ceramic artists and learned her craft from her mother and grandmother. Borts began exhibiting her work at the Santa Fe Indian Market in 1996 and immediately attracted a following of collectors and curators through her innovative designs, the technical proficiency of her carving and burnishing, and her distinctive color sense. The majority of her designs are based on nature studies of flora or fauna.

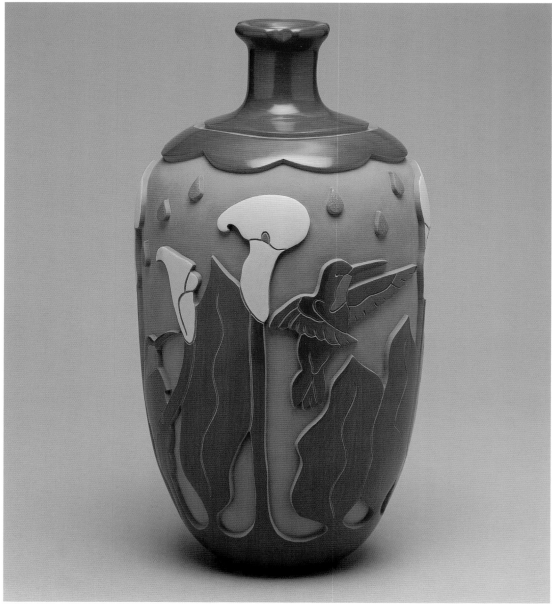

Cala Lily Vase, 1999
Polychromed earthenware
Height: 12½ (31.8)
Collection Becky and Ralph Rader

Richard Zane Smith ⅄

Born 1955, Atlanta, Georgia; lives Glorieta, New Mexico

Born in Atlanta, Georgia, Richard Zane Smith's family moved to St. Louis, Missouri, where he attended high school and junior college and went on to study ceramics at the Kansas City Art Institute from 1975 to 1976. During the same period of time, Smith began investigating his own Wyandot heritage and ancestors, including his great-great-grandfather, who had refused U.S. citizenship in order to stay on the tribal rolls in 1867. In 1978 Smith taught art at a Navajo mission in Arizona and was introduced to native clays, Anasazi potsherds, and specialized techniques of construction that have become a hallmark of his work. The artist combines his Wyandot heritage with an aesthetic identified with the Southwest. Smith has continued to innovate in both forms and patterns over the years and has been a seminal figure in the ceramic renaissance in the Southwest.

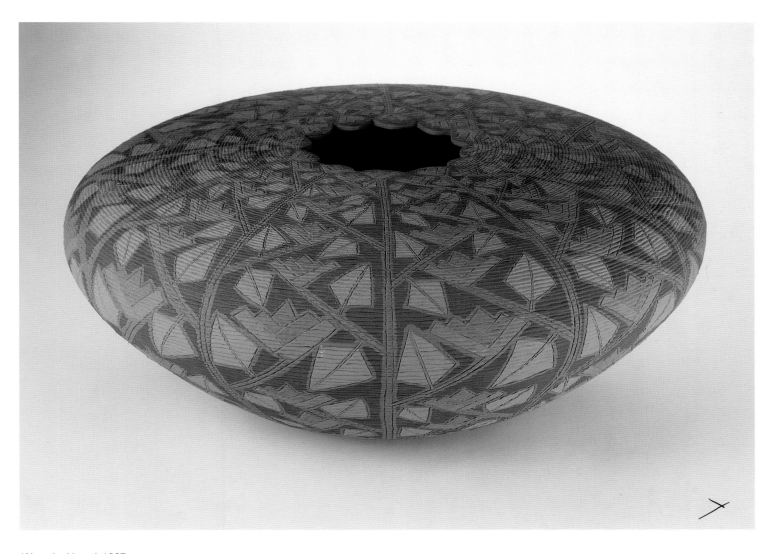

Wyandot Vessel, 1997
Polychromed earthenware
7½ x 16 (19.1 x 40.6)
Collection American Craft
Museum; gift of Judge Jean S.
Cooper

Polly Rose Folwell

Born 1962, Taos, New Mexico; lives Ojo Caliente, New Mexico

Polly Rose Folwell grew up within the rich pottery traditions of her family and made pottery from an early age. After attending high school in Española, New Mexico, she studied cinematography in Santa Fe, New Mexico. Her varied background in the arts and her perennial interest in pottery as a vehicle of artistic expression are reflected in her ceramic designs, which often incorporate personal and political narrative.

"My family did a fashion photo shoot in June of this year for *Cowboys and Indians* magazine. The session took place on my mother's ranch, where she raises Black Angus cattle, at Santa Clara Pueblo. I was thinking about the old days of the West, and the roles played by the characters we know from the movies, and it occurred to me that the characters were metaphors for my mother and my sister, who have taken the 'reins' of their own lives and careers as ceramic artists."

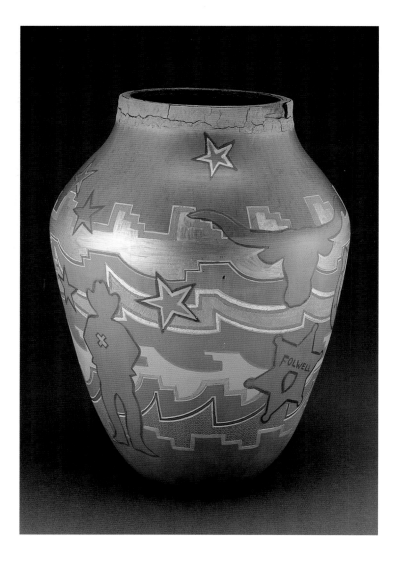

Cowboys, Horses, and Sheriff Folwell Vase, 2001
Polychromed earthenware
11 x 10 (27.9 x 25.4)
Collection Judge Jean S. Cooper

Joe Ben, Jr.

Born 1958, Shiprock, New Mexico; lives Shiprock, New Mexico

Joe Ben, Jr., began taking part in Navajo ceremonies as a child. Many of these ceremonies involved traditional sand painting, an ephemeral art form that embodied deeply held spiritual values. Unlike traditional sand paintings that vanished at the conclusion of the ceremonies, Ben's paintings are mounted and fixed to give them permanence. The naturally colored sands that he uses in his works are found on his travels in the United States and abroad. In addition, he uses finely pulverized mineral colors—turquoise and chrysocolla blue, gypsum white, sulfur yellow, as well as copper and bits of coal. Ben's work has been shown widely in the United States and at the Pompidou Center in Paris.

I Remember How It Used to Be, 2001
Sand, mixed media on wood
30 x 80 (76.2 x 203.2)
Courtesy Shiprock Trading Post

"Through the art of sand painting, I am capable of communicating my feelings and my ideas. I try to use nature's aesthetic work as a part of my life, adding another dimension to my existence. Sometimes one can be mesmerized for a moment by the past, a state in which thoughts, feelings, and emotions seem clear. This is the state of memory that I seek to convey in this work."

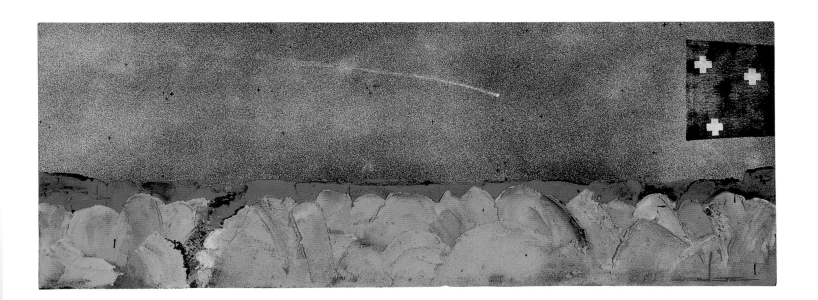

Ray Yazzie

Born 1953, Gallup, New Mexico; lives Gallup, New Mexico

Raised in a family of silversmiths, Ray Yazzie began making jewelry at the age of ten; his first job was helping his older brother, Lee, by cleaning the glue sticks used for mounting turquoise. Several years later, at the age of fourteen, his collaborative work with Lee was awarded Best of Show at the Gallup Intertribal Ceremony. Ray Yazzie acknowledges the influence of his brother in his work. Both artists' work is avidly collected: Ray's works make use of abstract and contemporary inlay patterns that feature carefully graduated passages of color made with various hues of coral or turquoise.

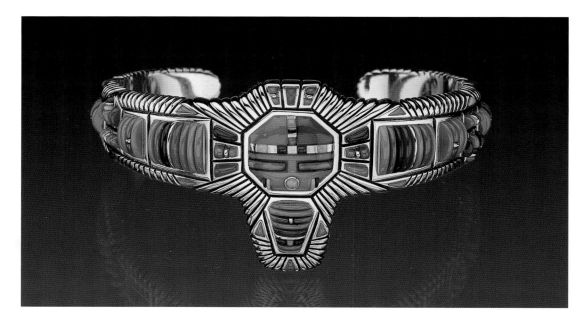

Sun Face Bracelet, 1997
Sterling silver, turquoise, coral, opal, lapis lazuli, sugulite
Width: 2½ (6.4)
From the private collection of
Constance and Malcolm Goodman

"This was a gift for the beginning of a new life, and the preciousness, beauty, and mysteries that surround it. I wanted it to reflect the baby's ancestral history and lineage. His mother is a Cattaraugus Seneca and his father an Akwesasne Mohawk. The six gold longhouses on the handle represent the Six Nations of the Iroquois Confederacy. The figure at the top of the handle reflects the baby's place among his people."

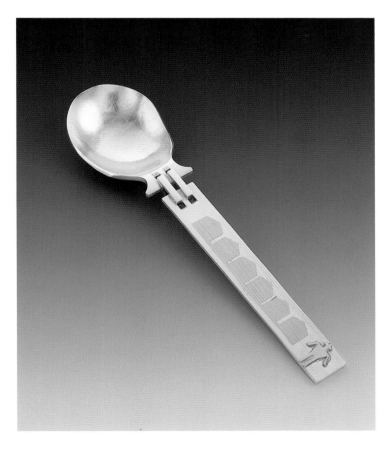

Cheyenne Harris
Ongodagweh's Spoon, 2001
Sterling silver, 14k and 24k gold
Length: 5½ (14)
Collection Leslie Logan

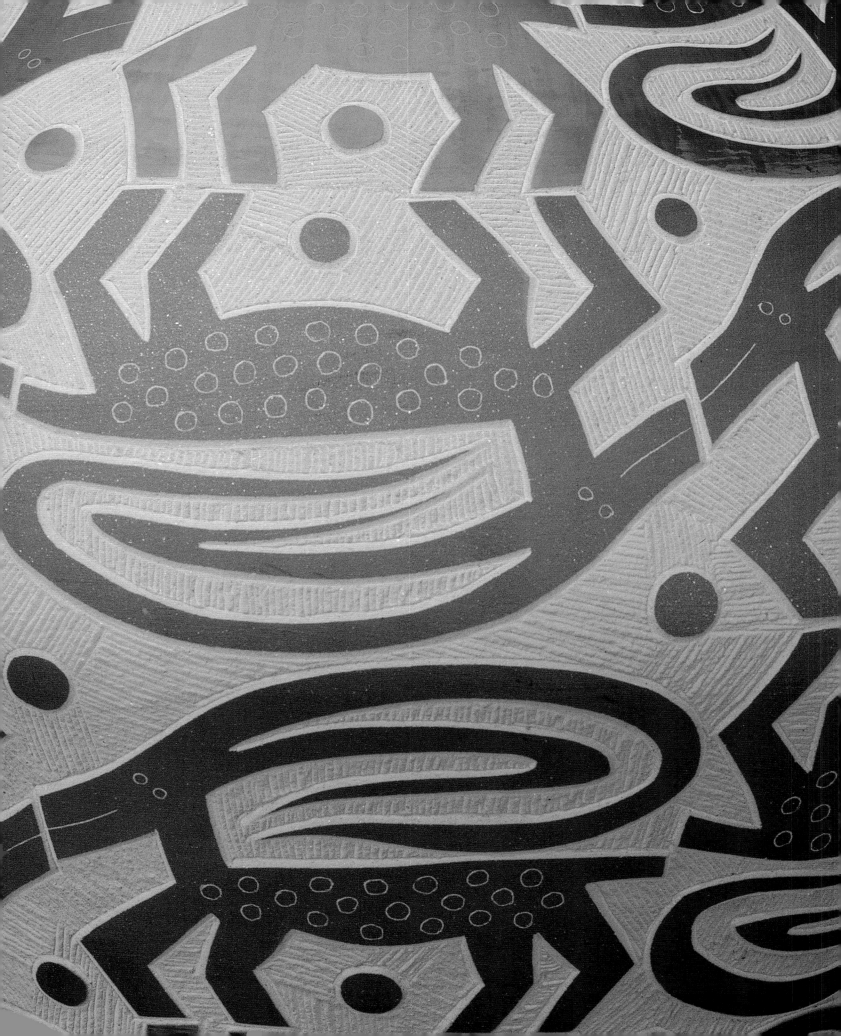

Jody Naranjo
Jar, 2000; see p. 122

Native Art at Auction: The Role of the Commercial Marketplace in Developing Contemporary Native Art

David M. Roche

It is the 1980s, on the corner of Third and Marshall Way in Scottsdale, Arizona. There is an anxious crowd outside Gallery 10. The heavy wood doors of its adobe structure open, and the people file into the courtyard in a near frenzy. Inside, there is an impressive array of artwork, including textiles, ceramics, jewelry, and paintings, all the creations of a rising group of Native superstars. It is not what one typically thinks of as traditional Native art, and yet many of these young artists are surprisingly connected to a tradition that is unique in the contemporary art market.

One of these artists is Jody Folwell. Her pots are hand coiled from clay harvested from ancient and secret family sources, fired in the ground, as were those of her ancestors of thousands of years ago, and done so against the landscape of the Santa Clara Pueblo. But while the method and place remain the same, little else about her work resembles that of the generations of Pueblo women before her. Her pots are asymmetrical, with strong political messages. She has broken from the traditional shapes and design canons of Santa Clara pottery to challenge the viewer to see the world from her individual perspective, as a woman and an artist.

From a mainstream perspective on art, what she is doing is not so unusual, but there is a subtle act of revolution in her work. Jody Folwell and her contemporaries are outside the mainstream. They are not naive or uninformed but have emerged from cultures that are dramatically different from the dominant culture that engulfs them. Tribal cultures emphasize the group, not the individual, and tradition is the mortar that binds the group.

There were pioneering Pueblo women before Jody Folwell who helped to pave the way for this revolution.

At the turn of the twentieth century, Nampeyo of Hano (1860–1942) had stones thrown at her by members of her own tribe because they resented her celebrity. Maria Martinez of San Ildefonso (1887–1980) traveled the world, lived to see her work exhibited in major institutions, and achieved a celebrity status that had previously been reserved for mainstream artists. Still, while both these women were undisputedly fine and inspired artists, the source of their inspiration was literally in the pottery shards of the past.

In the 1980s, Jody Folwell's inspiration, and genius, was taken from the future. Her work did not deny her heritage, but it did not define it either. She was part of a growing number of Native artists who demanded to have their work seen in a mainstream context and to have it subjected to the same critical standards as any working artist.

Lee Cohen, whose enthusiasm and sheer passion for the subject is now legendary, played a critical role in the development of the contemporary Native art market. A Chicago native who moved to Scottsdale and founded Gallery 10 in 1977, he was among the first to apply mainstream marketing techniques to the sale and promotion of art by contemporary Native artists. His vision included taking the artwork out of the traditional trading-post venue and placing it in a pure space—the proverbial "white-wall" gallery. In doing so, the work could be seen unfettered by romantic notions of Native America.

It would be unreasonable to assume that anyone interested in investing in a piece of contemporary Native artwork could ignore the heritage of these artists. Many contemporary collectors attest to the value that personally knowing an artist adds to the ownership experience. And one cannot deny the

intrigue of Native cultures and the lure of the Southwest. Nevertheless, Lee Cohen offered a fresh approach to the material that resulted in a broad new base of collectors and an unprecedented level of visibility for contemporary Native American art.

In truth, the contemporary Native American art scene in the 1980s benefited from a whole matrix of social, economic, and cultural factors. The U.S. economy was booming, and the art world was sexy, glamorous, and notoriously excessive. (In fact, it was not uncommon for Lee Cohen to fly Native artists to shows on his private jet.) Santa Fe style was in style, and people who had never entertained the idea of living with Native American art were decorating in the warm pastel tones associated with the Southwest. It was chic to have a Navajo textile or a Pueblo pot in your home.

Lee Cohen capitalized on these trends brilliantly. He created a huge demand for the works of artists such as Charles Loloma, Nancy Youngblood, Dextra Quotskyva, and Fritz Scholder, and the results were positive for everyone. But an important need began to arise to document the contemporary Southwest Native art movement and to contextualize this new phase in its development independently of the commercial marketplace.

By the 1980s, numerous museum shows dedicated to historic Native material had been organized and seen around the country. Many of these shows had accompanying catalogues that added significantly, and refreshingly, to the scholarship that had already been done in the field, much of which had a decidedly scientific, not artistic, bent. *Sacred Circles*, mounted in 1976, is perhaps the best known of them. Ralph T. Coe, former chief curator of the Nelson-Atkins Museum of Art, wrote in the introduction to

the exhibition catalogue: "The day when American Indian art could be dismissed as unartistic and provincial is over. It is beginning to receive worldwide attention, after centuries of neglect and much prejudice. The artistic evaluation of this art is still in its infancy, but we are just beginning to come to grips with some of its most important aspects."

The inclination to recognize and appreciate historical Native material as significant art had been around since the 1930s. Leaders in the Surrealist movement, such as André Breton and Max Ernst, brought a fresh eye to the material and urged the international art intelligentsia to look at the best-known examples of Native artifacts in natural-history museums and other institutional "curio cabinets" and to see them as art. Indeed, many Surrealists drew enormous inspiration from Native artists, particularly those from the Northwest and Southwest.

Documentation and interpretation of the new and exciting trends of contemporary Native art in the 1980s through literature, museum exhibitions, and the media was, however, spotty at best. The one notable exception was the publication of *American Indian Art Magazine*. In its inaugural issue in the autumn of 1975, the magazine stated that it was embarking on its first issue with the intent to "portray the art forms of the American Indian in a manner and format which will do justice to the art and its creators."

Contemporary artists regularly appeared in the periodical. In the first issue, Charles Loloma was featured, and subsequent issues carried stories on Larry Golsh and Fritz Scholder. Still, there was a serious absence of critical discourse on contemporary Native art.

Many of the publications dealing with the subject effectively looked backwards from an art-historical perspective but left a current interpretation dangling. Furthermore, many of these were produced by members of the trade and consequently lacked the objectivity, or counterbalance, that a scholar, curator, or critic might bring to the field of study. In the absence of attention from these people, the role that the commercial marketplace was playing in developing and raising awareness of contemporary Southwest Native art was vital. The galleries were the most dynamic and consistent stage for the revolution waged by Jody Folwell and her contemporaries, as well as a major catalyst for change.

In addition to the efforts of gallery owners such as Lee Cohen, Martha Cusick, Ray Dewey, and Rick Dillingham, another important component of the commercial marketplace was developing during the 1980s, and that was at auction. Indeed, the momentum created by four landmark sales during the 1970s in many ways set the stage for the leading gallery owners of the 1980s.

While auctions have provided an important marketplace since medieval times, Native American art did not appear on the block until the 1920s. Throughout most of the twentieth century, Native American art had been offered at major auction houses, but sporadically and in very small numbers, and usually mixed up in a sale of primitive art. In 1970, the Birdie Brown Estate, a highly regarded collection of Native American art that included over fourteen hundred Chemehuevi baskets, was sold at auction in Phoenix. It marked the first major increase in price for Native American material at auction.

In 1971, Sotheby's, New York, offered the Green collection of American Indian art. It was a water-shed sale in the American Indian art market. The Green family began to collect as early as 1870, and they had assembled a remarkable collection of American Indian art. The auction established a number of world-record prices and caught the attention of collectors worldwide.

Sotheby's followed the success of the Green sale in 1975 with the C. G. Wallace collection of American Indian art. C. G. Wallace, who lived and worked among the Indians on the Zuni reservation in north-western New Mexico for fifty years, was a passionate collector of American Indian art. He is credited with stimulating the development of Southwestern arts and crafts and compiled one of the world's best collections. His collection achieved a sale total of $1 million, an astonishing figure at the time.

The fourth sale was the James Hooper sale at Christie's, London, in 1977. Hooper was a major collector of African, Oceanic, and Northwest Coast art. Steven Phelps, art scholar, wrote a book entitled *Art and Artefacts of the Pacific, Africa and the Americas: The James Hooper Collection*, which was published in 1976 prior to the sale. The book was an extraordinary survey of the subject and a testament to the importance of the collection. Record prices were achieved in this sale as well.

The significance of these sales was not only in the high prices paid for individual objects, but also in the ramifications of the world's two largest auction houses recognizing the viability of American Indian art. These sales, which were held on either side of the Atlantic, not only thrust Native American art into the limelight of the international art market, but also situated it among established sales of venerable collecting categories such as Old Master paintings, Modern and Impressionist paintings, and Contemporary art.

Under the leadership of Ellen Napiura, Sotheby's was the pioneering force behind Native American art at auction in the late 1970s and throughout most of the 1980s. Sotheby's was the first to establish regularly held sales dedicated solely to American Indian art, and its auctions set numerous records for Southwest, Plains, Northwest Coast, and Eskimo works of art. The sustained success and steady growth of Sotheby's auctions caught the eye of the competition, and soon Christie's was going head-to-head with them on a regularly scheduled basis.

The competition for top collections that developed between the two houses during the 1990s would, in many ways, help to define and solidify the collective market for Native American art. Besides the positive impact of presenting the material in New York City, a major international center for the art trade, the presence of Native artwork in such well-attended venues as Christie's and Sotheby's encouraged new collectors and structurally facilitated collectors from other fields to "cross over."

Competition for market share demanded increased marketing efforts by both houses. Auction catalogues and sale exhibitions, which are valuable marketing and educational tools, were particularly important for a developing field such as Native American art because they served as a sustained and constant measure of the market. Auction catalogues at both houses became increasingly lavish, with color illustrations, scholarly essays, bibliographies, and cataloguing that included extensive footnotes. They now serve as important records. Scholars, members of the trade, and collectors actively seek to include them in their libraries, and, ironically, auction catalogues have even become valuable sale commodities.

The sale exhibitions were also important occasions. Twice a year, all those with an interest in the American Indian art market would convene in New York. It gave them an opportunity to meet and to discuss important issues. It also gave them the valuable opportunity to have firsthand experience of the objects being offered for sale. Andy Warhol, a famed collector of Native American art, once remarked that auction houses were the ultimate museum for precisely this reason. Finally, the spectacle and drama that auction can provide often mirrored the excitement felt by collectors of Native American art, and the increasingly high prices paid for Native works validated for some their beliefs about the significance of the art form.

But the growing success of American Indian art at auction was very much rooted in the historic and prehistoric material, not in the contemporary. In fact, it would not be until much later—1997 to be precise—that a significant collection of contemporary Southwestern material would appear at Sotheby's.

The collection belonged to the late Dr. Max Stettner and included mostly ceramics. Not surprisingly, Stettner was a disciple of Lee Cohen, although he collected wherever the material was available, which included buying at Indian Market, other galleries, and directly from the artists.

The collection included examples by leading contemporary artists such as Nancy Youngblood, Al Qöyawayma, Richard Zane Smith, and Jody Folwell, whose work had never been tested in a major auction-house sale. The results were strong, even, in some cases, exceeding the full retail prices being paid for comparable works in galleries across the country. Suddenly, the frenzy for contemporary South-

western Native art that had overtaken the galleries of the Southwest in the 1980s seemed to be resurfacing at Sotheby's a decade later.

The frenzy peaked during the sale of the collection of Lucille and Marshall Miller at Sotheby's in 1999. The Miller collection was among the finest of its kind anywhere in the world. It was a survey collection that included masterpieces of prehistoric, historic, and contemporary Southwestern Native American pottery. In that sale, a San Ildefonso blackware olla by Maria Martinez and Julian Martinez sold for $255,000, the highest price ever paid at auction for a Native ceramic. This sum represented more than twice the standing record that had been realized just six months earlier at the same auction house and has yet to be broken.

The numbers are hard to ignore. Art can be judged by many standards, but the economic success of a field cannot be denied when one is striving to prove its legitimacy to a general audience. Auction provides a barometer of the public's interest in any given area. And the huge price paid for the "Cartier" jar (which now resides in the Detroit Institute of Arts) confirmed on an international stage the changing status of twentieth-century Southwestern American Indian art, at auction and beyond. The surge of record prices realized for many contemporary Native artists in this sale had to reflect a significant mainstream interest in the field.

Perhaps most importantly, auction provides a meritocracy. Works by top contemporary Native artists are positioned among the works of other top artists. In November 1999, the Sotheby's sale of contemporary art featured a magnificent ribbed jar by Nancy Youngblood in the same catalogue as an equally magnificent painting by Agnes Martin. Being

allowed to compete in the world art market on the same level as non-Native art, free from the restrictions and the inherent prejudices of galleries and markets restricted to Native art only, contemporary Native art has recently found a unique and persuasive voice at auction.

The collective efforts of galleries and auction houses have played a vital role in the development of contemporary Native art. They have provided a sustained, and often dramatic, venue in which the works of leading contemporary artists have been seen and documented. The artist Michael Kabotie once wrote: "Despite the fads and agonies of cultural transition into the ways of the dominant culture, our art is alive, dynamic and headed towards positive goals. New creative talents are utilizing and mastering new medias [sic]—writing, recording, photographing, filming—to awaken, to lead, and to share with our people and non-Indians a dawning of a new era in American Indian art." The shared passions of the collectors, members of the trade, scholars, and curators create a synergy that would be diminished without any one component, and all help to lead the way toward this new era.

The American Craft Museum's exhibition *Changing Hands* provides a glimpse of the work of the art world's next generation of Native superstars. New materials and applications, new interpretations of old themes, and deeply personal visions are manifest in this exhibition. Still, the connection to tradition is evident. Beneath the swirling abstractions of Les Namingha's acrylic painted pots are the lessons of his mentor, the great Dextra Quotskuyva, and the lessons of those before her. The revolution continues, the stage is ever expanding, and we all play a role.

Southwestern Ceramics

Jody Folwell

In the past twenty years, the beat of change has swiftly claimed a new direction for contemporary Native American ceramists. The concept of innovation in the medium of clay in Native American ceramics is new and still being deliberated and defined.

The arrival of Gallery 10 in the 1980s, under Lee Cohen's direction, brought recognition, validation, and a public forum for a handful of potters who were anxious to make modern statements using an ancient art form. Without the support of Lee Cohen, the new avenues of creativity and different mediums in Native American art might not have been explored at all, or, at least, would have taken longer to develop. In addition to shepherding Native American artists into the marketplace, Lee Cohen educated the public in responding to their new art.

Native art traditions are tied to Native culture. Native languages, religions, politics, and the land base still affect Native art. In ceramics, respect for tradition will often supersede new imagery and shapes. Family ties and a need for acceptance within the community play an important role in maintaining the status quo. And yet, along with a conscious effort to maintain a stable artistic approach there has been a constant struggle to satiate the need for non-traditional art. I have had the privilege of coming from a progressive family. Basic traditions were not as important in my family, the Naranjo, as they were in some other Native families, and this is what has allowed most Naranjo artists to forge new paths into an old art form. Nevertheless, living in a place where community values were more important than one's independence brought difficulties and reprimands from potters, family, and community members.

Having grown up in a community where most of the members are potters, some of my earliest memories are of pottery processing—digging, refining, and mixing the clay, early-morning firings, and late-night pottery work. This pattern was part of the way we were raised and has become generational. We were constantly observing creativity and innovation unfolding. Many young Native ceramists were raised this way. When young Native ceramists are asked who has influenced their art, they are likely to reply that it has been a living relative or friend. We are fortunate that we can be inspired and motivated by leading, innovative contemporary potters. We are fortunate, too, to live where larger communities, such as Santa Fe and Taos, support artistic creativity.

Experimentation with shapes and designs has certainly created an open field for expression. The undaunted focus of the Native American artists who have shaped and directed a craft form into mainstream art must be acknowledged for defying preconceptions and forging a trail into the continual flux of uncertainty over the reception that their work will receive. As more Native American potters reach out to other ceramists, collaborating and commiserating with one another, the emerging new concepts and new voices will represent the prevailing visions of generations to come, leaving our reservations behind to explore the larger world of ceramic art.

Zuni Fetish Carving

Susan H. Totty

Strictly defined, fetishism is the worship of spirits that reside within material objects. The Zunis incorporate six theories in their religious beliefs—ancestor veneration, animism, causality, fear, fetishism, and totemism. Often tribal societies will adopt two or three of these theories and marry them into a central belief; the Zunis have adopted all six and for generations have successfully incorporated them into one practice.

In her 1932 report to the Bureau of Ethnology, anthropologist Ruth Bunzel stated, "A large part of Zuni ceremony centers around the veneration of sacred objects." The practice of fetishism permeates all aspects of Zuni religion and life, and has done so since prehistoric times. Historically, Zuni fetishes were found objects, such as stones, that resembled one of the animals revered by the Zunis. Occasionally these concretions were slightly enhanced by their finders, but they were not formally carved. In early examples, differences among these objects were subtle, and it was often difficult to distinguish which animal was being represented.

It was not until the twentieth century, with the skilled work of the "grandfathers" of Zuni fetish carving, Leekya Deyuse and Teddy Weahkee, that fetish carving began to emerge as a craft that Zuni artists could pursue in lieu of jewelry making, ceramics, or katsina carving. Working during the 1920s through the 1950s, with a limited number of materials and tools, Deyuse and Weahkee produced both small sculptures known as table fetishes and miniature carvings for jewelry that reflected their culture and beliefs.

During the 1960s and 1970s, "stringers" (small fetishes strung together as necklaces) garnered a great deal of attention and grew in popularity.

Recognizing the demand for fetish jewelry, several artists began carving and stringing necklaces. Perhaps as a result of their spiritual connotation the demand for table fetishes was limited. A few carvers, most of whom were Deyuse and Weahkee descendants, produced freestanding table fetishes that closely resembled those of their elders. It would take a few more years for table carvings to become desirable and for the demand for these objects to surpass that for fetish jewelry.

The appeal of table fetishes grew dramatically in the 1980s, perhaps in large part owing to their mystical qualities. An article about fetishes in the *Wall Street Journal* related tales of an attorney who would not go into the courtroom without the appropriate fetish in her briefcase, and the trader at the New York Stock Exchange who always carried his fetish bear in his pocket. Zuni fetishes had finally gained "mainstream" attention, and they had become as highly regarded as other Native American art forms. At the beginning of the 1980s, there were possibly twenty carvers devoted to creating table fetishes. By the decade's end, the number had increased fivefold. Today there are more than 350 Zuni artists who proudly call themselves fetish carvers.

The growth in the number of carvers has yielded a vast array of innovative carving styles. The use of materials more often associated with jewelry, such as lapis lazuli, sugulite, and opal, has heightened the visual impact and appeal of fetishes. In addition, the carving tools that are used today are more sophisticated and give carvers more ways to approach their craft. Carving styles are now categorized as "old style," photo-realistic, or interpretive. Carvers are also stimulated beyond their pueblo beliefs by exposure to mainstream culture and to animals that they experience through television, movies, and personal

travel. The carvers who have been bold enough to experiment with new materials, techniques, or subjects have hastened contemporary fetish carving's evolution and are being accorded recognition as innovators. Fetish collectors can now look at carvings and immediately identify the individual artists who created them without relying on a signature or attribution. These unique creations are distinguished by the true hallmarks of superb artists.

Roxanne Swentzell
Vulnerable, 2002; see p. 173

IV The Human Condition

Depictions of human figures, primarily in the form of stylized or abstracted images, have been important in Native American art in the Southwest from prehistory to the present. This rich tradition is today paralleled by a large number of Native artists who are examining other aspects of the human condition through the figure. For these artists, the human figure is not distanced and objective but intensely personal and revelatory of self-consciousness and cultural awareness. The artists featured in this section of *Changing Hands* are engaged with figuration in their work and are able to illuminate social and political issues, express individual or group sentiments, and communicate their reflections on values that give meaning and direction to their lives. Pathos, beauty, humor, and irony are embedded in their presentations of the human body. These artists describe themselves and their world through the figure, but also invite us to see ourselves in these images.

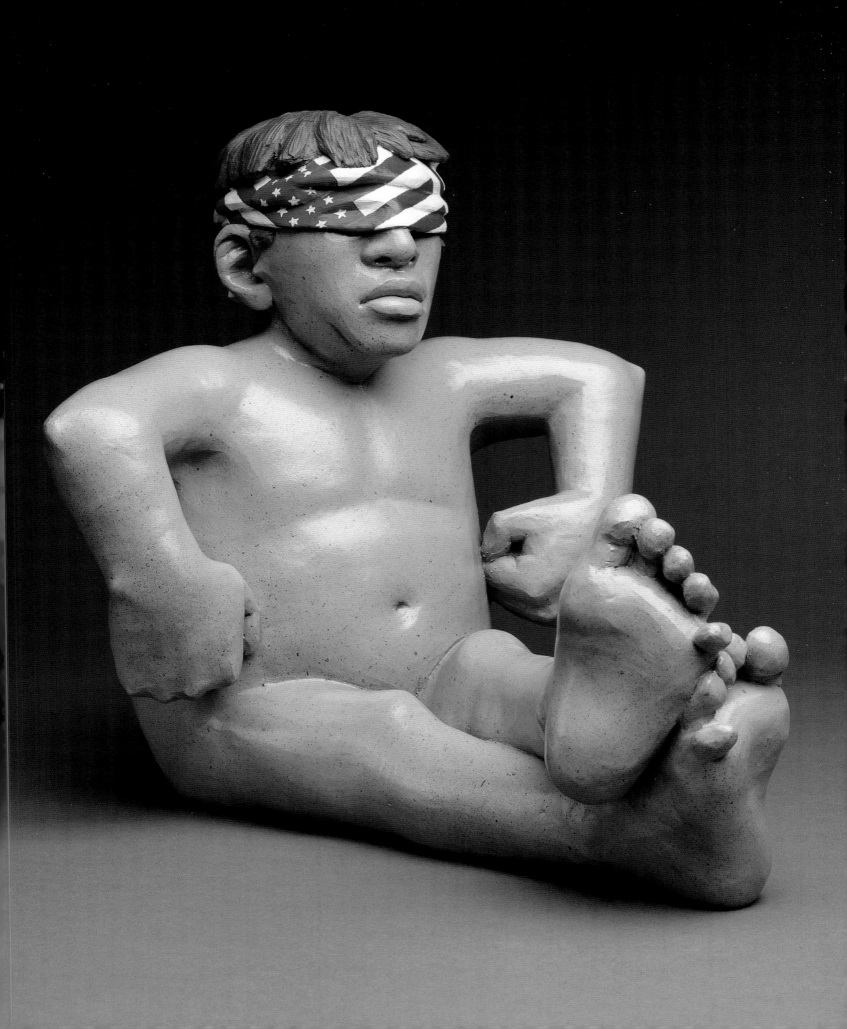

Patricia Michaels

Born 1966, Albuquerque, New Mexico; lives Taos New Mexico

Patricia Michaels began sewing as a child, making dance regalia and garments for Native American pow-wows and ceremonies. Fascinated by opera, Michaels went on to work in the costume department of the Santa Fe Opera. Subsequent study at the Institute of American Indian Arts in Santa Fe, New Mexico, was followed by further study in fashion and textiles at the School of the Art Institute of Chicago and work at the Field Museum, Chicago, in the anthropology collections. Her fashion shows are multimedia productions; the artist produces the music and lighting, and choreographs the runway presentations. Michaels's clothing is intended to be functional but is also often used as a vehicle for expressing issues and concerns that engage her attention.

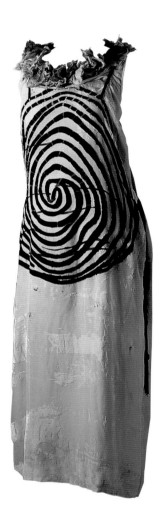 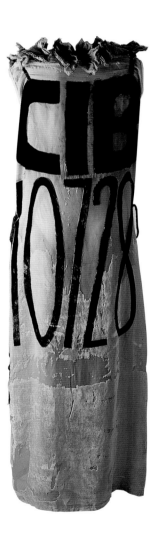

Dress, 2000
Chiffon, velvet, glass beads, dye, cotton binding
Length: 54 (137.2)
Collection of the artist

"The spiral thumbprint is a common human denominator, yet each individual's fingerprint is unique. Fingerprints are unique identification forms for everyone. All Native American Indians have CIB (Certificate of Indian Blood) numbers, yet our tribes are all varied, and each person within the tribe is different. This garment tries to convey how normally Natives are grouped together as one, yet inside Native country there is change from place to place, from context to context. This includes everything from politics, economics, environment, and physical traits to religious issues. This makes for a richer artistic development of our Native insight."

Shirt, 2000
Linen, cotton, indigo
Length: 25¼ (64.1)
Collection of the artist

"This man's garment deals with the stereotypes of how men become men, specifically issues surrounding how much money a man makes, his sexual experiences, time spent male bonding: all the supposed male strengths he has to face. The slashes on the shirt are signifiers of the cold, insensitive world he has to endure because he's a man, not showing emotion. Of course, in the last twenty to thirty years this has changed somewhat, including in Native culture, and the stereotypes have relaxed somewhat."

Myron Panteah

Born 1966, Gallup, New Mexico; lives Zuni, New Mexico

Myron Panteah began making jewelry at an early age, learning from both his father and his grandmother. He studied intermittently while working at other occupations, including furniture making and assembling computer circuit cards for the U.S. Navy. He maintained his interest in jewelry design, however, and is now working full time as a silversmith.

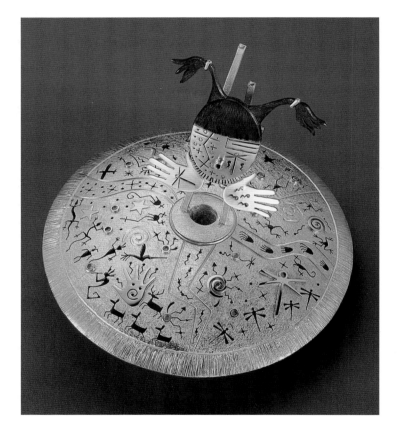

Necklace, 2001
Sterling silver, 14k gold,
agate, jasper, obsidian, chalcedony
Necklace length: 14 (7.6)
Pendant length: 3¼ (8.3)
Collection of the artist

"My ideas come to me while I am working. Many of my pieces have migration and water symbols incorporated into their design. The spiral is a migration symbol —it is like the solar system, the spirals on our fingertips, the rings on a tree. Life is a spiral."

Impressed Clown, 2001
Sterling silver, 14k gold
4⅞ x 4½ (19.1 x 11.4)
Courtesy Faust Gallery

"Everything starts out at the center and comes out, as this pin figure does from its silver kiva. The ladder is the means of emergence into the world."

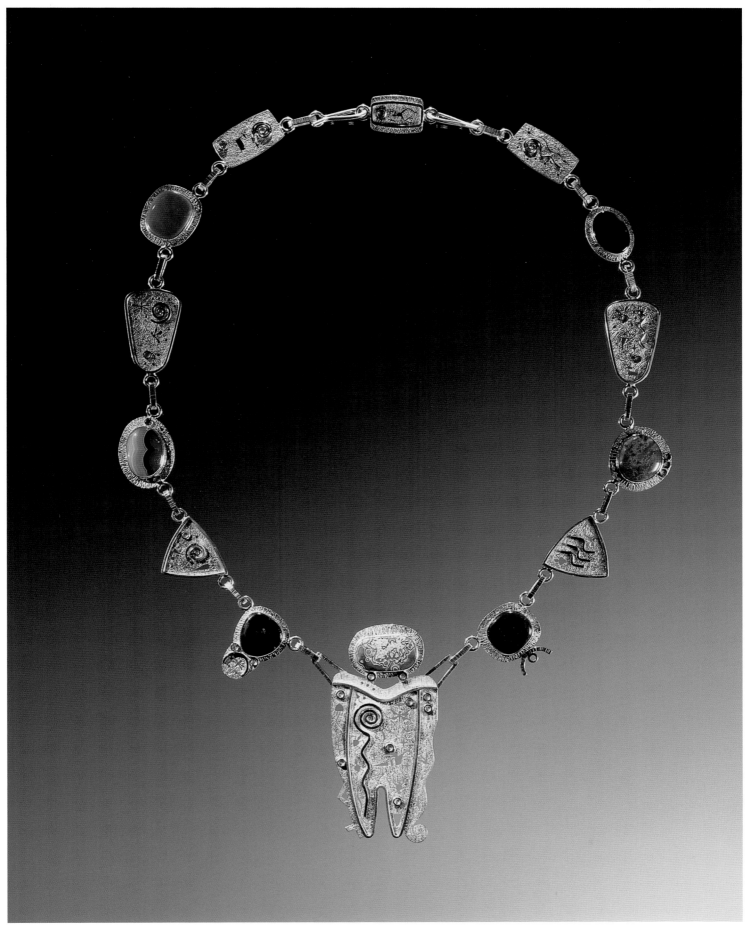

169

Daniel Chattin

Born 1975, Gallup, New Mexico; lives Zuni, New Mexico

Daniel Chattin learned how to carve when he met his future wife, Jovanna Poblano, and her jeweler mother, Veronica Poblano. For a time he worked at a local gem shop, which also gave him experience with stones and other materials. The artist has specialized in working with mixed materials, fossilized ivory, and shell.

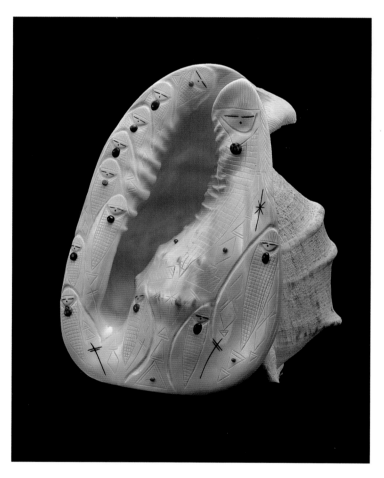

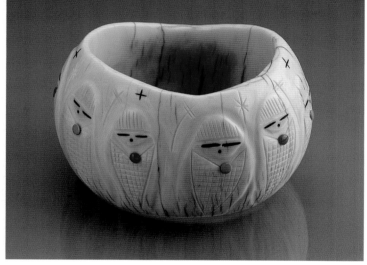

Corn Maiden Bangle Bracelet,
2001
Ivory, turquoise, coral
Diameter: 3¼ (8.3)
Collection of the artist

Sculpture, 2001
Conch shell, coral, turquoise, lapis
lazuli, sugulite, hematite
11¾ x 9½ (29.8 x 24.1)
Collection of the artist

Al Qöyawayma

Born 1938, Los Angeles, California; lives Prescott, Arizona

Al Qöyawayma studied ceramics and art at Arizona State University and
Scottsdale Community College. His further studies led to a bachelor of
science degree in engineering, followed by a master of science degree
from the University of Southern California. He is a co-founder and first
chairman of the American Indian Science and Engineering Society, and
has been awarded an honorary doctorate from the University of Colorado
at Boulder. In addition to an active professional career in technology, he
has been a prolific and dedicated artist in clay. He was a Fulbright Fellow
to the Maori of Australia, and worked with them to reestablish their
pottery traditions. Qöyawayma has been a perpetual innovator in the field
of ceramics, and has developed unique techniques, such as high-relief
sculptural details that use a ceramic version of the repoussé technique.
Many of his works are inspired by ancient history and artifacts, recast
in a contemporary style.

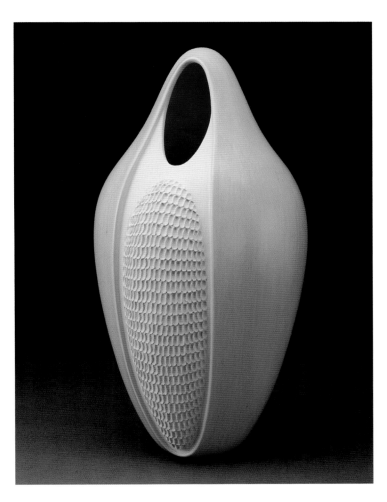

Corn Maiden, 2001
Earthenware
Height: 11 (27.9)
Courtesy Blue Rain Gallery

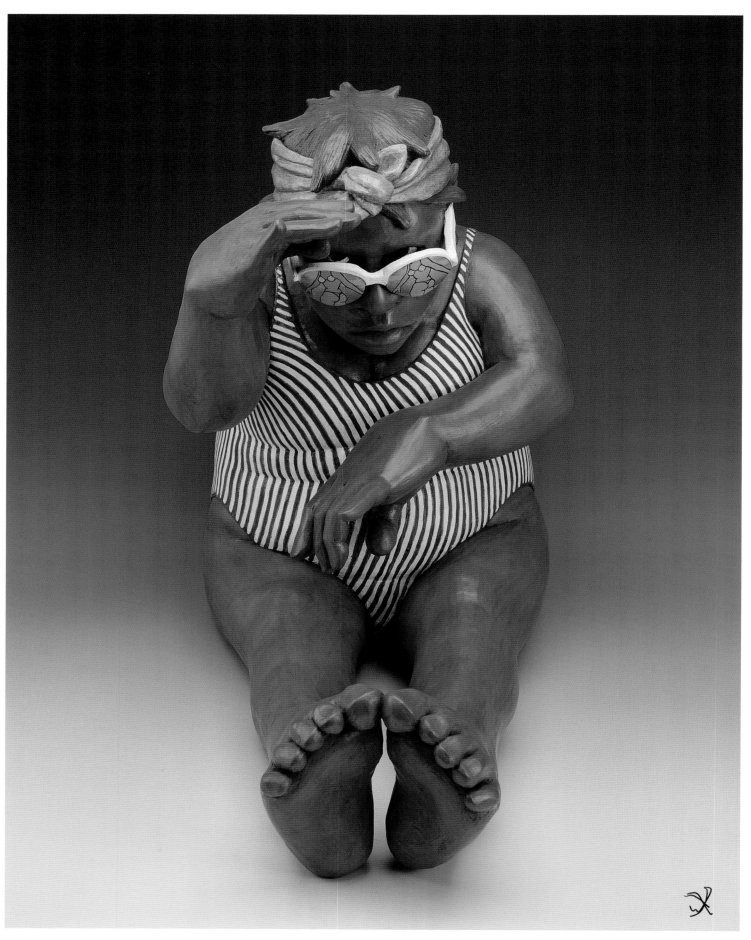

Roxanne Swentzell

Born 1962, Santa Clara, New Mexico; lives Santa Clara, New Mexico

Born into an artistically, intellectually, and politically active family, Roxanne Swentzell has carved out a unique niche in ceramics with her large figural works and her compelling imagery. Swentzell began making ceramics as a child; she compensated for a childhood speech impediment by using figural studies as a means of communication. The artist studied at the Institute of American Indian Arts in Santa Fe, New Mexico, and began exhibiting her work at that time. She uses her figures to evoke states of being, perception, and awareness in individuals and cultures. Unlike many of her contemporaries, Swentzell works with commercial clays and fires her work in an electric kiln. Nevertheless, her connection to her heritage and traditions is unflinching, particularly in her works that deal with cultural identity and the homogenization of culture.

"This figure is a commentary on public and private images. American society has been influenced by and preoccupied with the media portrayal of beauty. This work is about someone 'real' who is looking at a stereotypical image. We, the viewers, look at both, and become part of this process of self-examination."

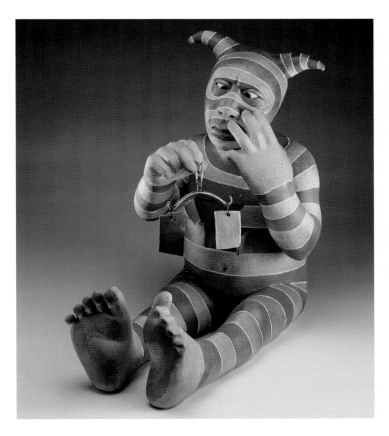

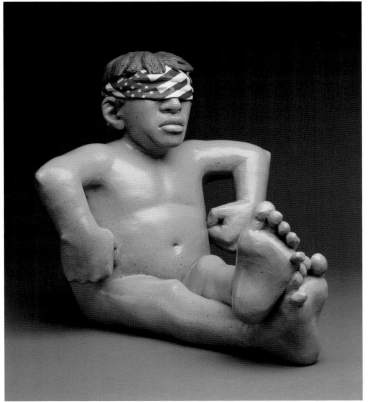

A Question of Balance, 1998
Polychromed earthenware
18½ x 17 x 12 (47.4 x 43.2 x 30.5)
Collection Judge Jean S. Cooper

Left:
Reality Check, 2001
Polychromed earthenware
15 x 10½ x 18 (38.1 x 26.7 x 45.7)
Collection Emile Mathis

"I have always liked to play with the idea that all creation is a matter of balance. When and if the balance is 'off,' we experience problems. We all seek balance between many aspects of our lives—night and day, male and female, death and life, winter and summer. Achieving balance is necessary for creation to work properly."

Vulnerable, 2002
Polychromed earthenware
14 x 15 x 12 (35.6 x 38.1 x 30.5)
Collection of the artist

"The September 11 ordeal has deeply affected my work and caused me to reflect on the meanings of the event. I believe that our vulnerability to terrorism lies more in our outlook on things than on the presence or absence of military strength. I fear for all of us in this country because of what we are unable to see, more than because of our level of defense. We are vulnerable because of ourselves."

Sarah Paul Begay

Born 1956, Winslow, Arizona; lives Whitecone, Arizona

Sarah Paul Begay learned weaving from her maternal grandmother at the age of six and sold her first weaving one year later. While Begay's early weavings were traditional in nature, by the mid-1980s she had begun to develop a unique personal style. By 1987, she had received awards for her innovations at the Northern Arizona Navajo show and went on to win honors at the Santa Fe Indian Market and the Gallup Intertribal Ceremonials. In 1996 Begay was awarded a fellowship from the Southwestern Association for Indian Arts (SWAIA).

"I started designing my own style back in 1986. I wanted to be different from all the weavers and thought I should put some excitement back into Navajo rugs so that people wouldn't look at them as mere curios. If a painter can stroke that brush across the canvas, so can I, only with different materials. Anything is possible if you just set your mind to it. Many weavers are afraid to express themselves through their art. To me, it just comes naturally."

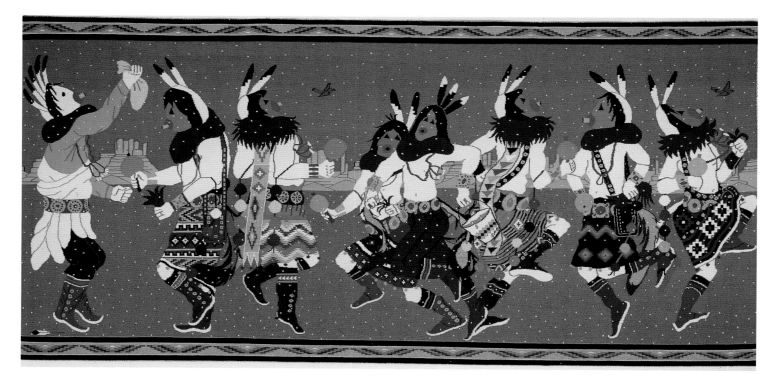

Millennium Rug, 2001
Handspun and respun wool,
vegetal dyes
58½ x 122 (148.6 x 309.9)
Courtesy Cheff collection

Arlo Namingha

Born 1973, Santa Fe, New Mexico; lives Santa Fe, New Mexico

Son of noted painter and sculptor Dan Namingha, Arlo Namingha has been surrounded by creativity throughout his life. After attending Community College for Architecture in Santa Fe, New Mexico, he left the program to pursue a full-time career working in the family gallery. Having been inducted into Hopi katsina society at a young age, he began carving wood to make dolls and other ceremonial paraphernalia. His carving is a departure from a more traditional style in its fluidity and abstract quality. The finishes on his work often give them the appearance of stone.

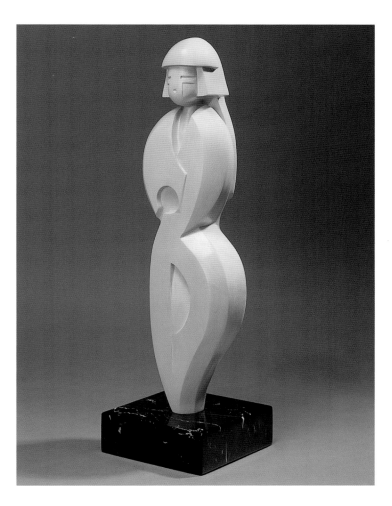

Dancer, 2000
Wood (Malaysian jelutong)
Height: 21½ (54.6)
Collection Jann and Vivian
Levinsky-Carter

"I was inspired by katsinas from my native Tewa-Hopi culture. This is not a specific katsina, but a way of capturing the idea of movement and form."

Dan Namingha
Maidens I, 1998
Bronze (edition of 15)
Height: 35½ (89.5)
Courtesy Niman Fine Art

"The subject is two butterfly
maidens. Their different patinas
indicate the dualities of life."

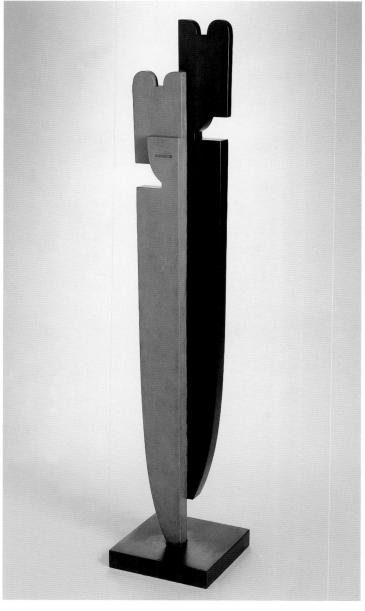

Nathan Begaye
Box with Lid, 2001
Polychromed earthenware
Height: 10¾ (27.3)
Courtesy Charles King Gallery

"In our culture the phallus is used
in many symbolic ways on masks
and in paintings. The motif has
nothing to do with eroticism,
but with the male energy of the
clouds. This is why the cloud
symbol sits on the lid. If you turn
the work around, it also
resembles a kneeling figure in
deep meditation. The vessel deals
with traditional thought and belief,
but it is still tied to our world
today in its naturalism. I am not
abandoning my tradition, but
making it more realistic."

"I always experiment with new tools and techniques to create distinctive textures. Sometimes I reshape tools I have purchased, and sometimes I make them from scratch, using concrete nails, old files, and chisels. Sometimes I stamp wire designs using steel guitar strings. I like to challenge myself."

Norbert Peshlakai
Mask Pin, 2001
Sterling silver
2⅝ x 2¼ (6.7 x 5.7)
Collection Marlys and Harry Stern

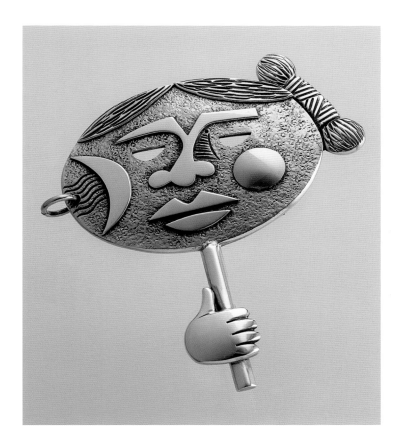

Diego Romero

Luncheon in the Canyon Bowl,
2000
Polychromed earthenware
Diameter: 12 (30.5)
Collection Pamela Elizabeth George

Diego Romero

Girl Waiting, 1996
Polychromed earthenware, gilding
Diameter: 10⅜ (26.4)
Private collection

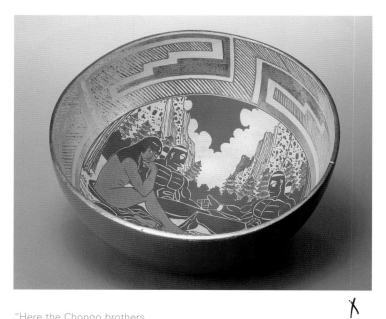

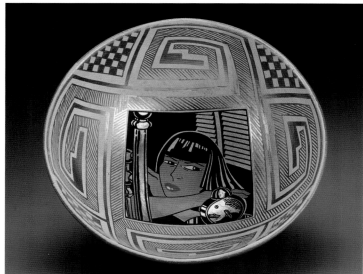

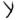

"Here the Chongo brothers
re-create a legendary art-historical
moment. Their setting is now in
Frijoles Canyon in New Mexico.
Like the original *Déjeuner sur
l'herbe*, this image deals with
the objectification of the female.
I have reinterpreted the scene, but
the issues are still weighty ones."

"This piece is about the anxiety
the girl feels waiting for her lover.
Roxanne Swentzell says that this
piece is about the life of my
girlfriends as they wait for a
collect call."

Elsie Holiday

Set of Trays: Changing Woman,
2000
Natural and dyed sumac
Diameters: 18, 18, 17, 12
(45, 45, 43.2, 30.5)
Collection Anita and Walter Lange

"This set is based on the paintings of Southwestern painter Helen Hardin and inspired by a book about Hardin's life as an independent, self-sufficient, and influential woman, something that I could identify with. The images represent the transformation of a girl into a woman. *Changing Woman* is the ideal model for a young woman, but she is respected so highly by Navajo people that she is not often represented in Navajo art. The most important thing is that *Changing Woman* is based solely on positive energy."

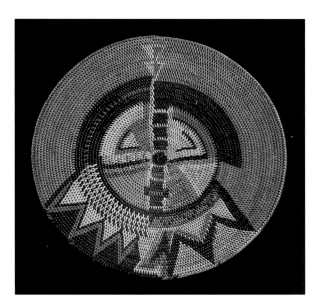

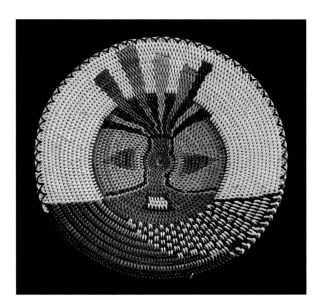

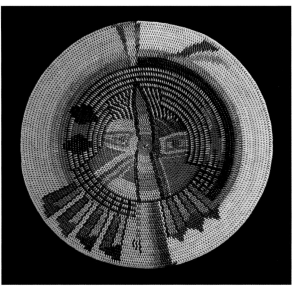

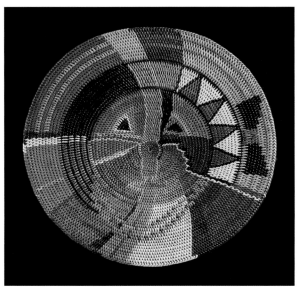

Richard Zane Smith
Beans and Squash Lament . . .
"What Have They Done to Our
Sister?," 2001 (interior)
Polychromed earthenware,
medical tubing, wire
Diameter: 13⅝ (34.6)
Collection American Craft
Museum; purchased with funds
provided by Nancy Olnick and
Giorgio Spanu, 2001

"Corn, beans, and squash are the three sisters. These sacred gifts that gave life to our ancestors are now taken to the laboratories of science, where they are manipulated and bred to become profit-slaves for multi-billion dollar corporations. See how the tubes and wires come from sister corn and make her infertile so that farmers of the world can no longer plant her seed as before but must buy new seed every year from the big companies. We will mourn her loss."

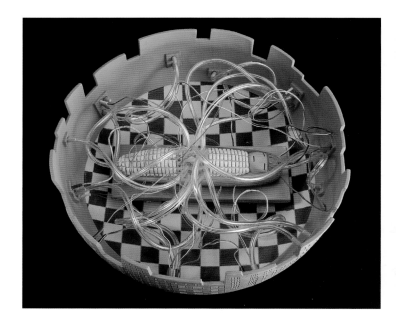

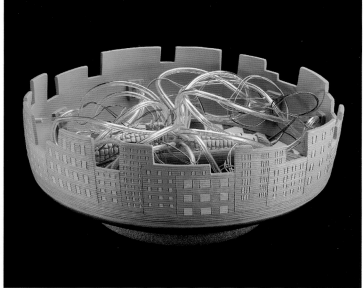

Richard Zane Smith
Beans and Squash Lament . . .
"What Have They Done to Our
Sister?," 2001 (exterior)

"I began this work after the death of my son, to whom it is dedicated. It took me six months to complete. The sun represents life—the sun radiates everything that is good."

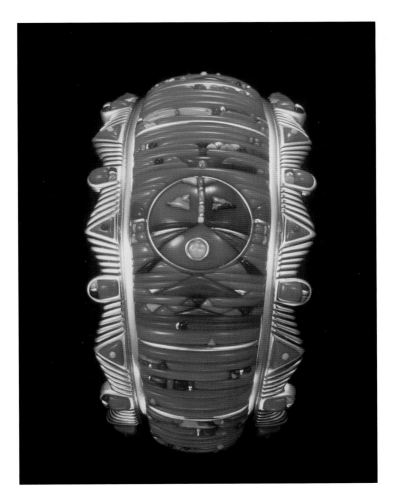

Raymond Yazzie
Life Will Go On Bracelet, 2001
18k gold, coral, Lone Mountain turquoise, sugulite, lapis lazuli, Orville Jack faustite
Width: 3 (7.5)
Collection Pat Warren

Verma Nequatewa

Born 1949, Hotevilla, Arizona; lives Hotevilla, Arizona

Verma Nequatewa is the niece of the legendary American jeweler Charles Loloma, who revolutionized the field of Native American jewelry with his unorthodox combinations of materials and exuberant sculptural forms. Nequatewa studied with her uncle from 1966 until 1986. Her fame rests on her exceptional ability to move Loloma's style forward and to continue to be innovative. Her working name, Sonwai, is the feminine word for beauty in the Hopi language, a parallel to the masculine word for beauty, *Loloma*. Sonwai's list of awards and honors is impressive, as is her exhibition history. She was recently included in the exhibition *Women Designers in the USA 1900–2000: Diversity and Difference* at the Bard Graduate Center in New York.

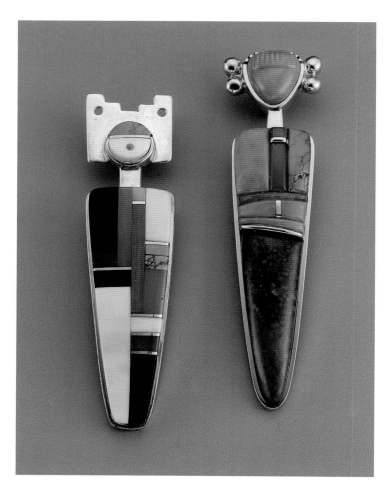

Richard I. Chavez
Pendant, 2001
14k gold, coral, turquoise, black jade
Length: 2 (5.1)
Courtesy Lovena Ohl/
Waddell Gallery

Figural Pendants, c.1998
18k gold, sterling silver, coral, turquoise, opal, shell, wood, lapis lazuli
Lengths (left): 3¼ (8.3);
(right): 3½ (8.9)
Collection Marcia Docter

Michael Dean Jenkins

Born 1959, Williams, Arizona; lives Flagstaff, Arizona

While still a child Michael Dean Jenkins began collecting model cars and building his own toys. During his teenage years, he traveled across the Southwest, and also to Hawaii, Alaska and Hollywood, California. These experiences, combined with his interest in the work of Michelangelo and The Great Santini, comic-book heroes and villains, and Hollywood characters inform the work of this unique katsina carver. Humor, irony, satire, and compassion all find a place in Jenkins's carvings. Working within the ancient traditions of Hopi katsina carving, he creates images based on the past, but recast in a modern light. In addition to his active career as a carver, Jenkins plays lead and rhythm guitar with his band and continues to collect—hot-rod cars, vintage guitars, and "anything unusual."

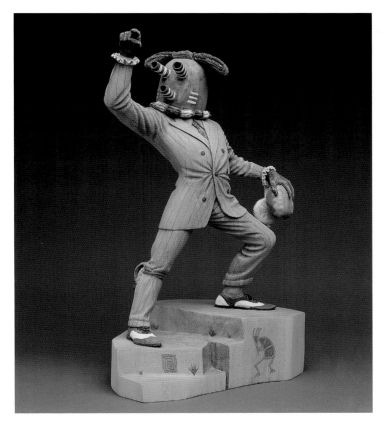 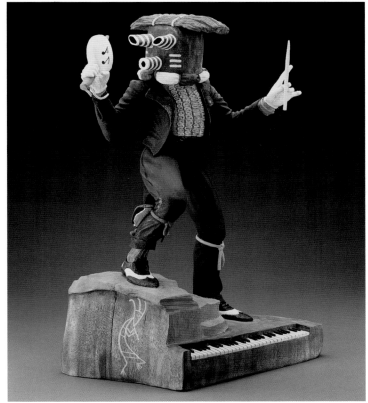

Zoot Suit Katsina, 2000
Cottonwood root, acrylic paints
Height: 15½ (39.4)
Courtesy Lyn A. Fox, Fine Historic Pottery

"The inspiration for this image came from old Hollywood movies and was modeled after the Joker in *Batman*, by way of a porcelain souvenir doll I saw in an old comic-book store on Sunset Strip. I used the traditional 'Mocking Katsina' form, but gave him modern clothes."

Kwikwilaka Mocking Katsina, 2000
Cottonwood root, acrylic paints
Height: 14½ (36.2)
Private collection

"I make up my images. Maybe because I am an old rock-and-roller, music has a lot to do with my work. If I am not playing music, then I'm carving. I like to watch conductors, which is the basis for this katsina."

Bob Haozous

Born 1943, Los Angeles, California; lives Santa Fe, New Mexico
Bob Haozous is a highly accomplished and respected artist, best known for his mixed-media sculpture. His work has been exhibited and collected by major museums throughout the United States and abroad. Son of renowned sculptor Alan Houser, he received his bachelor of fine arts degree in 1971 from California College of Arts and Crafts in Oakland, California. Haozous's work is often charged with social and political commentary, and informed by his concern for the cultural past, for the environment, and for the human condition. He was among a select group of artists shown in *Twentieth-Century American Sculpture at The White House: Honoring Native America* in 1997.

"I personally believe that there are two art forms, one that tells you who you are and another made for the purpose of entertainment. I have a feeling that if Native artists could turn their art inward or back toward their own people for healing or educational purposes, then perhaps a truly unique contemporary art statement would emerge. What better role for the arts of any culture than to tell their own people who they are, rather than who they were?"

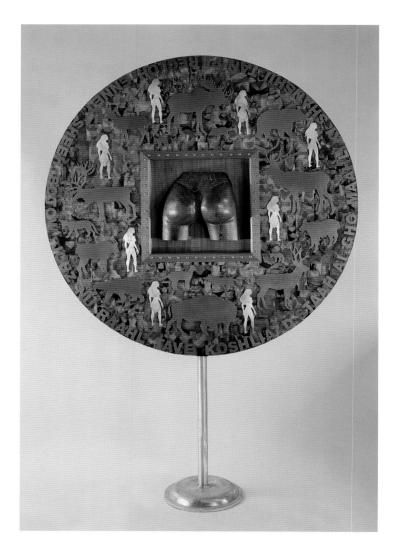

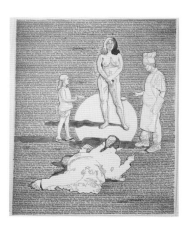

The Flower, 2002
Stainless steel, bronze, aluminum, walnut
Diameter: 60 (183)
Collection of the artist

Defining the Great Mystery, 2002
Pencil, ink, and watercolor on paper
28½ x 22½ (70.25 x 56.25)
Collection of the artist

"On finding a balance: a way of life must be coordinated with a way of thinking that is tempered by common sense and nature. Maintenance of an existing culture can stop development if creative change becomes unimportant. Indigenous identity is inclusive of time; the communal member is responsible to and exists for multiple generations. The challenge of renewing indigenous cultural values and redefining indigenous identity lies in finding the base of nature that always defined us."

Nora Naranjo-Morse

Born 1952, Española, New Mexico; lives Española, New Mexico
Nora Naranjo-Morse grew up among a distinguished family of artists, writers, and educators, and received her liberal arts degree from the College of Santa Fe. The artist's mother, noted potter Rose Naranjo, was an important influence in her choice of clay as a medium. Naranjo-Morse chose to create sculpture rather than traditional vessels, and since making that decision, she has been an innovative force in Southwestern art. Her clay forms became larger and more sophisticated, and the artist expanded into other media, such as printmaking, videography, and poetry. Today the artist is also working in bronze, as well as creating site-specific installations. Her book *Mudwoman: Poems from the Clay* (1992) charted new directions for documenting not only the Pueblo clay process but also the commercialization of Native cultures in a dominant society.

"My approach to creating is simple. I watch, listen, and remember. The story or message I am relating through my work most often determines the medium I use. However, the basis of my creativity remains clay. The earth's foundation gives me a creative anchor that makes cultural, environmental, and spiritual sense for me."

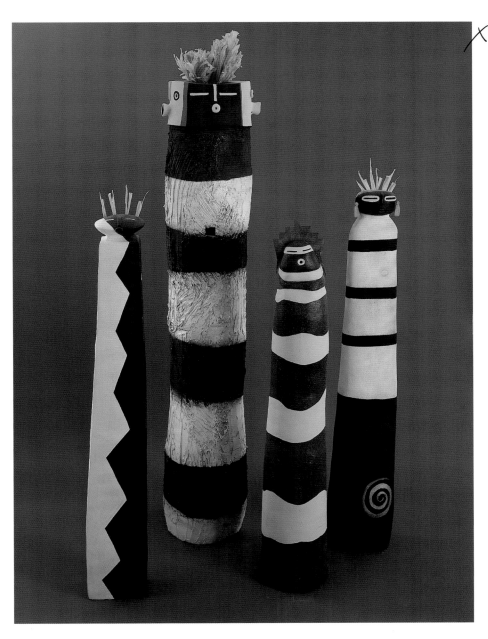

Figural Group, 1997–98
Polychromed earthenware,
acrylic paints
Heights: 64 to 102 (150 to 255)
Collection Sara and David
Lieberman

Virgil Ortiz

Born 1969, Cochiti, New Mexico; lives Santa Fe, New Mexico

Virgil Ortiz is among the most prominent and provocative of a new generation of Native artists working in the Southwest. His often shocking, salacious, or satirical figures, growing out of a Cochiti tradition of caricature figurines, are prized by collectors and museums alike. Ortiz is also a prolific fashion designer, a fact often reflected in the painted or sewn clothing worn by his figures. The artist received early recognition with awards from the Southwestern Association for Indian Arts (SWAIA) at Indian Market in Santa Fe, New Mexico, at the age of fourteen.

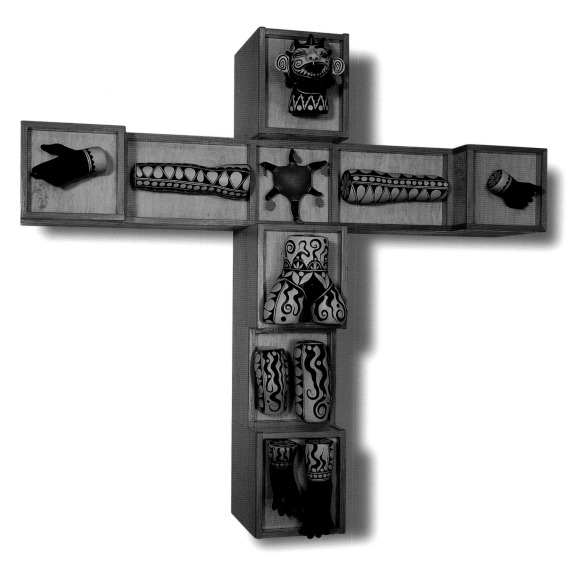

Untitled, 2001
Polychromed earthenware, wood
Height: 58 (203)
Collection Natalie Fitz-Gerald

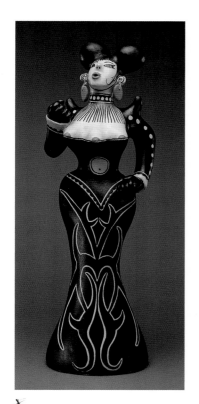 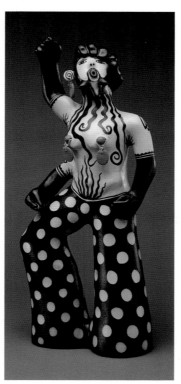 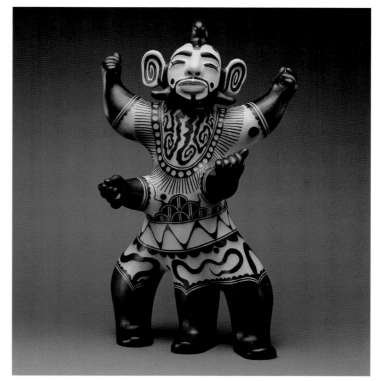

Untitled, 1999
Polychromed earthenware
Height: 17 (43.18)
Collection JoAnn and Bob Balzer

Untitled, 2000
Polychromed earthenware
Height: 20½ (52.7)
Collection JoAnn and Bob Balzer

Untitled, 1999
Polychromed earthenware
Height: 18 (45.72)
Collection JoAnn and Bob Balzer

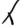 **Virgil Ortiz**
Untitled, 2002
Polychromed earthenware, vinyl,
netting, artificial hair, feathers
Height: 30 (76.2)
Courtesy Robert F. Nichols Gallery

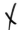 **Virgil Ortiz**
Untitled, 2002
Polychromed earthenware, vinyl,
netting, artificial hair
Height: 22 (55.9)
Courtesy Robert F. Nichols Gallery

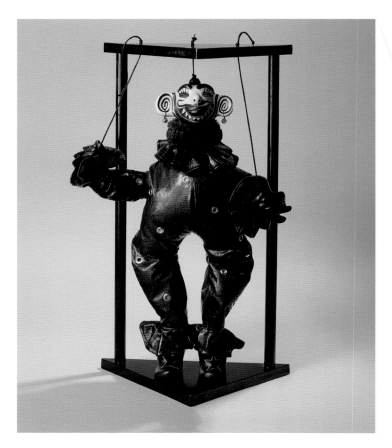

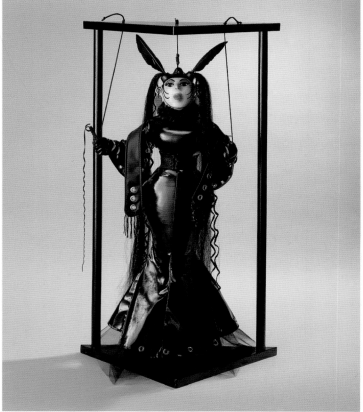

"Clothing is an important element
of all my work. I like the idea that
people reveal their souls through
what they wear. There is also an
element of humor and satire in
my work."

Virgil Ortiz
Untitled, 1999
Polychromed earthenware
Height: 16 (40.6)
Collection Mr. and Mrs. Daniel
Hidding

"The theater has always been a source of ideas and inspiration for me. I enjoy the idea of art and movement being brought together and try to capture this spirit in my work."

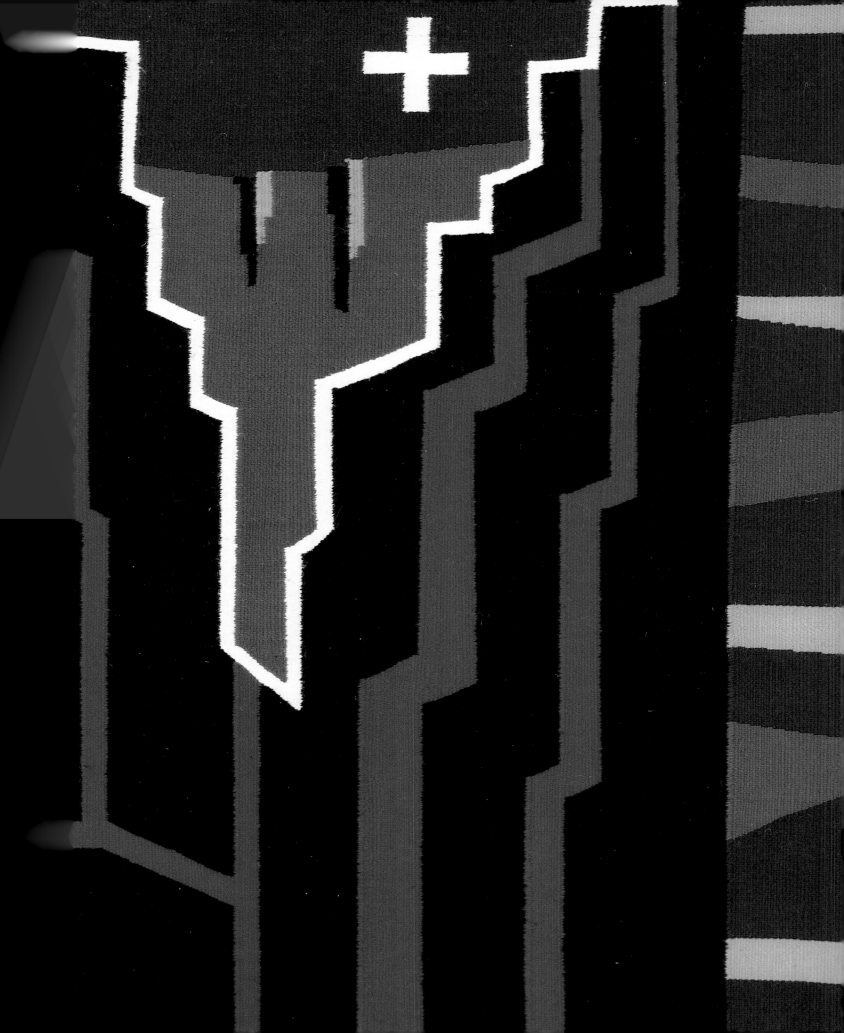

Eleanor Yazzie
Grand Canyon Weaving, 2001;
see p. 147

Changing Hands: Changing Views

Ellen Napiura Taubman

Collecting Native American art has always been limited to a relatively small and select group of individuals who recognized the visual quality and historical significance of artifacts made by this country's indigenous cultures. Until quite recently, however, collectors of Native American art focused almost entirely on historical artifacts and seldom on contemporary work. Native American art was, to a large extent, the art of dead cultures, not living societies. Artifacts were privileged over art, even though individual masterworks of exceptional quality were avidly collected, traded, and even displayed in major art museums. The development of the association of named artists with individual works in Native American art echoes the similar development that took place in the history of Western European art. The identification of personality with product adds another layer of meaning to an object, often increasing its monetary as well as its documentary value.

The important changes that have occurred in the perception and appreciation of work created by talented Native American artists today can be noted in the number of private collectors who have become patrons of individual artists, in the gradual introduction of their works into galleries and auctions, and in the increase in the number of museums collecting contemporary Indian art and featuring it in major art exhibitions.

The changes that have taken place in the way Native American art is viewed, collected, displayed, and reviewed have been enormous and fascinating. Around thirty years ago, the world of Native American art was focused on the past, with relatively little concern for the present. Today, respect and admiration for the past is paralleled by a growing interest in the art of the present. I am happy to have been an observer and a participant in the process of change

that is so powerfully conveyed in the work shown in *Changing Hands: Art Without Reservation*. Systems, institutions, markets, and venues for this art have changed, and so have all of us who have lived through this exciting moment.

The world of Southwestern art has changed dramatically over the past fifty years. Before the San Ildefonso potter Maria Martinez began to sign her beautiful blackware vessels, collectors readily bought Southwestern pottery, and most other American Indian works for that matter, without knowing the identity of the artist. Prior to the last few decades, much of the Native American art that was bought and sold was presented as souvenirs of the American West, and often as the last vestiges of once-great societies now in decline. Today, circumstances are entirely different. Native American art, both traditional and contemporary, is collected by serious collectors, it is bought and sold on the international market, and knowledge of who made a particular piece can greatly increase its value. For collectors of contemporary work, knowledge of who made a piece is essential to their even considering its acquisition.

Traditionally, the knowledge of who made a particular Native American work of art has been elusive. The makers of the overwhelming majority of collected works by Native peoples of centuries past remain anonymous. The American Museum of Natural History in New York City houses extensive holdings of Native American artifacts that were collected in the early decades of the nineteenth century, primarily by anthropologists and archaeologists. These objects are generally documented in terms of the date they were acquired and their use, either practical or ritual. The explanations of why they were important to the Native peoples who made them, and sometimes

even when they were made, are often based on the observations and/or knowledge of outsiders looking in. In addition, certain categories of traditional objects have been identified by the gender of the maker or the user—Navajo women wove blankets, Hopi men wove blankets, Plains women beaded garments, and Plains men carved pipes, to cite a few examples. But actual name associations with the objects on display are generally based on collection data and ownership, not on the authorship of the work. Pertinent to a discussion of *Changing Hands* is the fact that pottery making tended to be a woman's occupation in the late nineteenth century and throughout most of the twentieth century, while silversmithing was generally identified as a man's occupation. Today, while men's and women's roles are often still clearly defined, gender specificity in terms of artists and the media they work in is no longer rigidly proscribed.

Despite the blanket of anonymity that covers historical Native American creations, certain objects from the past have stood out because of the skill and ingenuity that have gone into their creation: such is the work of the Anasazi artist in Arizona who some time between six hundred and one thousand years ago used a steady and highly skilled hand and a clear understanding of color and texture to create a perfectly formed clay vessel and decorate it with a highly contrasted design of black linear elements against a white ground; or the wearing blanket made in the first half of the nineteenth century by a Navajo woman, who, despite unimaginable limitations, perfected her craft at the loom, and, while simultaneously meeting the demands of her nomadic existence, wove a textile of timeless beauty, using a pattern both simple and complex in its subtlety; or the cut and sinew-sewn hide shirt with elaborate fringe and dyed porcupine-quill deco-

ration made by a Plains Indian woman, who, using the skills she was taught and the parameters of decoration dictated to her, created a unique vocabulary of design in expertly executed beadwork that became the mark of office, or symbol of achievement and importance, for a Plains man to wear among his peers. This core group of objects transcends the boundaries of time and place imposed upon them and suggests that throughout history there have always been exemplary artists and/or craftspeople capable of producing works with such clarity of vision and mastery of materials and techniques that their creations are set apart from the ordinary. It is this group of transcendent objects that offers insight into the history and the creativity that have changed hands from past generations to the current. Many of the artists featured in *Changing Hands* have hearkened back to these works as a foundation for their own ideas and inspiration.

Early traders who went westward understood the desirability of Southwestern crafts. It was not until the early part of the twentieth century, however, that an entrepreneurial trader named Abe Cohn established a new plateau. Working out of the Nevada Emporium Company in Carson City, Nevada, Cohn was keenly aware of the added value that a maker's identity and associated attribution could bring to an object. To implement and capitalize on his realization, he became the patron of a highly talented Washoe basket maker named Louisa Keyser (more familiarly referred to by her Indian name, Dat-so-la-lee) and went even further by having certificates commercially printed, each bearing the name of the Nevada Emporium Company and a photograph depicting a group of Washoe baskets. For the baskets that Keyser made, each of which was considered aesthetically masterful and technically perfect, the purchaser received from Cohn a completed certificate

that included the artist's name, an "LK" number that had been assigned to that particular work, the date of the piece's completion, the materials from which it was made, the time it took for Louisa Keyser to complete it, and the motifs incorporated into it. For further interest, Cohn would often offer the "native" interpretation of such motifs. Today, these "masterpiece" baskets, of which there are fewer than one hundred, are considered some of the most valuable and desirable examples of Native American basketry and Native American art. The certificates offered, in a formalized fashion, far more information than had been available to collectors previously.

At the time that Louisa Keyser's baskets were being made and sold, they were already more expensive than other Native-made baskets and/or other Native American works in general. While it is known that she was surrounded by and also taught a number of other very talented Washoe basket makers, their work was generally not accompanied by similar credentials. Their work, while sometimes of almost comparable quality, is less expensive even today, despite the fact that many of their identities have now been discovered and particular works have been attributed to them. Like dealers in other areas of the fine arts, Abe Cohn clearly understood the potential increase in the value of an object when it had a known artist's name attached to it, and the artist herself was promoted.

Traders such as J. B. Moore, Lorenzo Hubbell, and Fred Harvey understood the potential for the increased marketing of Southwest artifacts; however, they did not formalize the documentation of the artists or the individual works to the extent that Abe Cohn did. In the early decades of the twentieth century, a Hopi potter known as Nampeyo found inspiration at the ancient Sikyatki ruins and began to make seed jars decorated with patterns reminiscent of ancient designs. Although she was not prolific, collectors recognized her talent and eagerly acquired (and paid the price for) these outstanding works. As tradition dictated, she shared her knowledge with her daughters, who worked in a similar style. Recognizing the salability of such wares, other artists also imitated her work, but without the skill and mastery that Nampeyo clearly possessed. Early traders at Hopi, aware of the importance of the name, began using printed stickers on random works that resembled Nampeyo's style to increase the salability of the lesser works that they also carried. Nampeyo did not "sign" her exquisite jars, but her very personal style is discernable to learned dealers and collectors. Those rare and exemplary pieces with her stylistic "signature" continue to command the highest prices. Today, those of Nampeyo's contemporaries whose works bore printed stickers with her name remain anonymous, their works sometimes serving as important study pieces for art historians but having little impact in the marketplace. In the work of Dextra Quotskuyva, Nampeyo's granddaughter, we see contemporary evidence of the talent that has been passed down through the generations in this family of significant artists.

Likewise, C. G. Wallace, the well-known trader working at Zuni in the early twentieth century, had a vision and entrepreneurial sense that paved the way for the success of a number of talented and creative silversmiths whom he encouraged to work in a more contemporary and more salable inlay style, using an array of cut stones, often in precious materials. While a limited number of the works produced under his guidance were signed or can currently be attributed, many were not. Recent scholarship has allowed for more definitive identification of some of these makers, and as a consequence, works made

by these "knowns" have increased considerably in value. Contemporary artists such as Veronica Poblano (whose father worked with Wallace), Jesse Monongye, and Carl Clark, while clearly influenced by the early work at Zuni, have taken the inlay technique and inclusion of precious stones to an entirely new level.

Perhaps the most successful at understanding the significance of artists' attributions was Lee Cohen. With a maestro's approach, he encouraged both a new generation of Native American artists—supporting them in their individuality and their artistic expression—and a new generation of collectors who were attracted to his more sophisticated and experienced style and panache. Cohen had a clear idea of how to present his artists and how best to promote their body of work to the collecting world.

The course that Lee Cohen set in the early 1980s permanently changed the direction of contemporary Native American art and clearly confirmed the role of the Native American craft artist in determining how his or her work would be perceived and acquired by collectors. A clear message went out to the art world that there was a new creative frontier being opened that could no longer be overlooked. Collectors, many of whom previously had considered only works done prior to 1920 to be "real," could no longer ignore the excitement and creative energy emanating from the Southwest. Cohen's call could be heard, and many collectors began to straddle both collecting fields.

A number of factors contributed to the tremendous growth and transformation of the American Indian art market between 1973 and 1983. A large number of private collections amassed by a group of older, "first-generation" collectors came into the marketplace, and the subsequent auctions showed a clear interest on the part of collectors to obtain the earliest and best objects available. Collectors were ready, willing, and able to travel from near and far to New York City's auction houses to bid competitively on such works. In 1972, Parke Bernet Galleries completed a merger with the formidable and generations-old English-based international auction company Sotheby's, effecting a significantly greater presence around the globe that extended the reach for finding American Indian objects and expanded the market for selling them. Because of early interest in the American West, particularly among the English and Germans, early and well-documented, but unknown, objects of Native American manufacture found their way to Sotheby's regional offices, from where they ended up in New York or London. Identifying, authenticating, and evaluating Native American art became an important responsibility for the auction house.

Equally important were a series of comprehensive exhibitions of Native art in which "artifacts" began to be looked at not only for their historical significance but also for their aesthetic merit. One of the earliest of these was the Whitney Museum's 1971 exhibition *Two Hundred Years of North American Indian Art*, curated by the well-known scholar Norman Feder. This was followed, in 1976, by a large and comprehensive overview of the subject, *Sacred Circles: Two Thousand Years of American Indian Art*, organized by Ralph Ted Coe, then curator at the Nelson-Atkins Museum of Art in Kansas City, in conjunction with the opening of the Hayward Gallery in London. Shortly thereafter the Art Institute of Chicago offered its own comprehensive overview with the exhibition *The Native American Heritage*, organized by their highly respected curator Evan Maurer, now director of the Minneapolis Institute of Arts. A significant breakthrough occurred when Maurer chose to include a number of contemporary

works, particularly from the Northwest and South-west, that were identified by the artists who made them—perhaps the most significant of which was a twelve-foot-tall redwood totem-pole-like sculpture, highly abstracted in form, that was carved in 1977 by noted Chippewa artist George Morrison. Ralph Ted Coe's organization of another comprehensive exhibition in 1985, *Lost and Found Traditions, Native American Art 1965–1985*, was confirmation that a new era in American Indian art was only beginning. No one could or would eliminate or overlook the importance of the many earlier objects that existed from prehistoric and historic periods, but there was no denying that new works of comparable caliber were being produced that provided insight into the complexity of modern Native cultures.

There appears today to be a greater pool of accomplished artists working in the Southwest than ever before, although regional markets continue to provide the best opportunities to see their new work. Today, there are also a greater number of active collectors of contemporary Southwestern art who are willing to and can competitively vie for all the important objects that come out of these many studios. Works by accomplished Native American artists can be so coveted that galleries and sometimes even the artists themselves have been compelled to sell by lottery to assure the many potential buyers that they are getting a fair and equal chance at buying a piece. Nor is it unusual to see truly committed collectors spending the night prior to Santa Fe Indian Market outside an artist's booth in order to be first in line, or camping out the night before a gallery opening to have a similar advantage. The amount of work that artists of this caliber produce on an annual basis seems relatively modest in relation to the number of prospective collectors who stand at the sidelines, ready, willing, and able to write a check. While this might lead some to assume that the creativity of an artist with guaranteed sales will be stunted, it is often quite the contrary, as, free from financial concerns, artists strive to move forward and to expand their ideas. Clearly, this is part of what makes the art of Native Southwest artists so exciting today.

Native American art is changing hands—from one generation to the next, from artist to patron, from private collector to public domain. A new and greater perspective has evolved, and the view is that contemporary Native American art is no longer art without an identity.

A Passion for Collecting Native American Art

JoAnn Lynn Balzer

I have a passion for collecting Native American art. Some of my friends call it an obsession, others an incurable disease. It all began twenty-eight years ago when my husband, Bob, and I attended our first Indian Market in Santa Fe, New Mexico. I couldn't believe my eyes. The art that I saw gave me a privileged opportunity to look into the world of Native Americans. The painting, sculpture, pottery, jewelry, beadwork, and more were incredible, the creativity was astounding, and the opportunity to meet and talk with the artists was thrilling. That experience changed my life forever, and I haven't missed an Indian Market since.

After a decade of attending the annual market, my husband and I were referred to as serious collectors. We didn't start out with that lofty goal in mind. We only wanted to buy what, to us, was the most interesting of this exciting work. Even early on, I considered Native American art to be a significant sector of the American art scene, so I thought it was an honor to be considered a serious collector of this important work.

Native American art was, and still is, a segment of the art market that is affordable and accessible, where one is welcomed by artists, museum directors, and curators, and given direction and advice by seasoned collectors and gallery owners. Collecting Native American art quickly became my way of life, defining who I am, where I go, what I care about, and even who my friends are.

Our passion and perseverance have resulted in a collection of more than five hundred objects, with an emphasis on pottery, fine art, and jewelry. The artists we have collected read like a *Who's Who* of Native American artists: Tony Abeyta, Tammy Garcia, Allan Houser, Dan Namingha, Jody Naranjo,

Virgil Ortiz, Robert Tenorio, Lonny Vigil, Denise Wallace, Nancy Youngblood, and others. When we last counted, we had 175 ceramic pots, representing all the major cultural styles of the Southwest.

As a hopelessly addicted collector, I continued to pursue my passion, but my collecting habits changed. Believing that Native American art is worthy of national and international acclaim, I was dismayed at its standing and reputation, and decided to help by assembling a body of work by selected individual artists. Through museum loans and educational programs, I hoped I could help promote their artistic genius, the overall aesthetic value of contemporary Native American art, and, if it were possible, get even more joy from collecting. I therefore decided to collect the work of a smaller set of artists, and, in order for these works to reach a broad public audience and gain acceptance in the mainstream art world as valued works of fine art, loan them to prestigious "non-Indian" museums such as the Cartier Foundation in Paris and the American Craft Museum in New York City.

Next, to help in some way to break down further the stereotype that Native American art is only about traditional baskets, rugs and pottery, I decided, once again, to redefine my collecting interests and began to acquire and promote new works best described as innovative. I believe it was Lee Cohen, the founder of a prestigious Southwestern gallery selling Native American art, who first used the term *innovators* to classify a group of Native American artists who were creating work with dynamic designs and new and exciting shapes, work that was often sensual and at other times could not be explained. You can see many wonderful examples of what I'm referring to in this exhibition. I focused on collecting from an even smaller set of artists,

specifically Tony Abeyta (Navajo), Tammy Garcia (Santa Clara), Virgil Ortiz (Cochiti), and Denise Wallace (Aleut). These artists share a courageous willingness to create objects that, although based on tradition, are the work of serious professional artists developing in dramatically new directions.

An exciting example is the pottery of the young, talented Cochiti artist Virgil Ortiz, whose work appears in *Changing Hands*. A true Renaissance man, Ortiz is an award-winning, highly sought-after potter, a fashion designer, and a filmmaker. But his figures are what caught my eye. *Munos* (Spanish for "mimicking doll") clay figures can stand up to several feet tall and impersonate individuals of unusual physical composition, such as circus characters. I was initially astonished by my attraction to these unique figures, which often leave interpretation up to the viewer. I own a four-armed man, a three-legged man, a three-faced man, a three-breasted woman, a tattooed man, and Siamese twins. I am intrigued by the creativity, innovation, and mystery in Virgil's masterful figures.

Incurable, yes. The collector's disease can be treated only by the therapy of continuous acquisition. So, look for me at this year's Indian Market. I'll be the first to arrive, the last to leave, and loaded to the max with recently acquired treasures.

David Gaussoin
Controlled Chaos, 2002;
see p. 213

V Material Evidence

Materials used in the making of art are rarely neutral but carry with them rich cultural associations that communicate meaning to the viewer. The technical skills needed to fashion materials into visually engaging and meaningful forms also provide an impetus for artists to transform ordinary techniques into virtuoso performances. In the Southwest, traditional materials are often imbued with profound cultural and spiritual values. The interaction of materials and techniques has fostered the growth of powerful traditions as well as provocative experimentation and evolution. The artists in this section of *Changing Hands* have pushed the boundaries of tradition through their exceptional skill at transforming mute materials into objects of radiant beauty. As innovators and as virtuosos, these artists are bringing change to life through their eyes, hands, and minds.

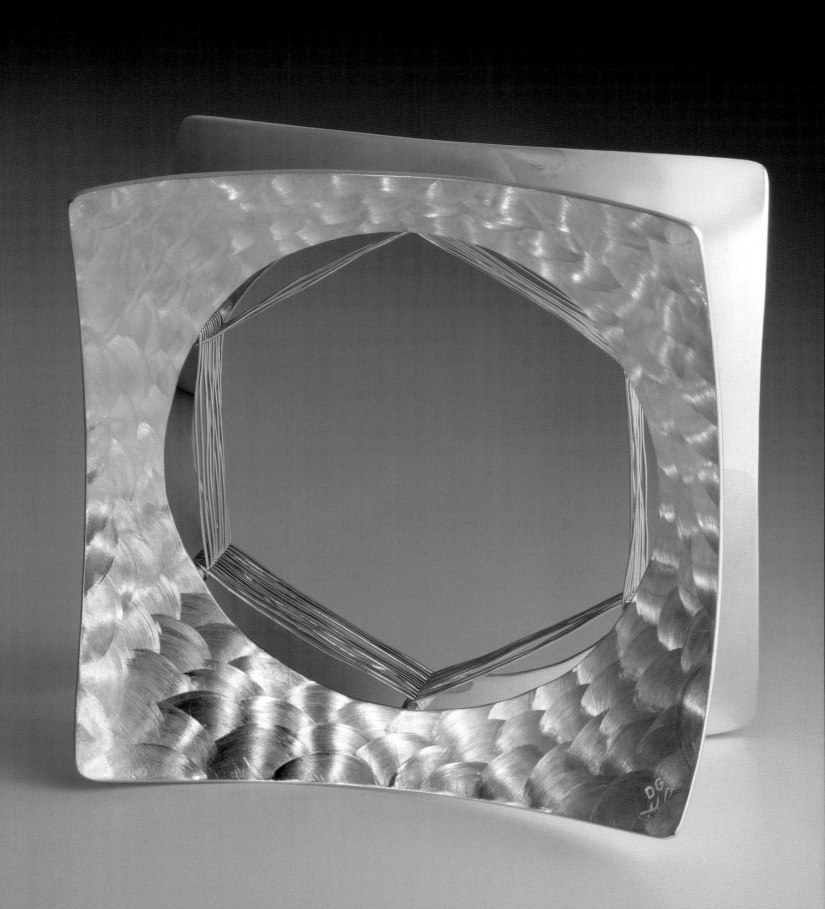

Mike Bird-Romero

Brooch, 2001
Sterling silver, Chinese writing-stone, moonstone
1¼ x 2½ (3 x 6.4)
Courtesy Blue Rain Gallery

"I have always enjoyed lapidary work as well as silversmithing. This brooch was inspired by a carved Northwest Coast Indian mask and translated into hardstone. It is set off by pieces of Chinese writing-stone, to reiterate the connection between the Northwest and Asia."

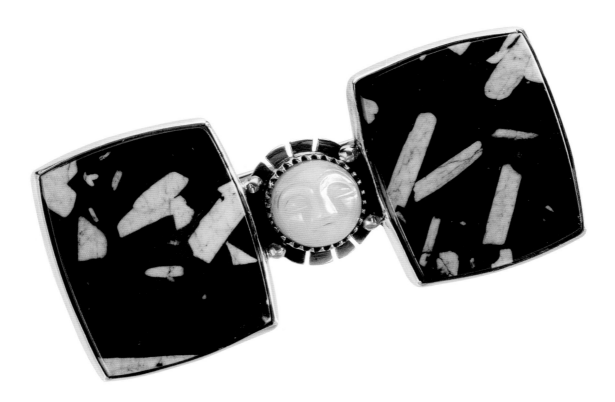

Richard Zane Smith
Untitled Vessel, 2001
Polychromed earthenware
19½ x 18¾ (49.5 x 47.6)
Collection American Craft
Museum; gift of the artist, 2001

"My life is like a clay vessel in progress. As a forty-six-year-old I have reached the point of the curving inward of the form. It is a sobering, yet strangely comforting, time of life, and I have begun to think much more seriously about how I want this 'vessel' to end. What will I leave behind when the rim is complete? It's not that I am consumed by thoughts of death, it's just that I want to finish well, to be complete."

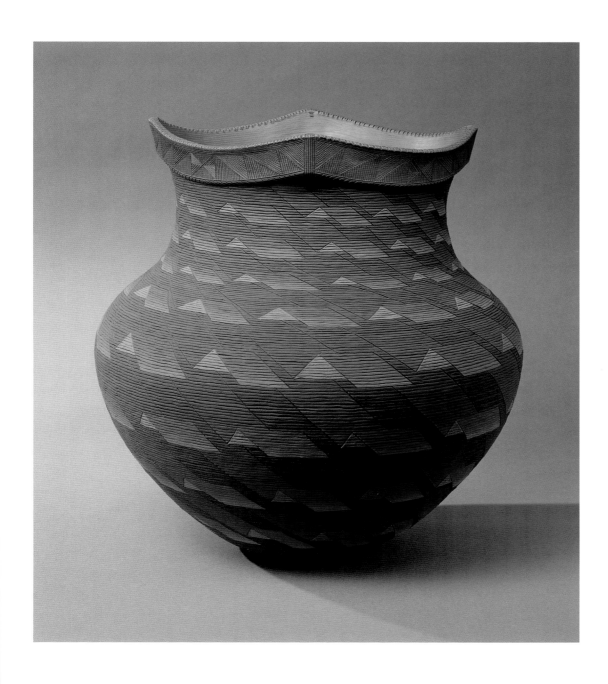

Carl Clark

Born 1952, Winslow, Arizona; lives in Phoenix, Arizona

Carl Clark is self-taught in various lapidary and metalworking techniques. Since the 1970s, he and his wife, Irene, have specialized in a unique style of what they term "micro-fine inlay" of semi-precious stones. Their works often incorporate thousands of tiny cut-and-fitted stones to create subtle gradations of color that resemble watercolor painting. While their motifs often hark back to Navajo traditions, their distinctive approach to technique sets them apart among Southwestern jewelry artists.

"We use the inlay to paint a picture and use the metalwork as a subtle picture frame."

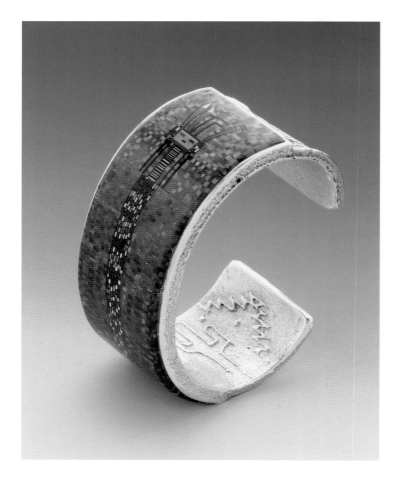

Bracelet, 2001
Sterling silver, turquoise, coral, sugulite, lapis lazuli, black jet, shell
Width: 2½ (6.4)
Courtesy Lovena Ohl/
Waddell Gallery

Pair of Bracelets, 2001
14k gold, lapis lazuli, turquoise,
sugulite, coral, opal
Widths: 2½ (6.4)
Courtesy Legacy Gallery

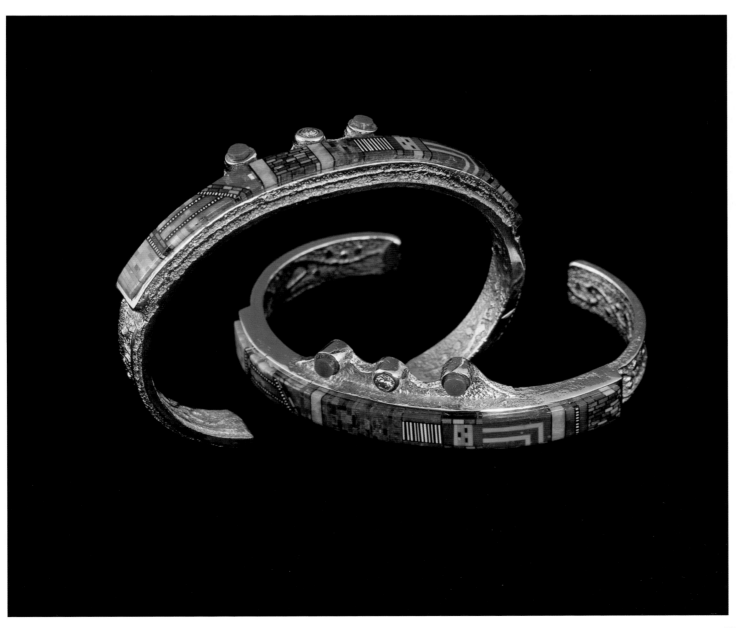

Yazzie Johnson and Gail Bird
Coral Necklace, late 1990s
Coral, 18k gold, pearls, garnets
Length: 17¼ (43.8)
Collection Valerie T. Diker

"By learning from and gaining confidence from tradition and history, our reputation for innovation was born. It gave us the freedom to use a broad range of materials, many times combined in one piece. Brass, copper, silver, gold, different-colored stones, precious and semi-precious beads from China, India, Italy—we saw our use of these materials as part of the cycle and evolution of jewelry making."

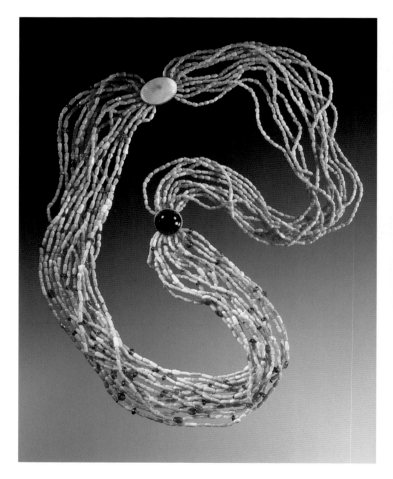

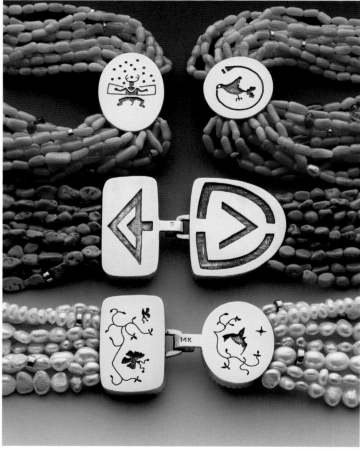

Yazzie Johnson and Gail Bird
Necklace Clasps, late 1990s
(detail; see also pp. 39 and 126)

Yazzie Johnson and Gail Bird
Opal Necklace, 2001
18k gold, opal matrix
Length: 18 (45.7)
Collection Jim and Jeanne Manning

Yazzie Johnson and Gail Bird
Necklace, 2002
18k gold, square-shaped coin
pearls, Yowah opal, chalcedony,
chrysoprase, coral, lapis lazuli,
aquamarine quartz
Length: 19¼ (48.9)
Collection of the artists

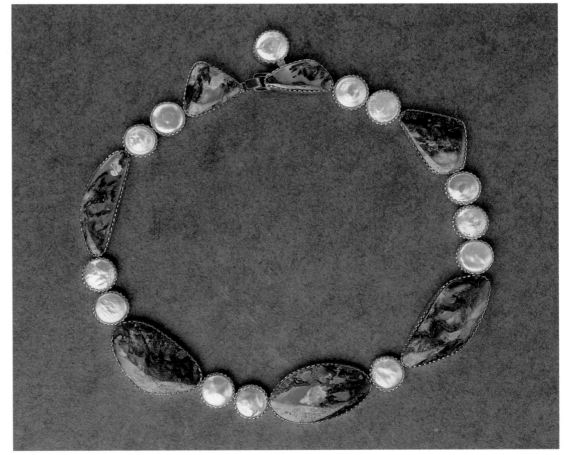

Jovanna Poblano

Born 1972, Gallup, New Mexico; lives Zuni, New Mexico

Granddaughter of Leo Poblano and daughter of jeweler Veronica Poblano, Jovanna Poblano has been innovative in designs and materials in her jewelry. She learned to make jewelry at home with her mother. A distant relative was a bead artist who gave her mother a beaded bolo; using this as an inspiration, Poblano taught herself to create finely constructed beadwork elements. Her work has been described as "modern eclecticism." Her abstract designs are composed of surprisingly juxtaposed natural stones, antique glass beads, and metal beads.

"My late grandfather, whom I never met, inspires me through his work and his memory. It is his vision that I am still carrying on."

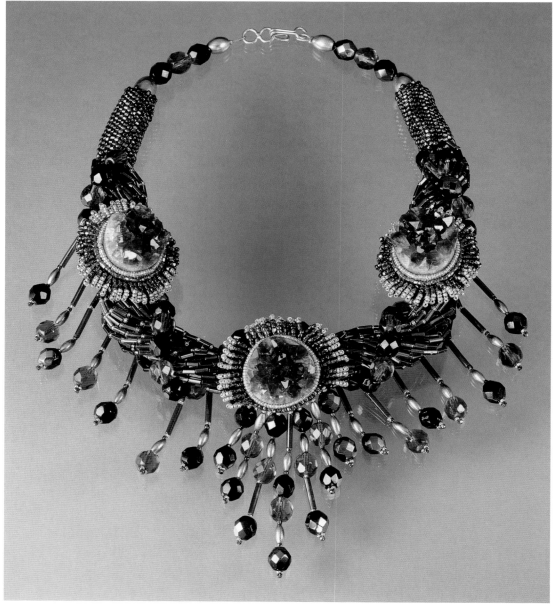

Necklace, 1996
Amethyst, glass, brass, gold-filled beads
Length: 14 (40.6)
Collection of the artist

Jovanna Poblano and Daniel Chattin
Maiden Necklace, 2001
Conch shell, sugulite, coral,
turquoise, gold-filled beads
Length: 13 (33)
Collection of the artists

Steve Lucas
Katsina Mask: Bird Symbolism,
1999
Polychromed earthenware
Diameter: 19 (48.3)
Collection Marlys and Harry Stern

"This work posed a degree of difficulty for me because of its size. I had made plates before, but none was as large as this. I used design elements relating to birds, water, clouds, stars, and katsina masks. I tried to use as many colors as I had to work with, so this piece is a good mix of colors and textures."

Jesse Monongye

*Necklace with Reversible Bear
Pendant*, 1998
18k gold, shell, onyx, coral,
turquoise, opal, sugulite, lapis
lazuli, mother-of-pearl
Necklace length: 26½ (67.3)
Pendant length: 1¾ x 3¼ (4.4 x 8.3)
Collection Marcia Docter

Jesse Monongye

Two Rings, 2000
18k gold, opal, shell, coral, onyx,
turquoise, lapis lazuli, sugulite
1⅞ x 1⅞ (4.8 x 4.8) (each)
Collection Marcia Docter

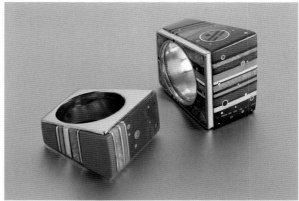

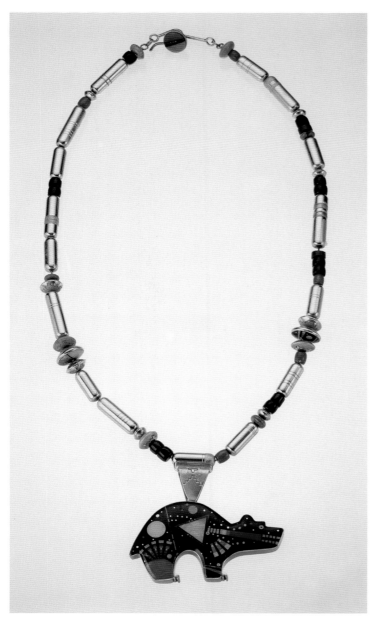

Tony Abeyta

Untitled, 2001
Metal, oil, sand, wood carvings,
on wood panel
57½ x 57½ (146.1 x 146.1)
Courtesy Blue Rain Gallery

"In this painting I have used tourist items—crudely carved katsinas—to serve as a metaphor for the rich traditions of Indian art that have been so important to me, but also to show how traditional subject matter can be restrictive when it becomes commercialized. I feel that I am free to participate in a larger spectrum of artistic activity than might have been possible earlier. I respect and draw inspiration from my heritage and traditions, but I want to move forward, to challenge myself through my art."

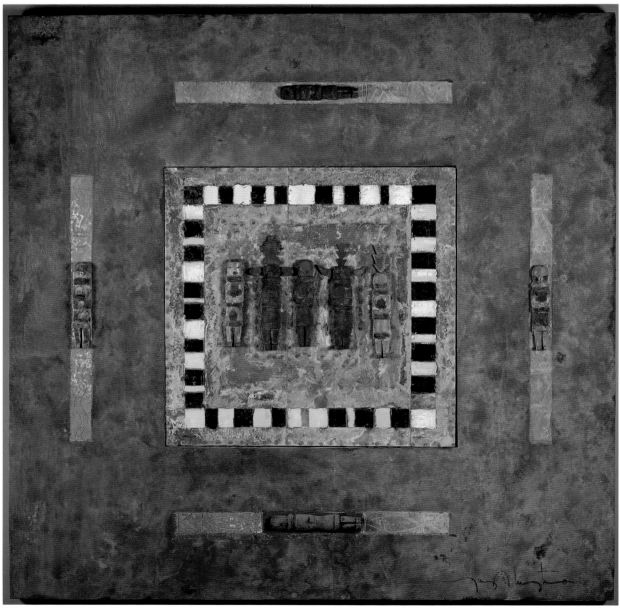

Dylan Poblano
Knuckle Ring, 1999
Sterling silver, synthetic stones
2 x 1¼ (5.1 x 3.2)
Collection American Craft
Museum: gift of Natalie
Fitz-Gerald, 2001

Ray Yazzie
Ring, 2002
14k gold, opal, sugulite, turquoise,
coral
1 x 1 (2.5 x 2.5)
Courtesy Lovena Ohl/
Waddell Gallery

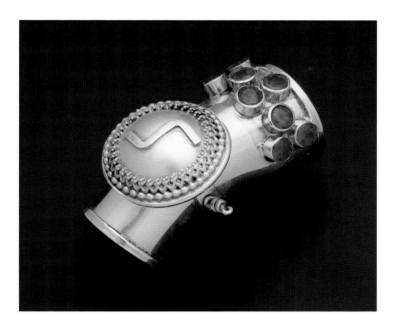

"Most of my pieces are one of a kind and made to order. Mixing stones and gems for inlay work may include placing natural turquoise, lapis lazuli, or sugulite with 1950s mirrors or glass shards. I want to present my vision of a new generation of design and tradition, a new style of elegance for our time."

"I owe a lot to my brother Lee for his demanding and excellent instruction. Competition with other artists in the field drives me to new heights in my own way. But I get my inspiration especially from my family, particularly my wife, Colina, a weaver. We contribute ideas to each other's designs."

Verma Nequatewa
Three Bracelets, mid-1990s
18k gold, coral, sugulite,
turquoise, lapis lazuli, malachite,
serpentine, fossilized ivory, teak,
ebony, onyx
Widths: 3¼ (8.3); 3 (7.6); 3 (7.6)
Collection Judy Cornfeld

"For me, change means refinement. It can also mean development in new areas or directions, using new ideas, new observations, and even new materials. Change in my work might come from seeing something new, either natural or manmade. Change is the natural process of development. It keeps us creating. That is change. That is art."

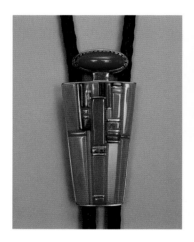

Verma Nequatewa
Bolo Slide, 1994
14k gold, coral, lapis lazuli
Length: 3¼ (8.3)
Collection Dr. and Mrs. E. Daniel
Albrecht

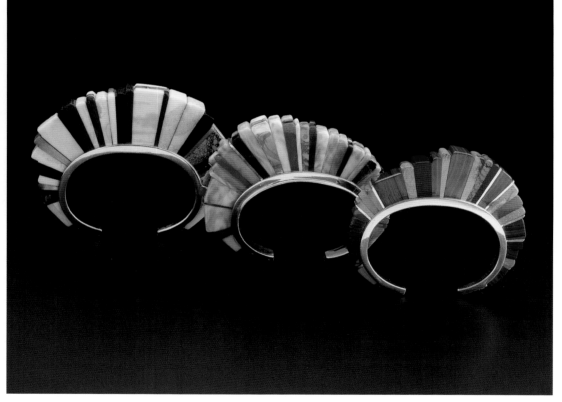

"I began making jewelry as a child. I saw it as a form of playing and being able to express my ideas. I still see it this way. I am always interested in finding new ways of creating. I feel artists must push themselves and not be afraid to create new designs or ideas. This helps an artist grow. I create art through metal, using silver and gold to express stability, and stone and shell to express emotion."

David Gaussoin
Controlled Chaos, 2002
Sterling silver, 14k gold wire
4 x 4 (10.2 x 10.2)
Collection of the artist

C. S. Tarpley

Born 1971, Abilene, Texas; lives Monterey, California

C. S. Tarpley was interested in art from childhood onward and learned to
sculpt and make jewelry in high school. He went on to work with
foundries and jewelry manufacturers, and became skilled in lapidary
work. He studied at the Pilchuck School of Glass in Seattle, Washington,
in 1996 with noted American glass artist Michael Glancy, a specialist in
electrodeposition techniques. Tarpley has adapted this technique to his
own work in glass and is known for vessels enriched with jewel-like
metal deposits, inspired by his interest in ornament of all countries and
periods. At present he is studying languages in the U.S. Air Force.

"The arabesque pattern on this jar
is my interpretation of Moorish
floral motifs, and reflects my deep
interest in Arabic culture."

Vase, 2000
Glass, copper
Diameter: 12½ (31.8)
Collection American Craft
Museum; gift of the artist, 2000

Richard I. Chavez
Bolo Slide, 1996
Sterling silver, lapis lazuli, coral,
turquoise, gold
Length: 2¾ (7)
Collection Philip M. Smith

Larry Golsh
Crystal Shaman Brooch, 1997
18k gold, peridot, tanzanite
Length: 2⅞ (7.5)
Collection Dr. and Mrs. E. Daniel
Albrecht

"Rock art often includes lively
stylized depictions of human
beings. While entirely abstract,
this brooch suggests the human
form, but also the erosion of
weather and time in the ridged
patterns on the metalwork."

"This is the kind of work I love to
do—it is not symmetrical and
uses my favorite stones. I enjoy
the challenge of making abstract
designs, sometimes focusing on a
specific stone color. This piece
was done in what I call my 'lapis'
period."

Rebecca Lucario

Born 1950, Acoma, New Mexico; lives Acoma, New Mexico

The eldest sister of five ceramists, Rebecca Lucario has achieved prominence for the skill and complexity of her painted ceramics. She learned her techniques from her grandmother, the noted potter Dolores Sanchez. Lucario has always worked in two modes. A substantial body of her work relates directly to tradition, inspired by Mimbres models and painted with stylized animals and ancient symbols. Lucario's innovative work is revealed in her monochromatic "eye-dazzler" pots and chargers, on which elaborate patterns composed of delicate hand-painted lines create a visual surface vibration.

Plate, 2000
Polychromed earthenware
Diameter: 13¼ (33.7)
Collection Jane and Bill
Buchsbaum

"When I first started really to work at my pottery, I admired the work of Marie Chino, noted Acoma potter. And I credit my sister Marilyn for helping me to look at new designs and shapes. As a result, today I experiment more with my work, and I think it's better."

"I wanted this piece to feature contemporary designs, yet the warp-dominant piece is traditional. I have Italian heritage as well as Native American. My new work also deals with the issues of my existence in two worlds."

"My experimentation in dyeing with natural plants is also a traditional Navajo art. For this piece, I used Navajo tea, sagebrush, and Hills Brothers coffee to dye my yarn. As a child, I remember my grandma making coffee with Hills Brothers coffee when we visited her. I hoped to capture the properties of these hot beverages, because these visits were a time of sharing and learning."

Morris Muskett
White on White Sash with Indigo Blue Selvage Cords, 2001
Cotton, indigo
44 x 7 (111.8 x 17.8)
Collection of the artist

Morris Muskett
Variegated Sash, 2001
Hand-dyed cotton
123½ x 3⅛ (313.7 x 7.8)
Collection of the artist

"The sheet-and-wire construction process allows me to use my mechanical and architectural drawing background to design a three-dimensional, geometric (or free-form) sculpture. This process highlights the use of lines, angles, surface textures, and the shadowing effects of oxidation."

"This weaving is made of vegetable-dyed handspun wool, using over sixty colors. It was a challenging project. I used an eight-by-ten-inch photograph of the Pentium chip, which I sectioned into one-sixteenths. I measured and marked my warp into sixteenths as well, and then wove the piece accordingly. I like to be innovative in my work, going one step further than my last weaving. In this work I was able to create an intricate design within the limitations of the technique."

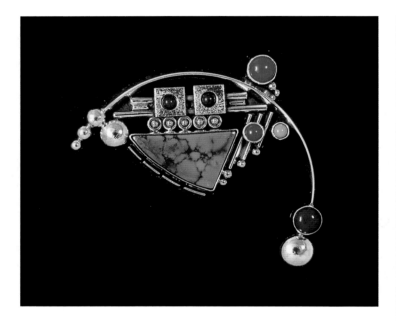

L. Eugene Nelson
Galaxy Pin, 1996
Sterling silver, 14k gold, turquoise,
lapis lazuli, coral
1⅝ x 2¼ (4.1 x 5.7)
Collection Chris Byrd

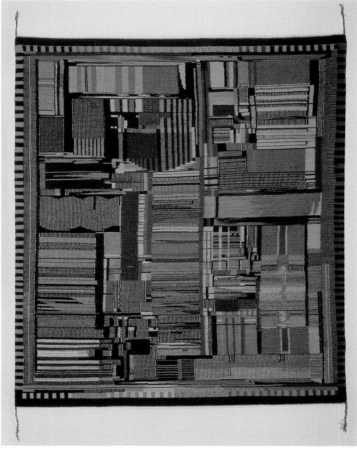

Marilou Schultz
Computer Chip Weaving, 1994
Handspun wool, vegetal dyes
70 x 70 (177.8 x 177.8)
Collection American Indian
Sciences and Engineering Society

Annie Antone

Born 1955, Tucson, Arizona; lives Gila Bend, Arizona
Annie Antone uses only materials harvested in her region of the Sonoran desert of Arizona. A member of the Tohono O'Odham tribe, Antone learned basketry techniques from her mother. Her work has been exhibited widely in the United States, and extensively published. While certain motifs used in her coiled baskets are traditional, she is best known for her unique and bold graphic designs, carried out in a rigorously limited palette of natural colors.

Snake and Birds, 1999
Coiled yucca, devil's claw, bear grass
Diameter: 17½ (44.5)
Collection Dr. and Mrs. E. Daniel Albrecht

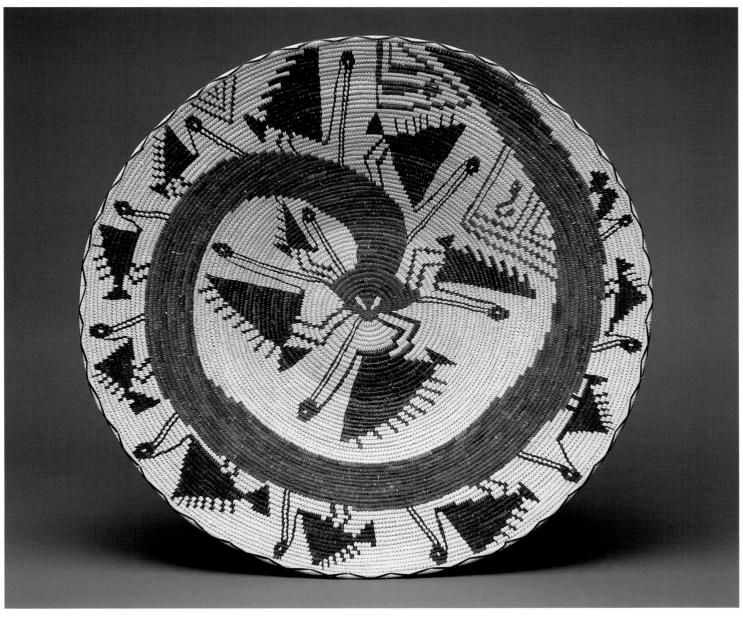

Art Education

Joanna O. Bigfeather

This year marks the fortieth anniversary of the Institute of American Indian Arts (IAIA), a junior college located in Santa Fe, New Mexico. The school was opened in September 1962 by the Bureau of Indian Affairs as an experiment dedicated to the teaching of new concepts in art and new art forms to young Native Americans from the United States and Canada. From the start, the two-year program offered course work in traditional arts, painting, sculpture, textiles, jewelry, photography, ceramics/traditional pottery, theater, and creative writing, and the student population represented tribes from both urban and Reservation communities.

What is important to note is that the opening of the school marked the beginning of the contemporary Native American art movement. The school was born during an era unlike any other in American history. It was a time of revolution and change springing from the political environment that gave rise to the Vietnam War, the Civil Rights Movement, and the American Indian Movement (AIM). In response, artists of every medium experimented with new materials and new ideas that spoke directly to the frenetic climate of American society: the Beatles, the Stones, Jimmy Hendrix, the Doors, Roy Lichenstein, Andy Warhol, and Claes Oldenburg all captured the spirit of the time.

The young faculty at IAIA was both Native and non-Native, and brought with them a combined history of artistic experience, enthusiasm, and knowledge that has yet to be rivaled. Professors such as Otellie and Charles Loloma introduced the students to painting, pottery, and jewelry, and their influence is still felt in the work of artists today. Allan Houser's instruction in sculpture also left its mark on today's sculptural forms. Ralph Pardington saw an advertisement on a bulletin board at Cranbrook Academy of Fine Art for a ceramics instructor at IAIA and applied for the position; he brought with him the influences of Paul Soldner, Peter Voulkos, Bernard Leach, and John Mason, and he stayed on to teach at the school for over twenty-five years, encouraging students to work from their cultural traditions but also to explore new forms and to push their concepts of art. These approaches to form and function liberated the young students to take risks.

The Institute of American Indian Arts was not just another "Indian" school in America. It was unique. It provided students the opportunity to explore their tribal backgrounds, experiment in a new artistic language, and interact with other Native students in a non-militaristic environment very different from that found in the BIA schools of that era. As students graduated from the two-year program, they created their own artistic styles and dictated what Indian art is today. The alumni list is long and prestigious—Dan Namingha, T. C. Cannon, Kevin Red Star, Earl Biss, Doug Coffin, Christine McHorse, Diego Romero, Preston Duwyenie, Jackie Stevens, Tony Jojola, and Duane Maktima were all students there. The influence of the school over four decades can be seen in the traditional arts of pottery, weaving, basketry, jewelry, painting, and sculpture, and the contemporary art world would be quite different from what we see today if the school had not been created. I would venture to say that today most collectors of Southwestern Indian art have at least one piece of art from an IAIA graduate.

Other important influences have driven the Native artist, too. The prestigious Indian Market sponsored by the Southwestern Association for Indian Arts (SWAIA), held annually in Santa Fe on the third weekend of August, is the grandfather of all Native art fairs, with attendance that has grown to 125,000.

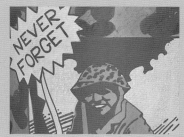

For over two decades, I have observed Indian Market and participated in it, and this has given me the opportunity to analyze the event. All forms of art are available to the buyer at the fair, but the most popular categories of wares are pottery and jewelry. It is important to note that at the fair it is not necessarily the art that decides "what Indian art is"; it is the collector. When the artist moves away from what the collector says is Indian art, the work no longer sells. Generally, the work that is most sought after is not the political, the conceptual, or the work that is challenging. Instead, it is the work that follows more traditional concepts. Yet there are artists at the fair whose work challenges the viewer and pushes the so-called envelope. Diego Romero and Roxanne Swentzell have been able to cross over into the political as well as work in traditional forms and venues, Diego in an overt way and Roxanne in a subtle way. Both artists have stayed true to their art and have continued to challenge the viewer.

When examining where the Native American art movement is today, we need to look at the broad picture of American art. Is Native American art American art? Is it part of an artistic movement within the United States? I raise these questions because contemporary Native American art is absent from American art-history books—most notably H. H. Arnason's *History of Modern Art* and more recently Robert Hughes's *American Visions: The Epic History*.

We need to look at the reasons why art by Native Americans is not included in the major college texts of today. Students in America know very little about the First People. Generally, they do not learn about indigenous people until they are introduced to them through a history course in the fourth grade. Their next exposure is not until high school (through another history course), and, if the student continues on to college, he or she might learn a little more through an elective or required multicultural class.

If people are not educated about Native people's history, forms, and visual language, it is difficult to imagine that they could understand the artwork. Native artists are not unlike other artists; they need critical writing about their work, not just the Sunday feature article in the local paper. What we find, as far as contemporary Native art is concerned, is a country that is ignorant of the First People and not willing to make a change. It is my challenge to educators and writers to learn their history. This is your history, a shared American history.

Bibliography

Abbott, Lawrence, ed. *I Stand in the Center of the Good: Interviews with Contemporary Native American Artists*. Lincoln, Nebr.: University of Nebraska Press, 1995.

Anderson, Duane. *All That Glitters: The Emergence of Native American Micaceous Art Pottery in Northern New Mexico*. Santa Fe, N. Mex.: School of American Research Press, 1999.

Bailey, Garrick, and Bailey, Roberta Glenn. *A History of the Navajos: The Reservation Years*. Santa Fe, N. Mex.: School of American Research Press, 1986.

Batkin, Jonathan, ed. *Clay People.* Santa Fe, N. Mex.: The Wheelwright Museum of the American Indian, 2001.

Berkenfield, Barbara. "Elsie Holiday: Navajo Basket Maker," *Indian Artist*, Winter 1999, p. 46.

Bernstein, Bruce. "Contexts for the Growth and Development of the Indian Art World in the 1960s and 1970s." In *Native American Art in the Twentieth Century: Makers, Meanings, Histories*, edited by W. Jackson Rushing III. London and New York: Routledge, 1999, pp. 57–71.

Brugge, David M. *Hubbell Trading Post: National Historic Site*. Tucson, Ariz.: Southwest Parks and Monuments Association, 1993.

Cirillo, Dexter. *Southwestern Indian Jewelry*. New York: Abbeville Press, 1992.

Coe, Ralph T. *Lost and Found Traditions: Native American Art 1965–1985*. Seattle, Wash., and New York: University of Washington Press/American Federation of the Arts, 1986.

Cohen, Lee M. *Art of Clay: Timeless Pottery of the Southwest*. Santa Fe, N. Mex.: Clear Light Publications, 1993.

Dalrymple, Larry, and McGreevy, Susan Brown. *Indian Basketmakers of the Southwest*. Santa Fe, N. Mex.: Museum of New Mexico Press, 2000.

Dillingham, Rick. *Fourteen Families of Pueblo Potters*. Albuquerque, N. Mex.: University of New Mexico Press, 1994.

Dubin, Lois Sherr. *North American Indian Jewelry and Adornment: From Prehistory to the Present*. New York: Harry N. Abrams, 1999.

Dubin, Margaret. *Native America Collected*. Albuquerque, N. Mex.: University of New Mexico Press, 2001.

———. "Sanctioned Scribes: How Critics and Historians Write the Native American Art World." In *Native American Art in the Twentieth Century: Makers, Meanings, Histories*, edited by W. Jackson Rushing III. London and New York: Routledge, 1999, pp. 149–66.

Eddington, Patrick, and Makov, Susan. *Trading Post Guidebook*. Flagstaff, Ariz.: Northland Publishing, 1995.

Edison, Carol A., ed. *Willow Stories: Utah Navajo Baskets*. Salt Lake City, Utah: Utah Arts Council, 1996.

Getzwiller, Steve, and Manley, Ray. *The Fine Art of Navajo Weaving*. Tucson, Ariz.: Ray Manley Publications, 1984.

Hammond, George P., and Rey, Agapito, eds. *Expeditions into New Mexico Made by Antonio de Espejo, 1582–1583*. Los Angeles, Calif.: Quivira Society Publications, 1929.

Hedlund, Ann Lane. *Reflections of the Weaver's World*. Denver, Colo.: Denver Art Museum, 1992.

Hoving, Thomas. *The Art of Dan Namingha*. New York: Harry N. Abrams, 2000.

Howard, Kathleen L., and Pardue, Diana F. *Inventing the Southwest: The Fred Harvey Company and Native American Art*. Flagstaff, Ariz.: Northland Publishing, 1996.

Jacka, Lois Essary. *Art of the Hopi: Contemporary Journeys on Ancient Pathways*. Flagstaff, Ariz.: Northland Press, 1998.

———. "Weaves of Grass," *Arizona Highways*, November 1997, pp. 18–23.

———. *Enduring Traditions: Art of the Navajo*. Flagstaff, Ariz.: Northland Press, 1994.

———. *Beyond Tradition: Contemporary Indian Art and Its Evolution*. Flagstaff, Ariz.: Northland Press, 1994.

James, H. L. *Posts and Rugs: The Story of Navajo Rugs and Their Homes*. Globe, Ariz.: Southwest Parks and Monuments Association, 1976.

Kaufman, Alice, and Selser, Christopher. *The Navajo Weaving Tradition: 1650 to the Present*. New York: E. P. Dutton, 1985.

Kent, Kate Peck. *Navajo Weaving: Three Centuries of Change*. Santa Fe, N. Mex.: School of American Research Press, 1985.

McGreevy, Susan Brown. *Indian Basketry Artists of the Southwest: Deep Roots, New Growth*. Santa Fe, N. Mex.: School of American Research Press, 2001.

McMaster, Gerald. *Reservation X*. Seattle, Wash.: University of Washington Press and Hull, Quebec: Canadian Museum of Civilization, 1998.

Photo Credits

McNitt, Frank. *The Indian Traders*. Norman, Okla.: University of Oklahoma Press, 1962.

Mullin, Molly H. *Culture in the Marketplace: Gender, Art, and Value in the American Southwest*. Durham, N.C.: Duke University, 2001.

Nahwooksy, Fred, and Hill, Richard, Sr. *Who Stole the Tee Pee*? Phoenix, Ariz.: Atlatl, Inc., 2000.

Painter, Robert. *The Native American Indian Artist Directory*. Albuquerque, N. Mex.: First Nations Art, 1998.

Pardue, Diana. *The Cutting Edge: Contemporary Southwestern Jewelry and Metalwork*. Phoenix, Ariz.: The Heard Museum, 1997.

Peterson, Susan. *Pottery by American Indian Women: The Legacy of Generations*. New York: Abbeville Press, 1995.

Phillips, Ruth B. "Art History and the Native-Made Object." In *Native American Art in the Twentieth Century: Makers, Meanings, Histories*, edited by W. Jackson Rushing III. London and New York: Routledge, 1999, pp. 97–112.

Rodee, Marian, and Ostler, James. *The Fetish Carvers of Zuni*. Albuquerque, N. Mex.: The Maxwell Museum of Anthropology and Pueblo of Zuni, 1995.

Rushing, W. Jackson III, ed. *Native American Art in the Twentieth Century*. New York: Routledge, 1999.

Struever, Martha. *Painted Perfection: The Pottery of Dextra Quotskuyva*. Santa Fe, N. Mex.: The Wheelwright Museum of the American Indian, 2001.

Tack, David. "Reweaving Tradition: New Trends in Contemporary Southwestern Basketry," *Native Peoples*, September/October 2000.

Index

Bold numbers indicate an artist's main entry; *italics* indicate any other illustration of his or her work.